Illinois

A History in Pictures

GERALD A. DANZER

Illinois
A History in Pictures

University of Illinois Press

Urbana, Chicago, and Springfield

Library of Congress Cataloging-in-Publication Data
Danzer, Gerald A.
Illinois : a history in pictures / Gerald A. Danzer.
p. cm.
Includes bibliographical references and index.
ISBN-13: 978-0-252-03288-2 (hardcover : alk. paper)
ISBN-10: 0-252-03288-8 (hardcover : alk. paper)
1. Illinois—History. I. Title.
F541.D24 2010
977.3—dc22 2010042415

To Ashley, Aaron, Kyle, Alisa,
Magdalene, Drake, and Reese,
God bless you on your journey

Contents

Preface

This is a book of pictures but is also a collection of ideas. A brief text provides a historical context to connect the images with the thoughts and actions that have defined this place as Illinois, a land between the Great River and the Great Lakes. The story is told, graphically as well as literally, to engage us in a quest for understanding. It is meant to be a challenge to think, to explore, and to discover how historic forces have moved various people to create the Prairie State.

These images, whether snapped by a photographer, sketched by an artist, shaped by a sculptor, drawn by a map-maker, or pictured in the mind's eye, help construct the story of Illinois. This is the name of a state, but an even older designation refers to a people, and along with them to the land where they lived. A namesake river serves as the backbone for the land of Illinois. It is a notable stream that reaches up from the Mississippi Valley to brush against the waters of Lake Michigan or, as it was called by early French explorers, the Lac des Illinois. Illinois is a place where the Great Valley of Mid-America connects with the Great Lakes. Today, multitudes of people crowd around the broad linkage between these two geographical regions, and great rivers continue to frame the state: the Mississippi, the Ohio, and the Wabash. These waters flow outward, connecting Illinois to its neighbors, to the nation, and to the world. State history, in the final analysis, is a means of connecting personal and local experiences to national affairs and global perspectives.

Artists have left a rich heritage as they pictured Illinois in landscapes, rural scenes, townscapes, and cityscapes. Their portraits of people, records of events, and images of past geographies enable us to see that which has passed away. These paintings, drawings, sculptures, build-ings—indeed, images and artifacts of every description—comprise an immense legacy. We are called upon to search them for understanding, view them with appreciation, and conserve them for fu-ture generations. Photographs, which are available for most of the state's history,

add to our store of treasures but do not entirely replace other graphic sources. Then there are maps, plans, and blueprints and the like, which in various ways help us comprehend space. Numbers are another way of seeing. They can help us perceive distributions, changes, trends, and balances. Graphs, diagrams, and charts also reveal the past in special ways, often illuminating what at first glance was hidden or obscure.

Pictorial resources provide an exciting way to learn history, but, as one historian has observed, they are like those children of long ago who spoke only when spoken to. As with all historical sources, pictures and objects must be actively engaged, looked at with questions in mind, searched for hidden meanings, confronted as advocates for particular interests, and grilled by latter-day readers to reveal their purposes and prejudices. Practice in using pictorial sources as historic documents develops visual literacy, a skill of great value in today's culture. And, if you look at any picture in a reflective way you will, if you tarry long enough, begin to see yourself. History, if it has any real value, must connect to the self.

Two long-time colleagues, David Buisseret and Perry Duis, commented on early versions of this project, and critical readers, including James F. Davis and Michael D. Sublett, have greatly improved the final rendering. Willis G. Regier, the director of the University of Illinois Press, has been a steadying and encouraging editor. Victor Benitez prepared the index. My hope is that the result does justice to their efforts. In any case, I owe each of these scholars a deep debt of gratitude. My understanding of the nature of state history, the particulars of the Illinois experience, and the special qualities of graphic sources is not yet in full flower, so I plan to depend on them, and readers as well, for continued help as we get our Illinois heritage in shape for the bicentennial celebration in 2018.

All history is, in one sense, pictorial in nature. Enlarging our field of vision

enriches our understanding of self. Then history, as it helps us to comprehend our days and ourselves, makes it possible to conceive of the future. Without pictures of the past, and concepts that enable us to understand them, we would have great difficulty envisioning the future. As we reflect on the stream of time, whether standing on the shore of Lake Michigan or gazing down a great river, the capstone question, Why? will surely emerge from the basic who, what, when, and where. When why dominates our thoughts we will be on our way to a real education.

Thus, as we look at the following pictures of the past, let us resolve to be alert to connections, to the many ways the present is informed by these images, and, finally, to how in many subtle ways they help us conceive of the future. As we begin to glimpse the richness of the story of Illinois and its potential for enlarging our lives we might repeat a classic refrain from the historical record, one I have heard so often and on so many occasions that it has become a daily litany: God bless us on our journey.

Illinois

A History in Pictures

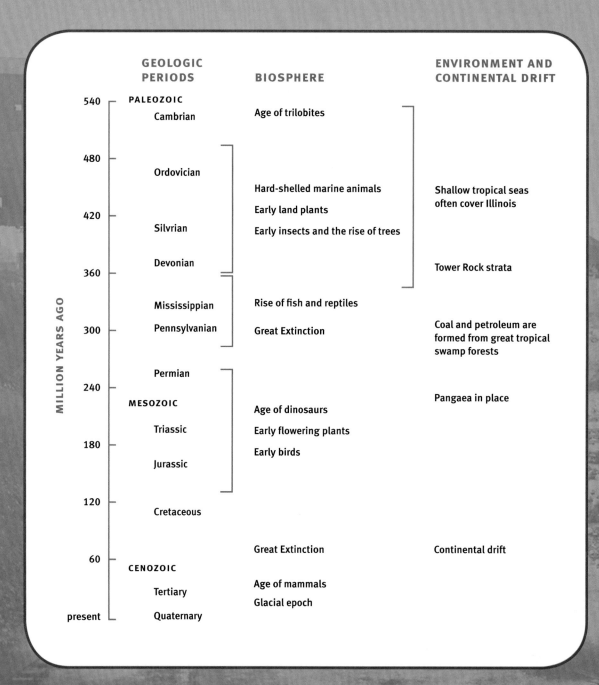

	GEOLOGIC PERIODS	BIOSPHERE	ENVIRONMENT AND CONTINENTAL DRIFT
540	PALEOZOIC		
	Cambrian	Age of trilobites	
480	Ordovician		
		Hard-shelled marine animals	Shallow tropical seas often cover Illinois
420		Early land plants	
	Silvrian	Early insects and the rise of trees	
	Devonian		Tower Rock strata
360			
	Mississippian	Rise of fish and reptiles	
300	Pennsylvanian	Great Extinction	Coal and petroleum are formed from great tropical swamp forests
	Permian		
240			Pangaea in place
	MESOZOIC	Age of dinosaurs	
	Triassic	Early flowering plants	
180		Early birds	
	Jurassic		
120	Cretaceous		
60		Great Extinction	Continental drift
	CENOZOIC		
	Tertiary	Age of mammals	
		Glacial epoch	
present	Quaternary		

MILLION YEARS AGO

ONE

Contours

The Physical Geography of Illinois

TODAY, the word *Illinois* serves, first of all, as a place name. It is a geographical label for a place bounded by imaginary lines that run down rivers, over hills, across prairies, and project out into Lake Michigan. The land and its characteristics lay a foundation for the collective identity of its people, the citizens of the state of Illinois. The look of the land is therefore a good place to begin a narrative of the state's history.

During the Lincoln-Douglas Debates of 1858, this one in Jonesboro, Stephen A. Douglas recalled his journey from the hills of New England onto the flatlands of Illinois: "I . . . found my mind liberalized and my opinions enlarged when I got on those broad prairies," the Little Giant concluded, "with only the heavens to bound my vision." A half-century later, Daniel Burnham reached a similar conclusion, standing on the shoreline where the central lowland province merged into the expanse of Lake Michigan: "In its every aspect it [the lake] is a living thing, delighting man's eye and refreshing his spirit."

Landscape, of course, does not by itself mold character or shape history. Culture, heritage, resources, political institutions, economic systems, and the like also have something to say, not to mention character and contingency. But the essential point deserves attention: geography is more than a stage on which the human drama takes place, it is part and parcel of the story itself, a readable text and not merely a picturesque background. Indeed, the variety discerned in a close reading of the place we call Illinois leads to a more complex history. An awareness of the dynamic qualities of the physical environment puts everything in motion; even the rocks and hills record, in geological time, a story of dramatic change, preparing us for everyday movements observed in flowing waters, nodding trees, and billowing grasses.

Broad horizons reached across the Prairie State from the earliest days of human habitation. Extending north and south over five and a half degrees of latitude, the Illinois country exhibited a variety of resource zones. As people de-veloped the land they produced a diversity of products, so the theory went, encouraging commercial exchange. North-south trade would meet the westward course of empire, creating a crossroads in the heart of the Mississippi Valley. If one traveled "from Chicago to Cairo, down the Illinois Central," an advertisement declared in 1869, "he will have experienced more varieties of soil, climate, and productions than can be found in any other state in the Union. He sees everything from the pine of the North to the magnolia of the South; from corn and potatoes to cotton and tobacco."

The Illinois River, like its flanking streams, the Mississippi and the Wabash-Ohio, generally flowed from the north to the south. Lake Michigan took a similar orientation. Thus like the shape of the state itself, Illinois and its extensions, a Great Lake to the north and the Great River to the south, suggested a central axis for American history. The low divide between the Mississippi Valley and the basin of the Great Lakes, at the point where it reaches

closest to the heart of the United States, provided a pivot for national history. Illinois, in its very situation, would be at the center of national affairs.

Geographers often speak of five fundamental themes: location, place, movement, region, and human-environmental interaction. Location in absolute terms defines our spot on the planet. In relative terms it connects us to our immediate surroundings. A location turns into a place as people encounter it and use it for their own purposes. The patch marked by latitude and longitude turns into a place when people give it a name and attach to it their experiences, memories, and expectations. Movement brings people, goods, ideas, cultures, and technologies to the place, setting up land-use patterns and establishing networks of exchange. In the process regions can be discerned, geographical areas that share certain characteristics and are connected in some way. Illinois belongs to many regions: the Midwest, the Prairie Province, the Corn Belt, and the Northeastern Manufacturing Belt, to list a few. It also marked, two centuries ago, the transition from the grassland of the West to the great continental forest of the East.

In 1818, when Illinois became an American state, one could travel across North America from the Atlantic Coast to the Illinois border and never step out from the shade of the trees. Then, proceeding westward, the traveler could walk hundreds of miles across the grasslands. In Illinois the Great Forest met the Great Plains, partaking some elements of both natural regions. But whether in the woods or on the prairie, people and the physical environment interacted with each other, in the process sustaining social, economic, cultural, and political systems. Thus we start the story of Illinois by looking at the land itself, picturing it in different ways from a variety of vantage points.

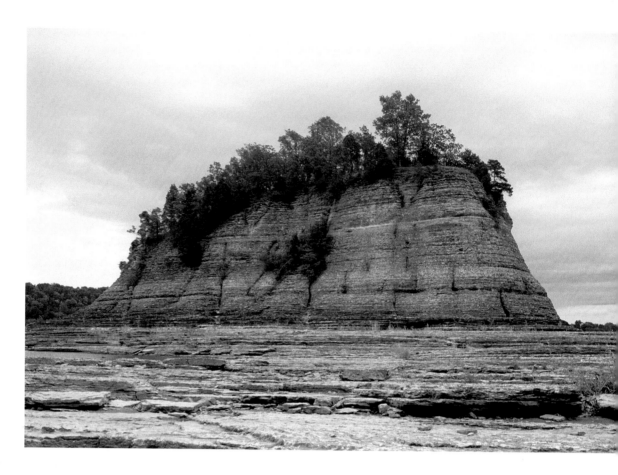

1.1 TOWER ROCK

The way we view the landscape influences how we live our lives. Tower Rock is a case in point. The town nearby is Grand Tower, and this fortress of Devonian limestone reveals the bedrock of the midcontinent, formed when the land spent long eras beneath warm, shallow seas. The accumulation of marine deposits eventually turned into limestone, such as the layers exposed in Tower Rock. These rocks, formed between 417 to 354 million years ago, appear near the surface along the Mississippi River in western Illinois. But they present only one segment of the sedimentary tiers that reach hundreds, even thousands, of feet beneath the surface, forming deep foundations for the state.

1.2 JOLIET QUARRY (*RIGHT/TOP*)

Illinois limestone became a popular building material where it was located close to the surface and when it benefited from inexpensive transportation. The construction of the Illinois and Michigan Canal in the 1840s created these conditions in the Joliet-Lemont area. Locks, bridges, and viaducts for the canal used limestone excavated from the canal bed and quarries nearby. The canal then furnished a cheap way to move the stone around the state. The state penitentiary at Joliet operated this particular pit to employ prisoners in a useful occupation. In 1869 the legislature even specified that the present state capitol be constructed of "prisoner stone" from Joliet (fig. 8.1).

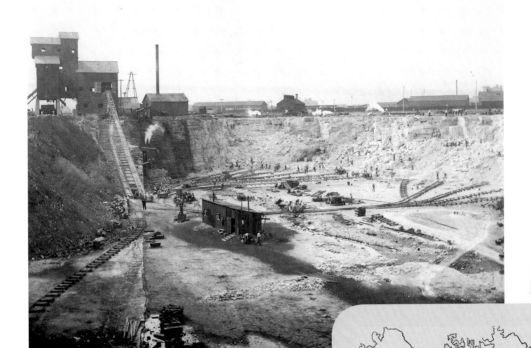

1.3 THE ICE AGE (*RIGHT*)

In the sequence of geological time Illinois drifted northward, rose above the sea, and then was, much later, subjected to advancing ice sheets of continental proportions during the most recent eras. The Ice Age in Illinois extends backward almost two million years, but the last ice sheet retreated only recently, even by our recording of time. Human beings witnessed its final retreat, having arrived in Illinois by twelve thousand years ago when the region's topography was assuming its current shape. This map gives a general idea of the major centers of ice accumulation and the furthest extent of glacial advance. The glaciers never covered the driftless areas, including the northwest corner of Illinois (compare figs. 1.5 and 1.6).

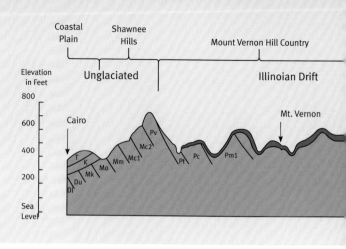

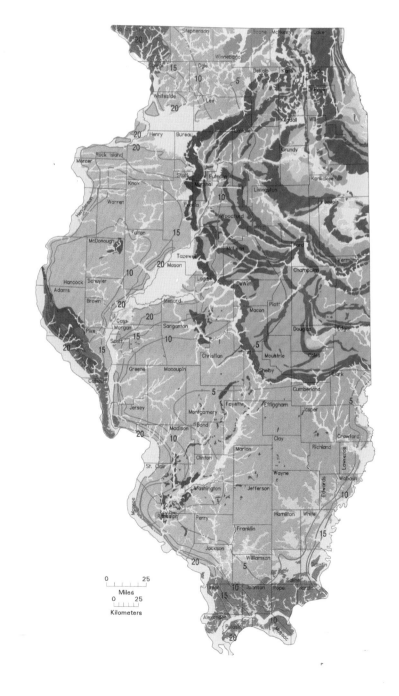

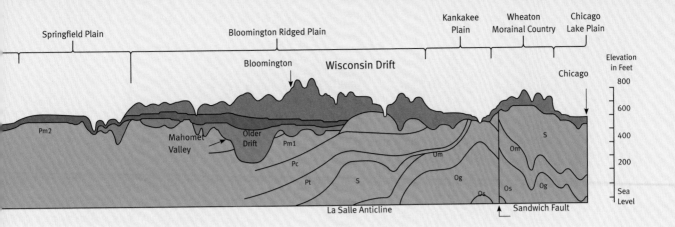

Springfield Plain · Bloomington Ridged Plain · Kankakee Plain · Wheaton Morainal Country · Chicago Lake Plain

Bloomington · Wisconsin Drift · Chicago

Elevation in Feet

800
600
400
200
Sea Level

Pm2 · Mahomet Valley · Older Drift · Pm1 · Pc · Pt · S · Om · Og · Os · Om · Os · S · Og

La Salle Anticline · Sandwich Fault

1.4 A CROSS SECTION OF ILLINOIS TOPOGRAPHY (*TOP*)

This cross section greatly exaggerates vertical elevation to point out the various types of deposits left behind by ice sheets. The diagram extends from Cairo at the southern tip of Illinois northward to Bloomington and then turns to reach Chicago. The various rock strata are warped and dip below the surface. In Chicago, Silurian rocks (S) form the bedrock. Near the Sandwich fault, older Ordovirian strata (O) reach the surface. In northern Illinois the younger Mississippian (M) and coal-bearing Pennsylvania (P) strata are completely missing. Because ice sheets and erosion have removed all the still younger Triassic and Jurassic rocks, Illinois has no dinosaur fossils. In their place, the surface is covered with great depths of glacial drift: rocks, clay, sand, silt, and soil moved by the Wisconsin, Illinoian, and older ice sheets.

1.5 GLACIAL MAP OF ILLINOIS (*LEFT*)

The surface of Illinois is a product of the ice sheets. Although glaciers never covered several sections of Illinois, ice influenced their topography. Great ice sheets, a mile or two in height, dictated the subsequent land surface in many ways. First, they scraped the surface as they advanced and deposited material they picked up elsewhere. These deposits (till) are dark blue, pink, or green on the map, designating materials left by early ice episodes or the Illinoian and Wisconsin stages more recently. Melting water collected in lakes (light blue) or created run-off channels (yellow). Finally, as the land dried after the great melt, very strong winds picked up the silt and blew it across the land, filling depressions and packing leeward slopes. These water and windblown deposits are key components of the state's rich soils.

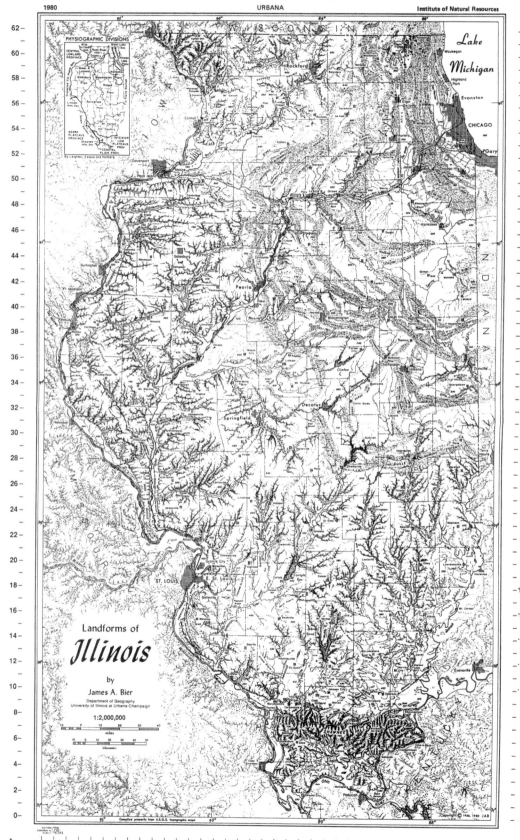

Landforms of

Illinois

by

James A. Bier

Department of Geography
University of Illinois at Urbana-Champaign

1:2,000,000

PHYSIOGRAPHIC DIVISIONS

By Leighton, Ekblaw and Horberg

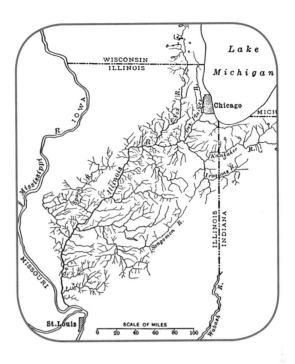

1.6 LANDFORMS OF ILLINOIS

James A. Bier created this dramatic map of the
state's landscape in 1956. The Shawnee Hills at
the southern end of the state were never glaci-
ated. Likewise, the deeply dissected plateau in
the driftless (not glaciated) northwest corner es-
caped the ice sheets. The flood plain of the Mis-
sissippi River stretches between these two areas.
Similar flood plains trace the Illinois, Ohio, and
Wabash rivers. In southern and western Illinois
the older deposits of the Illinois ice sheet have
been systematically eroded by many streams. In
the northeast, however, moraines (hilly deposits
left by glaciers) outwash plains, and the flat bot-
toms of former glacial lakes predominate.

A series of hills following a broad arc from
Peoria to Decatur and eastward to Terre Haute,
Indiana, marks the furthest extent of the Wis-
consin Ice Sheet. Some historians point to the
Shelbyville Moraine, the one farthest south, as an
important divide in Illinois history, roughly sepa-
rating the pioneers who reached Illinois through
two distinct gateways: the Ohio River and the Erie
Canal–Great Lakes route.

1.7 THE ILLINOIS RIVER SYSTEM

Illinois is a land of great rivers. Its namesake
stream dominates the drainage of the middle
part of the state and creates a major water cor-
ridor from the edge of Lake Michigan to the Lower
Mississippi Valley. Louis Jolliet and Fr. Jacques
Marquette, the French explorers who, with Native
American guidance, first recorded an ascent of the
Illinois River from its mouth to Lake Michigan, both
immediately saw the advantage of a canal to con-
nect the two great basins.

This map shows the extent of the greater Il-
linois Valley, created by the main stem of the river,
its major tributaries, and hundreds of supporting
creeks and streams. The waters of the Illinois,
joined by those of the Missouri River a bit down-
stream, greatly increase the volume of water in
the Great River. A line between St. Louis and Alton
thus marks the dividing point between the upper
and lower Mississippi River. Full-sized steamboats
navigated the lower river, but smaller, shallow-
draft craft were needed on the upper river and its
tributaries, the Missouri and the Illinois.

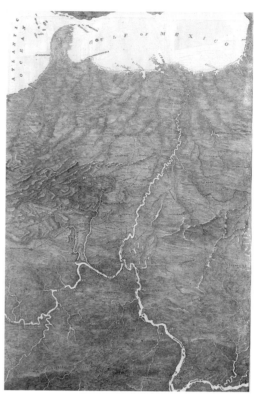

1.8 THE PRAIRIE PENINSULA (*LEFT*)

When ice sheets retreated across the continent of North America, tundra vegetation soon covered the bare land, followed in succession by grassland and forests. As the climate assumed its modern pattern the Great Eastern Forest could be expected to cover all the land east of the Mississippi River. Soils, temperature, rainfall, and topography all pointed to an Illinois completely covered by trees. But that had not come to pass by the dawn of modern times. Instead, a "peninsula" of prairie vegetation (yellow shading) reached across the Great River and extended all the way to the tip of Lake Michigan and into the Wabash River Valley. Some scholars hold that Native American use of fire to maintain grazing areas for wildlife helped extend the prairies eastward. Others think that climatic change was the root cause. Note how the Illinois and other major rivers supported forests along their banks (green shading).

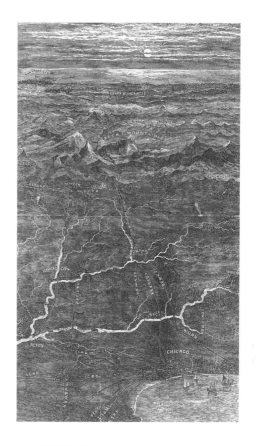

1.9 THE LOWER MISSISSIPPI VALLEY

In the middle of the nineteenth century several journalists sketched views from Illinois looking south and west. Using these perspectives today helps us grasp the location of Illinois in relative terms. This bird's-eye view of the Lower Mississippi Valley appeared in *Harper's Weekly* in July 1861. It was part of a series of such perspectives designed to help readers of the popular magazine follow the course of fighting during the Civil War. Illinois appears as a great wedge driven into the slave states of Kentucky and Missouri, with the potential to split the Confederacy all the way to the Gulf of Mexico. Similar maps, with different objectives, could show additional dynamics at work along the river corridor, such as traffic flows during the steamboat era, the appearance of the Great River in American literature, or the diffusion of jazz and the blues in the early twentieth century.

1.10 WESTWARD FROM CHICAGO

Charles Nordhoff used this striking perspective view to illustrate his guidebook *California for Health, Pleasure, and Residence: A Book for Travelers and Settlers.* Published in 1873, just four years after completion of the transcontinental railroad, the book included an account of a typical rail journey from Chicago to San Francisco. Although in some ways the picture seems quite rough, with an awkward perspective and a primitive, woodcut quality, it features a confident nation in the midst of westward expansion. Note the tangle of railroads serving Chicago and providing connections between the East and the West. A glowing sunset gives promise for a pleasant day ahead, anticipating a sunrise over the Great Lakes that will bring light to the entire Mississippi Valley and the Great West beyond.

	A GLOBAL CONTEXT	MIDWESTERN DEVELOPMENTS	THE ILLINOIS EXPERIENCE
12000 B.C.E.		**12000–9000 B.C.E.** As the climate moderates, glacial-melt waters drain to the ocean, the land dries, and tundra vegetation gives way to spruce forests	**11000–8000 B.C.E.** Nomadic hunters cross Illinois as the ice sheets retreat, pursuing all types of animals, including ancient big game
10000 B.C.E.		**9000–8500 B.C.E.** Gradually, pine and ash, then oak, replace spruce forests; much of the region remains grassland	
8000 B.C.E.			**ca. 8000–5000 B.C.E.** Ecosystems adjust as melt waters create new drainage patterns
	ca. 7000 B.C.E. Early experiments with agriculture in Asia, the Middle East, the Mediterranean World, and Tropical America		People in Illinois use more diverse tool kits to exploit a variety of resources in Early Archaic Period
6000 B.C.E.	**ca. 6000 B.C.E.** Corn cultivated in Mexico	**ca. 5000 B.C.E.** Wetlands furnish a variety of foodstuff as people utilize favored areas along rivers	
4000 B.C.E.			
	ca. 3500 B.C.E. Rice cultivated in China and Southeast Asia		**ca. 1000–500 B.C.E.** Cultivation of seed crops and use of pottery lead to permanent dwellings, settlements, and mound building. Late Archaic transition to Woodland Cultural Tradition
2000 B.C.E.	**ca. 500 B.C.E.** Confucius and the Buddha teach in China and India	**ca. 2000 B.C.E.** Wild grasses are domesticated; trading networks develop, bringing new plants, materials, and ideas to small, scattered settlements	
	ca. 221 B.C.E. Qin ruler begins push to establish the First Chinese Empire	**200 B.C.–400 C.E.** The Hopewell culture flourishes as corn and squash are introduced into the Midwest. Long-distance trade and formalized rituals	**500 B.C.–500 C.E.** Trade, ritual centers, and specialized labor enrich cultural life
0 C.E.	**ca. 25 C.E.** Jesus teaches in Palestine		
	476 C.E. Fall of Roman Empire in the West		
500 C.E.	**500 C.E.** Polynesians discover Hawaii	**ca. 500–900 C.E.** Effigy mounds constructed; widespread use of tobacco	
1000 C.E.	**1096–1228 C.E.** The Crusades	**900–1400 C.E.** Increased use of the bow and arrow	**ca. 1000 C.E.** Cahokia complex at its height and Mississippian ways of life spread over a large part of Mid-America
	1275 C.E. Marco Polo arrives in China		
	1492 C.E. Columbus reaches the West Indies		**ca. 1650 C.E.** European influence, represented by trade goods and diseases, precedes actual contact
1500 C.E.	**1609 C.E.** Galileo's telescope	**1622 C.E.** A French scout, Etienne Brulé, reaches Lake Superior	**after 1660 C.E.** Iroquois raiding parties with firearms reach Illinois

TWO
Early People to 1700

ONE OF the most striking aspects of the story of people in Illinois is that it reaches back over twelve thousand years to the waning of the glacial ages in Mid-America. We do not know who these "first people" were or exactly when they arrived. Their whereabouts has been largely lost in the mists of early time, but enough archaeological evidence has been gathered over the last century to tell a remarkable tale. These early people apparently came up to the very edge of the retreating ice sheets, hunting the animals, large and small, that inhabited the ecosystems that took back the bare land from the grip of the ice.

The transition to today's Illinois was very dramatic: fierce storms, the greening of a tundra landscape, the advance northward of the boreal spruce forest that had been pushed southward by the icy cold, and the ancient big-game animals like mastodons and wooly mammoths that fed on the emerging vegetation. In the most dramatic scenes, saber-tooth tigers sprang to action, feeding on grazing animals. And human be-

ings watched the spectacle, seizing their opportunities.

The first people are called Paleoindians, or the big-game hunters. To go after the biggest prizes seems to be a human trait, and these first inhabitants were very human in that they hunted the largest animals. Many mastodon skeletons have been uncovered in Illinois soils, and the distinctive spear points of big-game hunters have turned up throughout the state, but only at a single site have the projectile tips been found in association with a mastodon kill in the Midwest. This key association, discovered by scientists from the Illinois State Museum, lies in Missouri, across the Mississippi River. A similar find has yet to occur in Illinois, but there is no doubt that both the ancient animals and their human hunters were in Illinois at the very end of glacial times.

Another characteristic of human beings—their adaptability—came into play as the environment changed in the postglacial epoch. Ecosystems, and the ancient big game that lived in them, re-treated northward. Bison of the modern, curved-horn type remained in Illinois until about 1800, possibly keeping alive a bit of the big-game hunting tradition. As the big game diminished, human ingenuity led people to expand their food resources. Trapping small game, such as rabbits and squirrels, collecting edible seeds, nuts, and roots, and gathering fish and shellfish from rivers and wetlands took over from the hunt as sources of major food supply.

The exploitation of these localized food resources encouraged settling in favored places for much of the year. Continuous occupation for decades and centuries created a concentrated archaeological record that later scholars could uncover, read, and interpret.

Systematic study of several special sites with long traditions of human occupation has elaborated the story of Native American life in remarkable ways. Scholars have picked through the soils associated with human artifacts, looking for pollen, shells, and the remains of microscopic animals in order to recre-

ate the climate and the ecosystems in which ancient people lived. It is still not clear how groups of one archaeological horizon related to those of adjacent strata because layers of "sterile" soil almost always separate one period of habitation from the next. Studies of the Modoc Rock Shelter and the Koster Site provide details on the human presence over thousands of years, but they do not provide a continuous record of occupation. Groups came and went, and significant changes occurred in the gaps of time between their settlements.

The ancient big-game hunters in Illinois are known primarily by their projectile points, which are seemingly scattered at random across the region. When places of repeated settlement are located, the inhabitants from each period recorded in the various strata used different types of artifacts, including distinctive spear points. A long Archaic Period, extending from about 8000 B.C.E. to about 500 B.C.E., saw the emergence of diversified tools, the encouragement of certain wild plants by selecting the larg-est seeds to furnish the next year's yield, and the beginning of pottery making that provided vessels for the long-term storage of seeds and nuts.

With pottery, dwellings also became more substantial and permanent. A new era, featuring the Woodland Culture, began to take shape. Ritual centers, special burials, effigy mounds, and a diversified horticulture accompanied an expanded population. Trade with other groups in the region became regular practice, and luxury items from long distances appear at certain sites.

Two key developments pushed Woodland life into another cultural setting that we call Mississippian because of its relationship to the Great River: adoption of corn agriculture for an increasing portion of the food supply and use of the bow and arrow to make hunting more efficient. As these innovations took hold, populations expanded and contacts between groups increased. Leaders were able to garner stores of resources to support large ceremonial centers that exhibited imposing temple mounds. Regular

markets for goods developed, and central places apparently extended their influence over outlying villages. The great Mississippian complex of Cahokia, which flourished between 1000 and 1400 C.E., grew into the largest Native American settlement north of Mexico.

The Cahokia complex eventually collapsed, but Mississippian ways of life persisted in other places into the historic period when European traders and adventurers appeared. By the time Europeans arrived in Illinois, the Cahokia complex had been reduced to ruin and European trade goods made from iron, brass, and glass preceded the new arrivals by several generations. Even horses brought from Europe might have appeared in Illinois before French explorers, items obtained by way of the Native American trade network. Certainly, Old World diseases had by then started to wreak havoc on Native American settlements, carrying off large numbers of people, forcing adjustments in lifestyles, and encouraging the merging of separate groups in attempts to maintain viable populations. Thus the period of contact between Europeans and Native Americans was one of constant challenge, change, and conflict. People moved around, faced pressures of competition, engaged in warfare with other displaced or aggressive tribes, and transformed their lifestyles to accommodate the new things and ideas, plants and animals, which Europeans introduced into the Illinois Country.

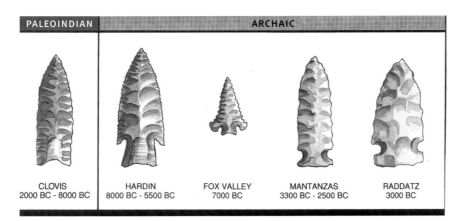

PALEOINDIAN	ARCHAIC			
CLOVIS 2000 BC - 8000 BC	HARDIN 8000 BC - 5500 BC	FOX VALLEY 7000 BC	MANTANZAS 3300 BC - 2500 BC	RADDATZ 3000 BC

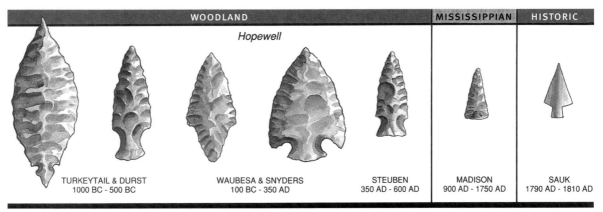

WOODLAND			MISSISSIPPIAN	HISTORIC
Hopewell				
TURKEYTAIL & DURST 1000 BC - 500 BC	WAUBESA & SNYDERS 100 BC - 350 AD	STEUBEN 350 AD - 600 AD	MADISON 900 AD - 1750 AD	SAUK 1790 AD - 1810 AD

2.1 PROJECTILE POINTS

Projectile points manufactured from durable stone furnish a comprehensive log of the Native American presence in Illinois. Several hints in archaeological findings suggest that there may have been a human presence even before big-game hunters. Note the high level of craftsmanship from the very beginning of the projectile record, about fourteen millennia before the present. The chert, or flint, from which most of these points were made, and the spear tips themselves, can be found throughout Illinois and across America. These materials appear as nodules embedded in limestone, the dominant bedrock in Illinois.

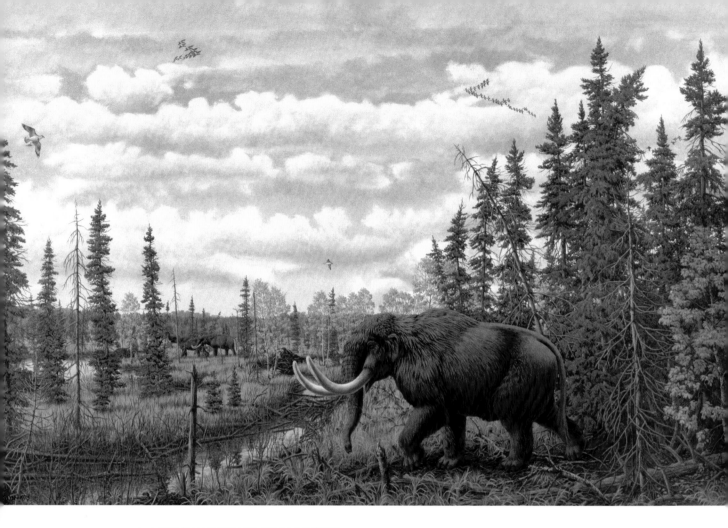

2.2 THE PALEOINDIAN ENVIRONMENT

R. G. Larson, a twentieth-century artist and pa-
leoecologist, prepared this interpretation of a
scene in northern Illinois fourteen thousand years
ago, about the time the earliest big-game hunt-
ers arrived. The ice sheets had left the region,
and a spruce forest had replaced the early tundra
vegetation. It, in turn, is here yielding to grasses
and deciduous trees. Wetlands were common in
the poorly drained glacial till, providing an ideal
environment for mastodons to roam.

2.3 PRAIRIE DU ROCHER

John Casper Wild, an itinerant artist, teamed with
a popular writer in 1844 to produce a travel book
of scenes along the Mississippi River. This pic-
turesque view of Barbeau Creek flowing from the
bluffs along the Mississippi River across Prairie
du Rocher to the Great River attracted renewed
attention in 1950 when archaeologists from the
Illinois State Museum discovered a long history
of human occupation at the Randolph County site.

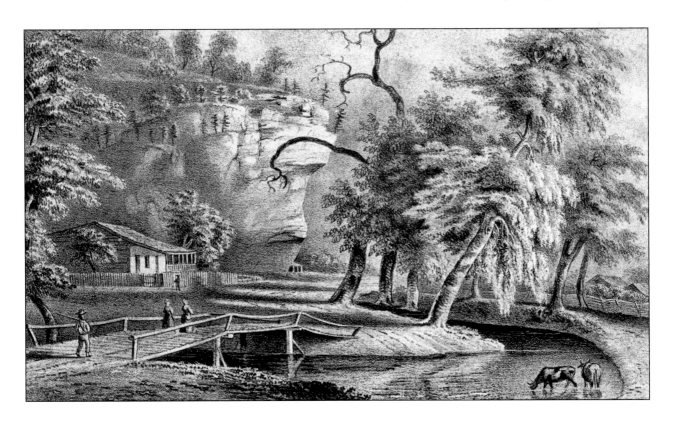

2.4 MODOC ROCK SHELTER

The overhanging rock at Prairie du Rocher at-tracted people in the Early Archaic Period. They probably leaned branches against the rock, creat-ing a shelter from the elements. The abundance and variety of resources nearby encouraged occupation of the site by hunting and gathering parties for about six thousand years. Starting in 1952, a series of archaeological reports fully doc-umented how archaic people reacted to a chang-ing environment by adapting their food gathering and storing practices. The various strata with evi-dence of human presence reach twenty-five feet into the sediments below today's surface.

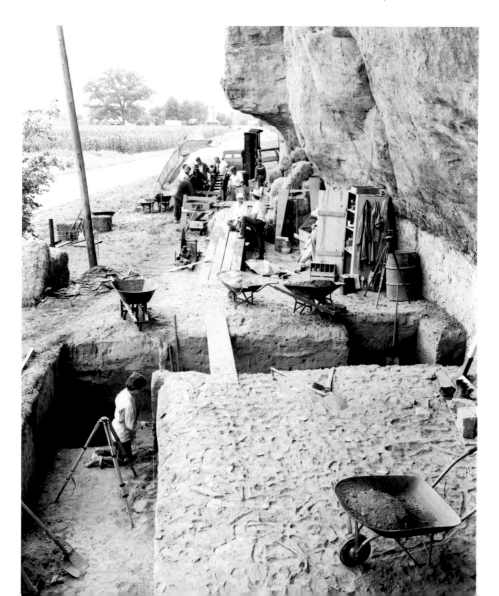

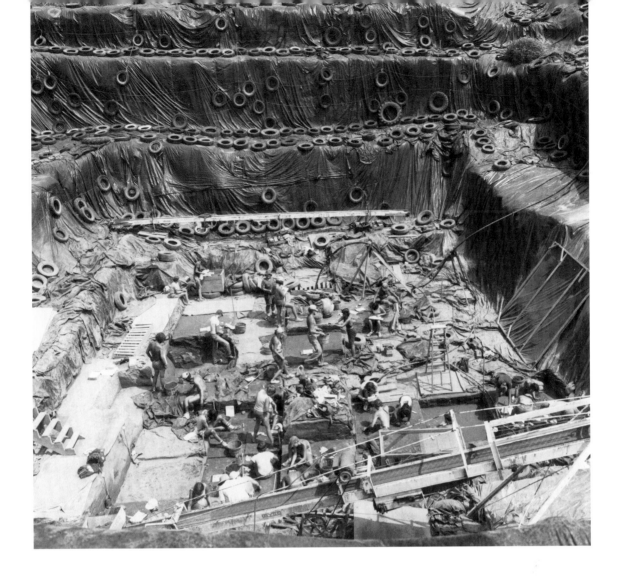

2.5 THE KOSTER SITE

The Koster farm in Greene County became the scene of an exciting archaeological dig between 1969 and 1978. Pioneering many of the techniques of the "new archaeology," especially its attention to the ecosystems in which artifacts were used, a small army of students led by Stuart Struever of Northwestern University turned Koster into one of the most intensively studied sites in America. Eventually, fourteen horizons of human settlements, mostly seasonal hamlets, provided a record of Illinois life from 7000 B.C.E. to 1000 C.E. One of the team's most spectacular finds featured several dog burials from 8,500 years ago.

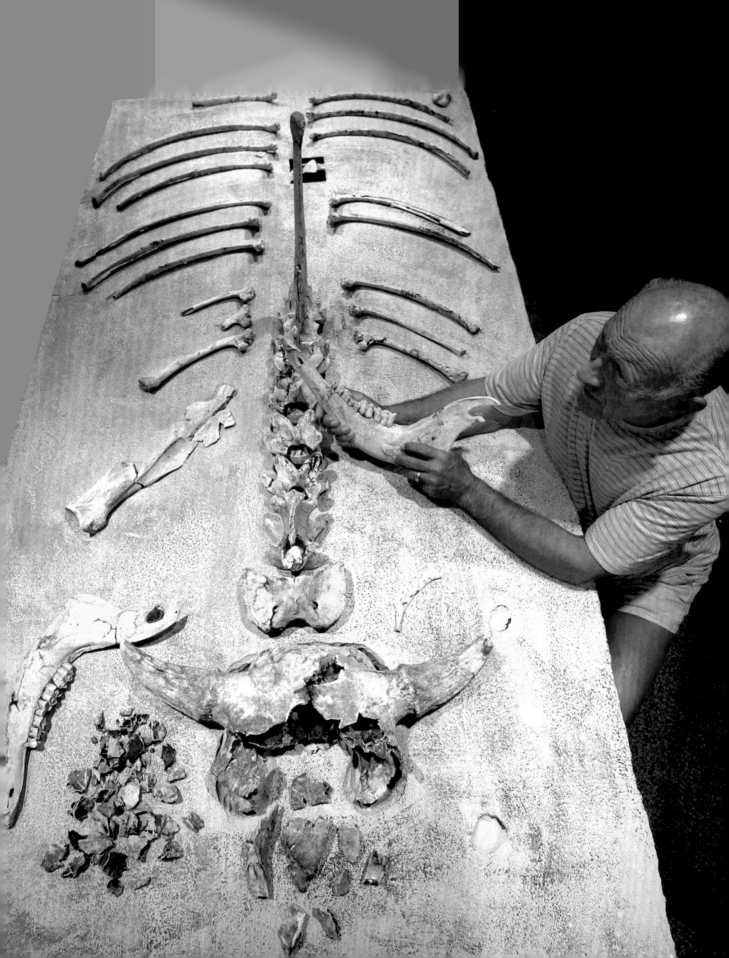

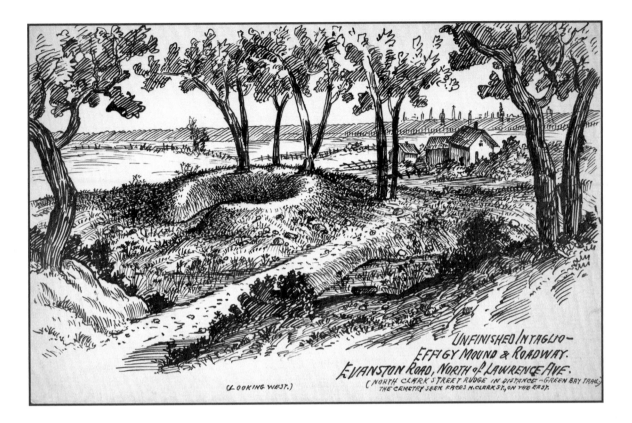

UNFINISHED INTAGLIO-
EFFIGY MOUND & ROADWAY.
EVANSTON ROAD, NORTH of LAWRENCE AVE.
(NORTH CLARK STREET RIDGE IN DISTANCE -GREEN BAY TRAIL.)
THE CEMETRY SEEN FACES N.CLARK ST, ON THE EAST.

(LOOKING WEST.)

2.6 A BISON KILL, 400 B.C.E. (*LEFT*)

As more locally focused Archaic lifestyles re-
placed nomadic big-game hunting traditions,
questions emerged about connections between
the two ways of living. Were Archaic people de-
scendents of the Paleoindians? Did any practices
of nomadic hunting survive in the newer tradi-
tions? These questions took on new life in 2005
when a bison skeleton was unearthed from the
banks of the Illinois River near Lewistown. Lodged
between its ribs was an Early Woodland spear
point, still sharp to the touch. The new evidence
documented the presence of bison in the state
at this early date and suggested the possibility
that a hunting style much like that employed by
Paleoindians thousands of years earlier provided
an element of continuity between the various
early people who inhabited the Illinois Country.
Alan Horn, an archeologist who spent more than
four decades in fieldwork, here studies one of the
most notable discoveries of his career.

2.7 AN EFFIGY MOUND IN CHICAGO (*TOP*)

Charles A. Dilg, a Chicago journalist in the late
nineteenth century, developed a great interest
in Native American archaeology. He spent much
effort gathering artifacts and taking notes for an
intended book on the "Indian History of the Chi-
cago Area." His death in 1904 ended the project,
but some of his sketches retain great value. This
one provides a record of a circular effigy mound,
probably from the Woodland Period, which was
clearly visible on the North Side of the city before
urban development erased it. The Lawrence Av-
enue site is one of several thousand prehistoric
mounds recorded in Illinois.

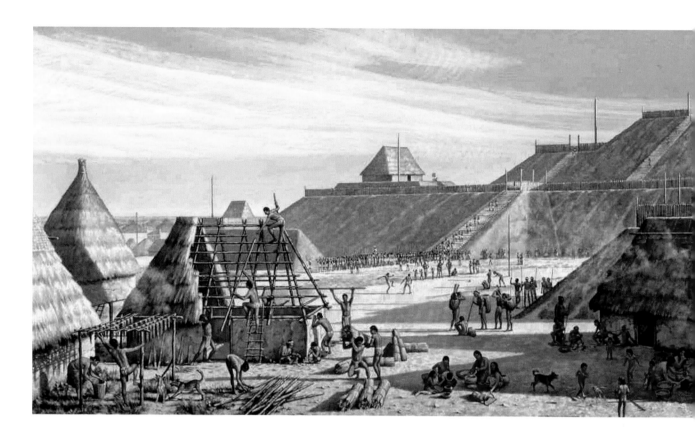

2.8 CAHOKIA

Downriver from the conjunction of the Illinois, Missouri, and Mississippi rivers the floodplain broadens into extensive bottomland. Replenished with each floodtide, these soils have long supported some of the most fertile fields in the world. As agriculture grew in importance to those who lived along this stretch of land, the population increased dramatically, as did the size of their mounds and settlements. Several distinct, competing centers emerged in this region. The leading ceremonial place, which we call Cahokia, became the largest Native American complex north of Mexico. Covering five square miles and housing about fifteen thousand people, the town's influence extended to many surrounding villages and hamlets. The central mound at its base would cover eleven football fields. In this scene a modern artist portrays the construction of housing for the leadership class close to the main temple mound.

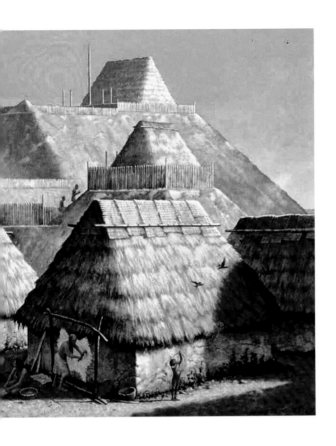

2.9 MISSISSIPPIAN PETROGLYPHS (*BELOW*)

The challenge to the leaders of Mississippian people was to integrate a dispersed population of farmers living in hamlets into a cohesive whole willing to support the building of monumental mounds in great centers like Cahokia. Elaborate myths and ceremonies probably animated Mississippian culture and provided the "glue" that bound dispersed villages into a large system. These rock drawings from the period may offer clues to that grand narrative.

The photograph from the Piney Creek Ravine shows a falcon. The redrawing of a portion of an extensive petroglyph composition at Millstone Bluff in Shawnee National Forest emphasizes a pattern featuring falcons (A), humanlike figures (B), and repeating symbols (C and D). Anthropologists have named these associated motifs the Falcon Impersonator.

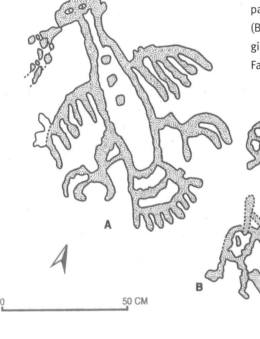

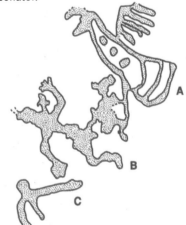

0 50 CM

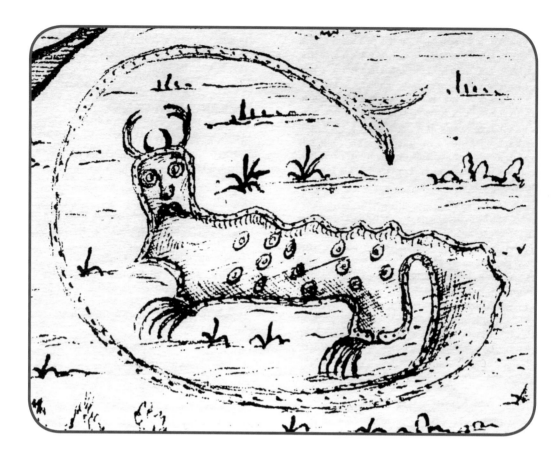

2.10 THE PIASA (*ABOVE*)

The most celebrated petroglyph in Illinois has been effaced by time, but it presented a vivid sight when a European explorer recorded impressions of the scene along the Mississippi River near Alton. "We saw high rocks with hideous monsters painted on them and upon which the bravest Indian dare not look," Fr. Jacques Marquette reportedly wrote in 1673. "They are as large as a calf, with head and horns like a goat, their eyes are red, beard like a tiger's and a face like a man's. Their tails are so long that they pass over their bodies . . . ending like a fish's tail. They are painted red, green, and black." This sketch appeared on a manuscript map by Jean-Baptiste Louis Franquelin, who probably copied it about 1678 from a lost original map by Jolliet.

2.11 A KASKASKIA WARRIOR (*RIGHT*)

The very beginning of recorded history in Illinois found a confederation of Algonquian-speaking people occupying fertile bottomland along the Illinois and the Mississippi rivers. The French explorers and missionaries who penned the first written records knew about the Illinois people and had met some of them on the shores of the northern Great Lakes before they reached the Illinois Country itself. Continuous contact between the French and the Illinois extends from 1673 onward. By 1796, when Victor Collot, a French artist, visited Illinois, most of these Native Americans had died or left their homeland, but he immortalized the nobility of the tribe in this image of a warrior from the Kaskaskia Nation.

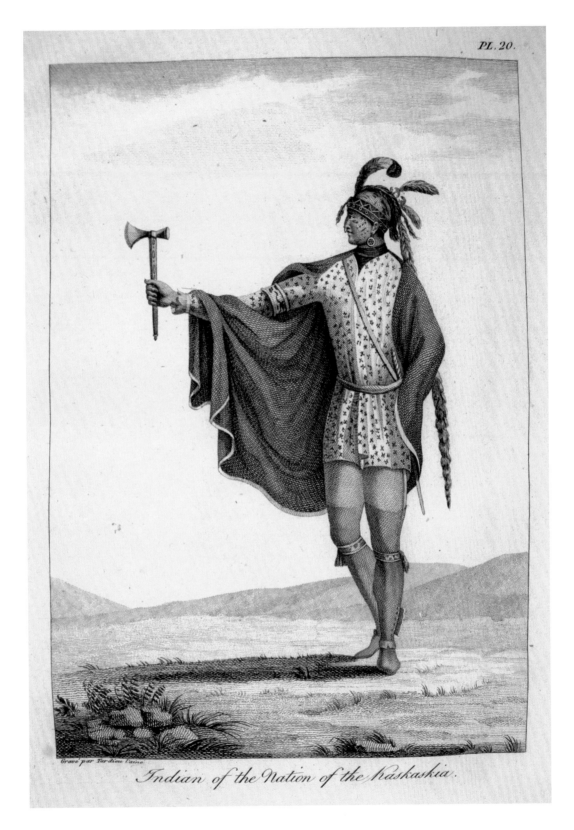

PL. 20.

Gravé par Tardieu l'aine.

Indian of the Nation of the Kaskaskia.

A HISTORICAL CONTEXT	THE FRENCH IN NORTH AMERICA	THE ILLINOIS EXPERIENCE
1670 Virginia revises its slavery laws	**1671** France claims Mid-America in ceremony at Sault Ste. Marie	**1673** Jolliet and Marquette explore Illinois
	1673 Jolliet-Marquette expedition	**1675** Mission of the Immaculate Conception is established on the Illinois River
1681 William Penn receives a charter for Pennsylvania	**1682** LaSalle reaches mouth of the Mississippi and claims its valley for France	**1680** La Salle erects Fort Crevecour near Peoria
		1682 La Salle builds Fort St. Louis at Starved Rock
1689 The Glorious Revolution in England		**1691** Fort St. Louis is moved downstream
1692 Salem witchcraft trials		**ca. 1696** Mission of the Guardian Angel is started near the Chicago Portage
	1699 The founding of Biloxi	**1699** Mission of the Holy Family at Cahokia
1702 Transatlantic mail service starts: England to the West Indies	**1701** The founding of Detroit	**1703** Kaskaskia is settled as a Jesuit mission
ca. 1710 Enlightenment ideas spread from Europe to America		
	1717 John Law generates stock speculation that leads to the Mississippi Bubble	**1717** Illinois villages are placed under the jurisdiction of Louisiana
	1718 The founding of New Orleans	**1718–30** The Fox Wars disrupt communications between the Great Lakes and the Mississippi Valley
	1721 Three slave ships arrive in Biloxi; black slaves soon reach the Illinois Country	**1726** A census records 383 French inhabitants plus 118 black slaves in Illinois
1732 The founding of Georgia	**1732** The founding of Vincennes, Indiana	**1732** A census lists three French settlements with 388 inhabitants
1733 Benjamin Franklin publishes *Poor Richard's Almanac*		
	1743 French explorers reach the Rocky Mountains	
ca. 1750 Industrial Revolution begins in England	**1744–48** King George's War pits the French against the British	

1670
1680
1690
1700
1710
1720
1730
1740
1750

The French Encounter and Settlements, 1673–1750

ONE OF THE most portentous moments in Illinois history, and one often portrayed by later artists, showed Fr. Jacques Marquette lifting a calumet, or peace pipe, high into the air to assure the Illinois people that he and his French companions had come in peace. The priest was then able to communicate with native leaders because he had spent the previous winter at Mackinac in the company of several Native Americans. One, from the Illinois Country, taught him the rudiments of the Illinois language. Marquette, a gifted person in many respects, had a genius for languages.

The occasion of the French visit to the land of the Illinois in 1673 was an exploring expedition to the Great River that we call the Mississippi. They took two canoes westward from Green Bay; paddled up the Fox River in today's Wisconsin; portaged to the Wisconsin River; and, carried along by the current, soon reached the Mississippi. The Jesuit missionary, interested in souls to be

saved, traveled as part of a small official expedition headed by Louis Jolliet, a fur trader from Montreal. Two years earlier, at an ostentatious ceremony at Sault Ste. Marie, the French claimed possession of the Great West. Native Americans told of a Great River that flowed southward and drained the territory west of the Great Lakes. These were the lands of the Illinois Confederacy. Marquette therefore referred to Lake Michigan as the "Lac des Illinois."

It took a long time before Jolliet's expedition located the first Illinois village, far downstream on the west bank of the Great River in today's Iowa. Disasters and disease had drastically reduced the number of Native Americans who lived in Illinois. Except for some scattered villages of the various confederated tribes along the Illinois and Mississippi rivers, much of the land formerly occupied by Mississippian and Woodland people was now vacant. At the time the French arrived the Illinois Confederacy had started to experience a dramatic decrease in numbers. In the next century

other people would enter the former Illinois territories. It is a complex story, full of comings and goings. In these shifts of population, the French were always vastly outnumbered by groups of Iowa, Kickapoo, Miami, Potawatomi, Shawnee, Winnebago, Sauk (Sac), and Fox that took up residence for a time.

At the first Illinois village they found, Jolliet and Marquette received a calumet as a present and used it as they continued down the Great River. Near the mouth of the Arkansas River they encountered hostile tribes that did not respect the calumet, and so they decided to return. Friendly Indians suggested going back by way of the Illinois River and the lake. The initial Europeans in Illinois thus crossed the future state from the southwest to the northeast. On this leg of the trip they encountered the Great Village of the Kaskaskia tribe near Starved Rock. After raising the calumet, the French visitors were well received and Father Marquette pledged to return.

He kept his promise in 1674, intending to start the Mission of the Immacu-

late Conception, but he was forced to leave because of ill health. After he died on the shores of Lake Michigan, René Robert Cavelier, Sieur de La Salle, another French explorer, attempted to build a string of fortified French posts in the North American interior from the Great Lakes, across Illinois, and down the Mississippi River.

In pursuing this grand plan La Salle constructed the first sailing vessel to ply the waters of the Great Lakes and a sister ship, a forty-ton bark with cannons, to operate on the Mississippi. He also descended the Mississippi River from Illinois to its mouth, claimed the entire valley for his king, and named it Louisiana in his honor. La Salle had constructed one of his posts, Fort St. Louis, on top of Starved Rock, but conflicts with his superiors in France and Montreal pushed his interests southward. He wanted to create a second French portal into North America, via the Great River, but while he tried to establish a French colony on the Gulf of Mexico his crew mutinied and murdered him.

La Salle's dream of Louisiana as a second French colony in North America, and of Illinois as its connecting link to Canada, proved to be very prophetic. Henri de Tonti, La Salle's lieutenant, moved the post in Illinois downriver from Starved Rock to Peoria or Beardstown. Although a French presence continued at Peoria for decades, the Kaskaskia tribe also felt the call of the Mississippi and moved to the extensive floodplain along its banks. The Jesuit mission followed in 1700, and a town of French traders sprang up at the site. A year earlier, another order of priests, founded at Quebec, received a commission to establish missions on the Mississippi River. After canvassing the area between the mouths of the Illinois and Arkansas rivers, they selected the village of the Cahokia tribe for their first mission. Thus the church at Cahokia, founded in 1699, became the oldest continuously operating European institution in Illinois.

The story of the French presence in Illinois, one of explorers, missionaries,

and fur traders, soon expanded to farmers as immigrants sought out the rich bottom soils along the Mississippi River just below the mouth of the Illinois River. These fertile lands once supported the extensive Mississippian center at Cahokia and were now the home base for Illinois tribes. Soon they also sustained a unique French colony whose presence still marks the landscape today.

French farmers came to Illinois by way of both Canada and Louisiana. Tonti, who continued to implement La Salle's grand scheme, established a post in Arkansas in 1696. Two years later he was at Quebec, from whence he escorted the seminary priests to Illinois. Then he went to Mobile, on the Gulf of Mexico, where he died in 1704. By then fur traders were reaching out in all directions from the new trading hub they established at Kaskaskia, their far-flung activities supported by others who remained at home in Illinois as merchants or farmers. The neighboring Indian villages had, from the beginning, provided most of the food the French needed, but now official polices encouraged European settlements.

New Orleans was founded in 1718 to be the *entrepôt* for the Great Valley, the same year that the king granted the Company of the West a monopoly on Louisiana trade provided that it brought six thousand colonists and three thousand slaves to the Mississippi. John Law, a Scottish whirlwind who had set himself up as a banker in Paris, gained control of the company and began to promote its stock. The price of the stock rapidly advanced as tales of the riches of the Mississippi Valley reached Paris. Fortunes appeared so rapidly that the French coined a new word for beneficiaries, *millionaires.* Illinois was part of a great opportunity.

The Mississippi Bubble, a granddaddy of all speculative stock manias, burst in 1720, but by then a convoy of settlers had ascended the river to Illinois. Fort de Chartes was under construction, and slaves had been sold to the new farmers. The Illinois Country settled into a slow, steady development. The French taste

for bread and livestock products encouraged farmers to plant wheat and import European farm animals. The settlers divided and worked the land following Old World ways that included compact villages, open grain fields divided into individual long lots, and common pastures. The result was a unique manifestation of medieval Europe in the middle of eighteenth-century North America.

Native American villages existed alongside French settlements. Their buildings, land use patterns, and agricultural practices exhibited another cultural tradition but often followed a way of life that had become dependent on French trade goods. When the Mesquakie (Fox) Wars disrupted French communications over the Chicago portage in the 1720s, French traders developed another route from Lake Erie through the Wabash Valley to the Mississippi River, erecting

Fort Vincennes in 1732. About 1750 the French government expressed renewed interest in its Mississippi Valley empire. They rebuilt Fort de Chartres as a stone fortress and erected the wooden Fort Ascension (Massac) in Illinois on the banks of the Ohio River in 1757.

The Illinois Country may have shipped flour, hams, bacon, and other agricultural products down the Mississippi River even before the founding of New Orleans in 1718. By the 1730s a substantial trade was securely in place and Illinois was called the "breadbasket of Louisiana." Illinois flour became especially well known, finding markets in the West Indies and Europe. In return, the "Interior French" received sugar, rice, fabrics, clothing, tools, glassware, and utensils. Distant and isolated in some respects, Illinois was well connected in others. It was on the map.

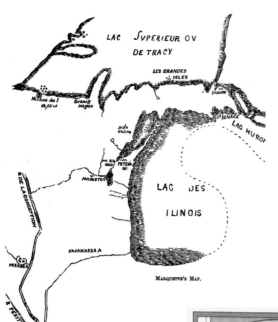

MARQUETTE'S MAP.

3.1 MARQUETTE'S MAP

Although the place names on this detail from a manuscript map may not be familiar to modern readers, we can follow its geography with little effort. Three of the Great Lakes come together near St. Ignace, the starting point for the Jolliet-Marquette expedition. The priest named the Great River, the object of their journey, the River of the Immaculate Conception in honor of the Virgin Mary. Using a compass and taking notes each

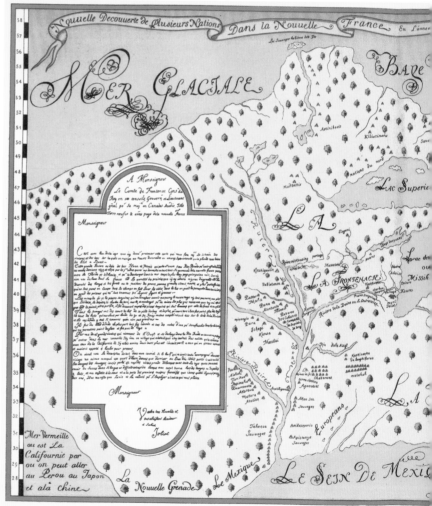

day, he was able to outline the course of the Mississippi and note its major tributaries.

Marquette listed many other "nations" of Native Americans some distance from the river. These names were probably based on reports he gathered along the way. He wanted to emphasize that the Mississippi Valley held great promise as a mission field.

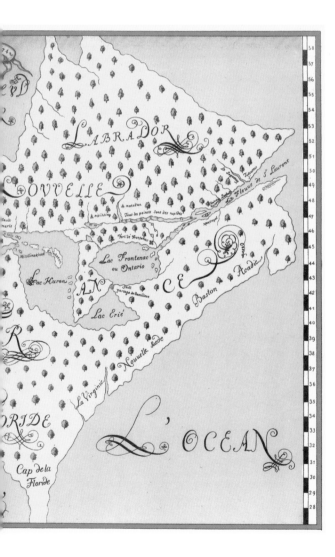

3.2 JOLLIET'S MAP

Louis Jolliet lost all of his notes when his canoe overturned, almost within sight of Montreal, on his return voyage. He reconstructed a map of the expedition from memory and prepared a presentation copy for the governor of New France. This is a contemporary copy of that map.

Jolliet's map is much more elaborate than Marquette's sketch and places the region that the expedition surveyed in the context of the entire continent. The Atlantic Ocean occupies the right-hand side of the map, the Arctic Sea is at the top, and the Vermillion Sea, or Gulf of California, part of the Pacific Ocean, appears at the lower left. Jolliet covered all the land with trees, suggesting great potential for development of the fur trade. He had glimpsed the prairies of Illinois, but traveling along forested river banks, he did not realize their extent. Tracing the route of the explorers on the map in figure 1.8 underscores this point.

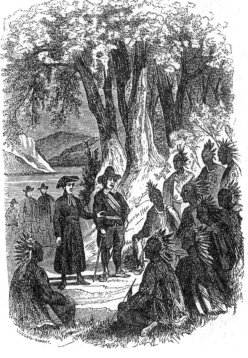

3.3–3.6 THE ENCOUNTER VISUALIZED

The encounter between the French and the
Illinois Indians marked a great turning point
in history, but a contemporary artist did not
record it. Over the years, however, others have
recreated the scene. These four views show how
the historical image has changed from generation
to generation.

Ballou's Pictorial Magazine, published in
Boston, ran a series of articles on the various
states in the 1850s. Their piece on Illinois, issued
on April 19, 1856, featured the meeting of Jolliet
and Marquette with the Illinois people who pre-
sented the expedition with the calumet (fig. 3.3).
Although the event took place in today's Iowa,
the reporter considered it the key event in the
history of the twenty-first state. The young boy
just behind the Illinois chief is, in the artist's

imagination, carrying a box of tobacco contain-
ing "a plentiful supply of the vile weed," as the
article put it.

The next artistic view of the encounter (fig.
3.4) appeared in 1860. Richard Edwards and M.
Hopewell, two popular authors, issued *Edwards's
Great West* as both a booster publication and a
business directory. According to their text, Father
Marquette was telling the attentive group, "My
companion is an envoy from France to discover
new countries and I am an ambassador from God
to enlighten them with the gospel." The scenery,
with its high hills and ancient forests, is obviously
as much a product of the artist's imagination as
the dress of the participants and staging of the
encounter.

The third version (fig. 3.5) pictures an event

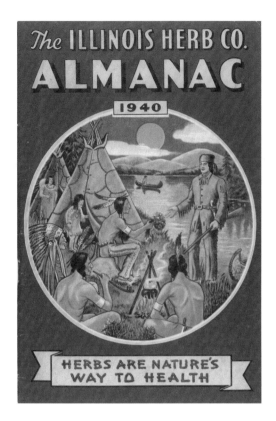

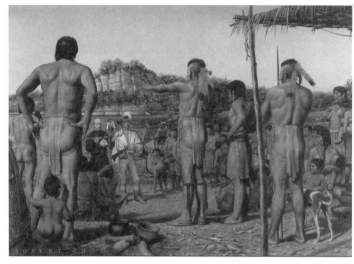

sometime after the original contact. The image appeared in almanacs sponsored by the Illinois Herb Company from 1938 until 1944. In it, an Indian gives medicinal plants to a neatly attired French trader, presumably some of the same botanical wonders that could be purchased from the firm. Neither the tepee nor the war bonnet would have been found among the Illinois tribes in the eighteenth century. Although the French trader may have brought a birch-bark canoe down from the Upper Mississippi River, it was certainly not an Illinois product. The iron pot points to the way that Illinois tribes quickly became dependant on European-manufactured goods.

In the fourth view (fig. 3.6) Robert Thom, a modern artist who specialized in painting historical events, employs up-to-date anthropological findings to recreate the scene when Jolliet and Marquette reached the great village of the Kaskaskia in August 1673. The French party at this point was heading homeward, but the priest promised to come back and did so two years later to found the Mission of the Immaculate Conception near this very spot.

In the background of figure 3.6, Starved Rock rises above the water on the Illinois River's left bank to reveal the sedimentary rocks deposited eons earlier in geological time. In the foreground are several pieces of pottery, one filled with corn, and a pet dog. A house, barely seen at the far left, is also rendered accurately.

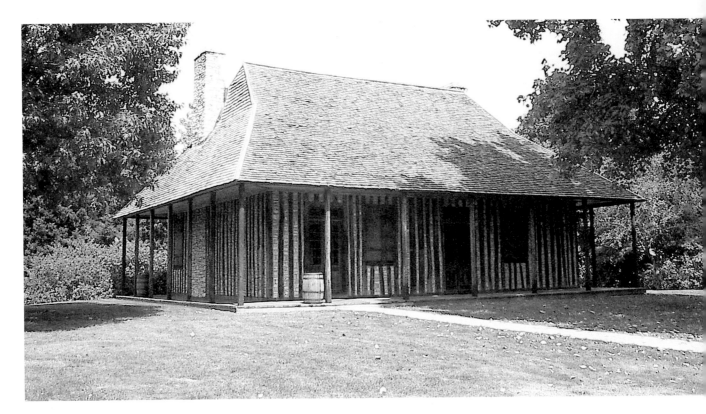

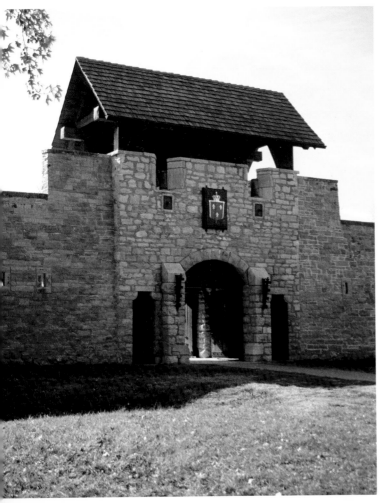

3.8 FORT DE CHARTRES (*LEFT*)

Late in 1718 a contingent of French soldiers left the newly found settlement at New Orleans and made their way up the river to Illinois. There they erected a wooden fort that was soon expanded with the addition of storehouses and trading facilities. The post served as a defensive site, an outpost of empire, a base for further explorations, and a meeting place for the diverse population of the region. In 1726 the garrison erected a more substantial complex nearby, and in the 1750s a military engineer oversaw the building of a new stone bastion a short distance away. Just after the third fort was completed, the French ceded it and all of their holdings on the continent to the British (fig. 4.2). Fort Chartres today is a state historic site, rebuilt and partially restored to its glory days.

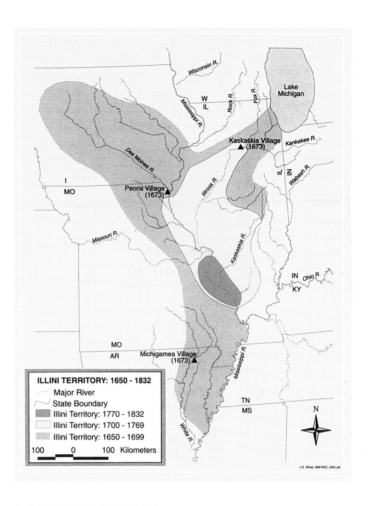

ILLINI TERRITORY: 1650 - 1832
- Major River
- State Boundary
- Illini Territory: 1770 - 1832
- Illini Territory: 1700 - 1769
- Illini Territory: 1650 - 1699

100 0 100 Kilometers

J.S. Oliver, ISM-RCC, GIS Lab

3.7 THE CAHOKIA COURTHOUSE (*TOP/LEFT*)

Although it was originally built as a private house in 1737, this structure became a courthouse in 1793 when the area was part of the Northwest Territory. During the 1890s the building was moved to Chicago to be exhibited as the oldest house in Illinois, but it was later returned to Cahokia and restored under the sponsorship of Illinois Historic Preservation Agency. The house on the move presented a classic example of French colonial architecture, which used stone foundations raised above the soil line and topped with wooden sills. Squared logs were then placed on the sills vertically, like palisades, to form walls. Steeply pitched roofs were made from oak shingles fastened with wooden pegs. The break in the roofline sometimes marked the beginning of a porch that occupied all four sides of the building. Compare the architecture of this structure with that of the farm house in figure 6.10.

3.9 THE CONTRACTION OF ILLINI TERRITORY, 1650–1832

The great villages of the Illinois Indians apparently started to lose population due to war and disease before encountering the French. Pressures from other tribes moving into their territories as well as continuing epidemics pushed the Illini Confederacy to form more compact settlements. In the end these were concentrated in the bottomlands of the Mississippi River alongside French settlements. When a French artist wanted to paint a warrior of the Kaskaskias in 1796 (fig. 2.11) he was told that only one full-blooded native was still around. This map shows the territory the Illini controlled and how it gradually contracted until the remnants of the tribe signed a final treaty, sold their land, and left their namesake state in 1832.

A HISTORICAL CONTEXT	NORTH AMERICA DEVELOPMENTS	THE ILLINOIS EXPERIENCE

1750

1752 First volume of the French Encyclopedia is published

1753 New masonry Fort de Chartres

1754 George Washington sent to protest French forts in the Ohio Valley

1755

1755 An earthquake destroys Lisbon, Portugal

1757 Fort Ascension is built on the Ohio River

1758 First blast furnace produces iron in England

1759 British defeat the French in the Battle of Quebec

1760

1761 London exhibition of agricultural machinery

1763 French cede lands east of the Mississippi River to the British

1763 Mozart, seven, gives a concert

1763 Treaty of Paris ends the Great War for Empire, and the British dominate North America

1763–64 Indian Resistance delays British occupation

1765

1764 British East India Company takes control of Bengal

1764 St. Louis is founded

1765 The British take control of Fort de Chartres

1769 Spain assumes control of New Orleans

1770

1770 European-Bantu conflict in South Africa

1772 The British move seat of government to Kaskaskia

1772 Oxygen discovered

1773 Boston Tea Party

1774 Parliament makes Illinois part of Quebec

1775

1775–83 War for American Independence

1778 George Rogers Clark and the Virginia militia capture Kaskaskia

1776 James Watt's steam engine demonstrated

1776 Declaration of Independence

1779 Clark marches across Illinois to take Vincennes on the Wabash River. A few settlers from Virginia and Maryland reach Illinois

1780

1780 Circular saw invented

1780 Spanish aid helps repulse British forces sent to retake Illinois

1783 Peace of Paris makes the Mississippi River the western boundary of the United States

1785

1785 Congress passes the Land Ordinance under the Articles of Confederation

1785 Jean Baptiste Point Du Sable erects a trading post at Chicago

The Struggle for Empire, 1750–83

IN 1753 a contingent of masons accompanied the annual fleet of river boats moving up the Mississippi to bring supplies of imported goods to the Illinois Country. The workers, sent from France, faced a four-year task of erecting a stone fortress in the heart of the Mississippi Valley. The new Fort de Chartres would be a stronghold to defend the Illinois Country as well as a convincing symbol of the French claim to the North American interior.

Throughout the 1750s the French also constructed a network of log forts in Mid-America, including Fort Ascension in southern Illinois, to secure linkages between Canada and the Ohio Valley. Meanwhile, traders and agents of land companies from Virginia and Pennsylvania crossed the Appalachian Mountains. In the process, warfare erupted as French designs and British interests clashed, first along the headwaters of the Ohio River and then in a full-scale war that featured landmark battles fought around the world. This Great War for Empire,

known as the French and Indian War in American history, had global repercussions. The key battle in North America, fought after a series of English victories, occurred at Quebec in 1759. When the smoke cleared the British had completely defeated the French.

The terms of peace after the fall of Canada called for French troops stationed in the Great Lakes basin to lay down their arms, but some contingents only withdrew to forts in the Ohio Valley and the Illinois Country. If Canada was lost, they reasoned, perhaps Louisiana might be saved for France. At this point Spain entered the war as an ally of France, and the British countered by seizing the Spanish bastions at Havana and Manila. To compensate their ally, the French gave Spain all rights to their claims west of the Mississippi River as well as the *entrepôt* of New Orleans.

The Treaty of Paris in 1763 brought peace but at great expense to the French Empire. The French lost everything in North America except for two small islands south of Newfoundland. Both Canada and the land east of the Mississippi became British territory, and so did Spanish Florida. New Orleans and Louisiana west of the Mississippi became Spanish possessions.

Although diplomats in Paris could rearrange their maps of North America, the situation on the ground was much different, mainly because various Native American tribes had not been considered in these arrangements. As it turned out, almost no one accepted the peace of 1763 as a final solution. A Native American alliance led by Pontiac, an Ottawa chief, seized control of many of the British forts in the West and delayed the British occupation of Fort de Chartres. Although Pontiac came to terms with the British, the Native Americans demonstrated that they were key players in the imperial struggle. Pontiac withdrew to the Illinois Country, now under British control. While in Cahokia in 1769 he was murdered, probably by an Illinois warrior.

Meanwhile, with a British garrison arriving at Fort de Chartres, enterpris-

ing commercial interests in Philadelphia felt it safe to construct a warehouse at Pittsburgh and send shipbuilders to construct an Ohio River fleet. These boats, used mainly for downstream traffic, soon supplied Kaskaskia with English goods. Four convoys reached Illinois in 1766, but they faced competition from a renewed New Orleans trade up river to Illinois. In the end, the traditional Mississippi route prevailed in spite of New Orleans being in Spanish territory.

Overall, however, things did not return to the normal pattern in Illinois. In general, Native American tribes seemed to view the political situation as a temporary arrangement. Most tribes were moving about, adapting to new lifestyles, and trying to figure out the best course of action: accommodation to the new regime or resistance to it. French farmers and traders faced similar issues. As Roman Catholics they were fearful of living under a Protestant monarch. Many moved to Spanish territory across the river. The initial plan for the city of St. Louis (1764) followed the design characteristic of France's Illinois settlements.

The British did not have a clear strategy for the Illinois Country. Some commercial interests viewed it as a land of opportunity and were anxious to put a new system of trade into place. Others conceived of the entire region between the Appalachians and the Mississippi as a real estate bonanza. Land companies formed in Virginia and Pennsylvania in the 1750s were anxious to settle the Great Valley of the Mississippi. A few pioneers pushed into the new land as squatters, but the first English-speaking settler did not arrive in Illinois until 1779. Clashes between Native Americans and pioneers led to an imperial policy of controlled expansion. In 1763 the Proclamation Line tried to close the western land to settlement, creating a vast Indian territory between the Allegheny Mountains and the Mississippi River.

Although 1763 marked the end of French Illinois, it would take decades before a new, English-speaking com-

munity would take hold. Indeed, in 1772 the British troops abandoned and destroyed Fort de Chartres, hauling its cannon up the Ohio River to Fort Pitt and then overland to Philadelphia. Tensions between British imperial policies and American colonial aspirations were leading to the War for American Independence. And with the American Revolution came a new vision for the American West. The Quebec Act of May 20, 1774, was not part of the anticolonial coercive legislation enacted on the same day, but colonists along the eastern seaboard regarded it as "intolerable" as they called for a continental congress to deal with the situation. The Quebec Act provided a centralized civil government for French settlements now part of the British Empire. The Catholic Church was, in this polity, given a favored position, and civil cases could be tried in local French courts without a jury. Moreover, Parliament extended Quebec's boundaries all the way to the Illinois settlements, land that Virginia claimed.

When the Second Continental Congress met in May 1775, fighting between patriot forces and British troops had already broken out. The Declaration of Independence had Illinois in mind when it charged King George III with establishing "an arbitrary government, and enlarging its Boundaries so as to render it at once an example and fit instrument for introducing the same absolute rule into these Colonies."

A year later, George Rogers Clark, a militia leader from the new American settlements in Kentucky under the authority of Patrick Henry, the governor of Virginia, set out to attack the small British contingents defending Illinois. On the way a messenger caught up with Clark to tell him that France had become an ally of the Revolutionary cause. Thus, after a surprise attack that seized Kaskaskia, Clark rang the church's bell on the evening of July 4, 1778, to gather French inhabitants to hear the astounding news of the French-American alliance.

Clark then selected a delegation of French settlers, including the local

priest, to set out for Vincennes on the Wabash River. Their mission met with success, and the people of the Wabash River settlement transferred allegiance from the British king to the state of Virginia. The Virginia legislature made Illinois a county of Virginia in December 1778. Meanwhile, the British sent troops backed by a large Indian force to retake Vincennes. In February 1779 Clark led his soldiers across Illinois, flooded after snowmelt, to surprise the British and capture the Wabash River fort.

After Clark's successful mission three courts established under Virginia's authority functioned in Illinois: one at Kaskaskia, one at Vincennes for the entire Wabash Valley, and one at Cahokia with a jurisdiction that extended up the Illinois River to Peoria. By another peace agreement in Paris, this time in 1783, Britain granted independence to the United States and recognized the Mississippi River as the new nation's western border. The very next year Virginia ceded its lands north and west of the Ohio River to the United States.

It took another four years for the Congress under the Articles of Confederation to provide an American government for the Northwest Territory. The official announcement of the Northwest Ordinance, dated July 13, 1787, occurred at Kaskaskia the following August. The Illinois Country thus became part of the Northwest Territory, but the society envisioned in the ordinance was markedly different from the actual situation. It would take another three decades, and more, to bring the vision and the reality into better alignment, a task for the Territorial Period of Illinois history.

4.1 GEORGE WASHINGTON'S MAP

The point where Pittsburgh now stands was a key location for control of the Ohio Valley. Here the Allegheny and Monongahela rivers join to form the Ohio River. In 1754 both French and British troops arrived at the site with intentions to erect a fort. George Washington, only twenty-one years old, had been sent to scout the situation in 1753, and upon his return the next year he engaged the enemy. His hastily erected Fort Necessity held off the first French attack, but he finally capitulated when the French mounted a second attack that included newly arrived troops from Fort de Chartres in Illinois. Washington's journal recording these events was soon published both in Williamsburg and London. The latter included this map with a title indicating its point of view: "Map of the Western Parts of the Colony of Virginia as far as the Mississippi."

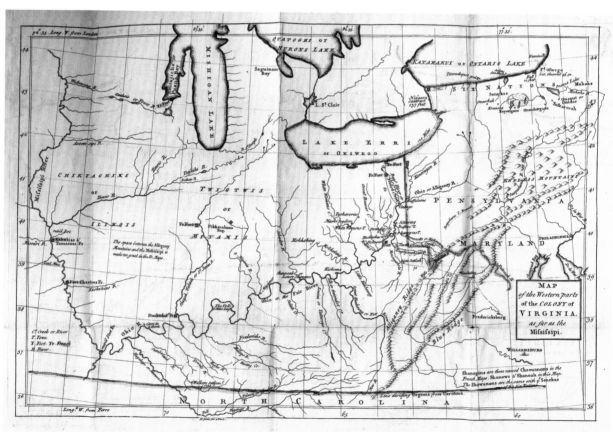

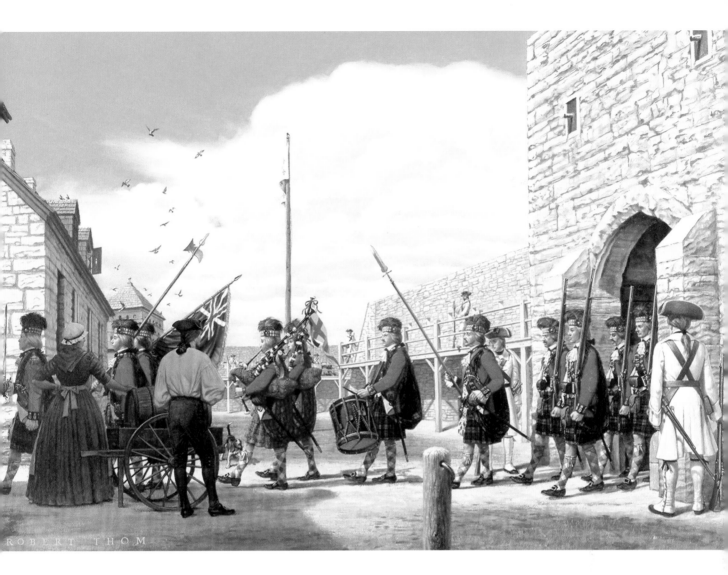

4.2 THE BRITISH OCCUPY FORT DE CHARTRES, 1765

Although the British had acquired the Illinois Country by the Treaty of Paris in 1763, they were not able to take control for several years because Native American forces blocked the way. First the Redcoats tried to reach Fort de Chartres by way of the Ohio River, but Pontiac's forces turned them back. Next they tried ascending the Mississippi River, but hostile Indians repulsed that expedition as well. On October 10, 1765, a contingent of British troops finally arrived. The final irony came when the British decided it was too expensive to maintain the fortress, abandoned it, and put it out of working order.

The changing of the guard in 1765 meant that, for the first time, some residents of Illinois spoke English. An artist created this rendering of the historic event to commemorate the state's Sesquicentennial in 1968.

4.3 PONTIAC, THE OTTAWA CHIEF

Pontiac gained great respect among the various Woodland tribes speaking an Algonquian language. At the end of the Great War for Empire he feared that the British victory would unleash hordes of settlers pouring across the mountains into Native American land. Therefore, he forged a confederacy to launch a coordinated attack on the newly established British forts between the Great Lakes and the Ohio River.

After widespread initial success, Pontiac's forces ran out of steam and eventually agreed to terms of peace. Assistance from the French still occupying Fort de Chartres was not forthcoming, and Pontiac's leadership rapidly declined, ending with his murder in Illinois in 1769. In this fanciful sketch an artist a century later pictured Pontiac at the height of his power. In this portrait both of Pontiac's weapons are European manufactured goods. The hatchet or tomahawk often appeared in later portrayals of Native American warriors (figs. 5.4 and 5.6).

4.4 A BRITISH VIEW OF NORTH AMERICA, 1766

This manuscript map shows the deployment of British troops in North America in 1766. Louisiana and New Mexico were then Spanish territory, but the rest of the land shown belonged to the British Empire. Fort de Chartres, the lone post on the Mississippi River, was still occupied by French troops in a region designated as Lands Reserved for the Indians. The reservation, however, seemed to be only temporary because the boundaries of the seaboard colonies extended all the way to the Mississippi River. The Illinois River is prominent on this map, but it is not clear that the cartographer was suggesting that the river would be a suitable boundary. The Quebec Act in 1774 placed all of this Indian land under that colony's jurisdiction, one of a cluster of laws that led directly to the Declaration of Independence.

4.5 THE ILLINOIS COUNTRY IN 1769–71

Thomas Hutchins, a British army officer born in New Jersey, led several small expeditions to take stock of the Ohio Country after Pontiac's War had abated. When he reached the Illinois Country he made detailed sketches for a map of the area. The map did not appear in print until 1778, and by then St. Louis, at the top of the map, had become the capital of Upper Louisiana.

The major road between Kaskaskia and Cahokia sought high ground via the hamlet of St. Philips (St. Philippe). Near the beautiful spring (Belle Fountain) a decade hence the first English-speaking pioneers would establish a small settlement. The town, now called Waterloo, has been referred to as the "oldest permanent American settlement in the Northwest Territory."

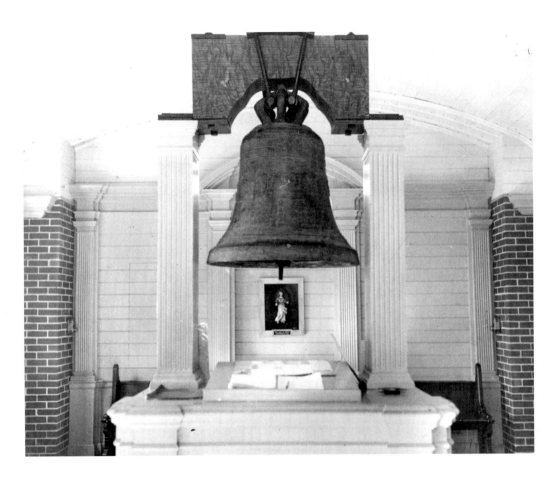

4.6 THE KASKASKIA BELL

George Rogers Clark rang the bell in the Kaskaskia
Church on July 4, 1778, to call inhabitants to-
gether after his Virginia militia had taken control
of the village. He informed the French-speaking
crowd that France was now an ally of the new
United States and that their rights and liberties
would be respected. Later, given the size and
shape of the bell, and its "Fourth-of-July" mes-
sage, it was called "America's Other Liberty Bell."

Cast in France in 1741, the bell was a gift from
the French king, Louis XV, to the people of Illinois.
It took two years, however, to move the huge bell
from France to New Orleans and then upriver to
Kaskaskia. Its inscription, translated from the
French, reads "To the people of Illinois, for their
worship."

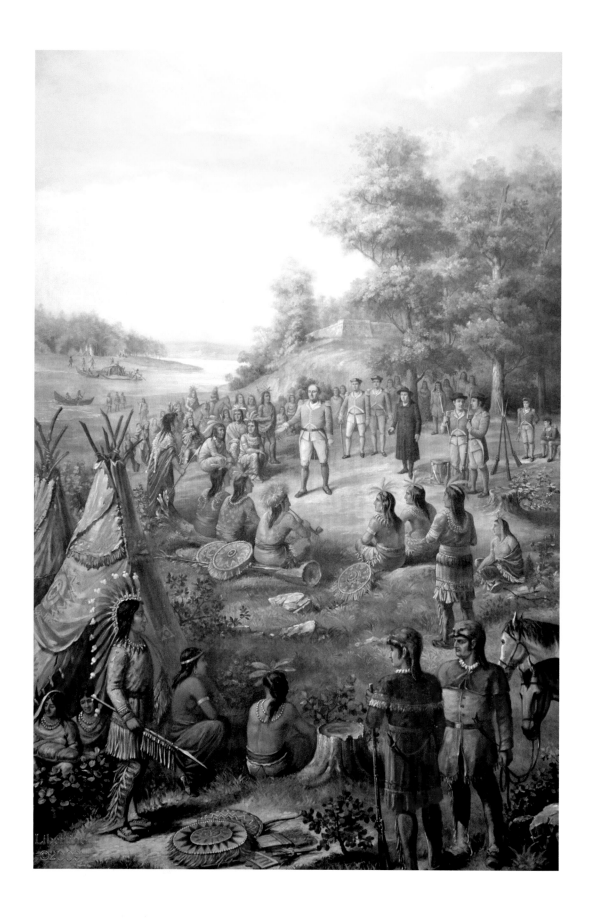

4.7 GEORGE ROGERS CLARK ADDRESSING THE INDIANS (*LEFT*)

A mural in the Illinois State Capitol depicts George Rogers Clark addressing the Illinois Indian village near Kaskaskia. As a whole, Native Americans held on to their loyalty to the French, encouraged by long association and the development of a notable population of *métis* (mixed-blood families), usually starting with a French husband and a Native American wife. When Clark conquered the British garrison in 1778 he trusted that the French Alliance would encourage the Illinois tribes to support the American Revolution. Some of the other Indian tribes moving into the former Illinois lands, however, gave their support to British. Throughout the War for Independence warriors from these tribes continuously threatened French and Illinois villages from Cahokia to Kaskaskia. On one occasion Cahokia was saved only by receiving aid from Spanish troops who had also become allies with the Americans.

Although critics have pointed to several inaccuracies in the painting, we should look beyond the actual event portrayed and place the image into the larger context of the European–Native American encounter pictured in chapter 3.

4.8 JEFFERSON'S PROPOSAL FOR STATES IN THE WEST, 1784 (*TOP*)

Thomas Jefferson, when he was elected governor of Virginia in June 1779, considered the Illinois Country to be part of his jurisdiction. He had an enduring interest in America's westward expansion, and when in 1784 he arrived in Paris to help negotiate treaties of trade with European nations he shared his ideas with a British agent. Perhaps the American sketched the plans on a tablecloth. At any rate, David Hartley redrew them on paper and sent the information to his superiors in London. Jefferson continued the east-west orientation of states west of the mountains. Today's Illinois would be located in three "horizontal" states instead of the later vertical alignment. The new states are numbered on the sketch, but no key exists to provide suggested names. Some suggestions Jefferson advanced for names earlier in the year, including Michigania, Illinoia, and Polypotamia, would fit states 4, 6, and 9, respectively.

	A HISTORICAL CONTEXT	MIDWESTERN DEVELOPMENTS	THE ILLINOIS EXPERIENCE
1780			
	1784 Russia establishes a colony in Alaska	**1784** Virginia cedes its north-western lands to the federal government	
1785	**1785** New York state abolishes slavery	**1785** Land Ordinance creates the congressional system for dividing and selling federal land	
	1787 Constitutional Convention in Philadelphia	**1787** Northwest Ordinance provides civil government for the Northwest Territory	
	1789 The French Revolution breaks out		
1790	**1791** Eli Whitney invents the cotton gin	**1792** Kentucky admitted as a state	**1790** Arthur St. Clair, governor of the Northwest Territory, creates first county in Illinois and names it after himself
	1792 Slave revolt leads to independent Haiti in 1804	**1794** Indians are defeated at Fallen Timbers	
1795	**1795** Metric system adopted in France	**1795** Treaty of Greenville	**1795** Indians cede sites for forts in Treaty of Greenville
		1798 Legislature for Northwest Territory meets at Cincinnati	**1801–3** Wilkinson Cantonment near mouth of the Ohio River
1800		**1800** Indiana Territory created, includes Illinois	
	1803 The Louisiana Purchase puts Illinois in the center of the nation	**1803** Ohio admitted to the Union	**1803** Fort Dearborn established. Indians cede much of southern Illinois in Treaty of Vincennes
1805	**1804** First successful steam locomotive is built in England		**1803–4** Lewis and Clark Expedition winters at Wood River
	1807 Great Britain outlaws the slave trade		**1807** Government Land Office marks Third Principal Meridian at mouth of the Ohio River
			1809 Illinois Territory is created
			1810 Illinois coal is shipped to New Orleans
1810			
	1812–15 War between Britain and the United States	**1811** First steamboat on the Ohio River	**1812** Burning of Fort Dearborn
		1811–12 New Madrid earthquakes	**1814** First printing press at Kaskaskia
		1812–15 British and American forces clash in Michigan and Wisconsin	**1816** Fort Dearborn rebuilt
1815	**1815** The Congress of Vienna ends the Napoleonic Era in Europe	**1816** Indiana becomes a state	**1816–17** Illinois Military Tract and Fort Armstrong established
	1816 Early photography experiments	**1820** The Missouri Compromise	**1818** Illinois is admitted as the twenty-first state on December 3

FIVE

The Territorial Period, 1783–1818

THE ILLINOIS Country became part of the United States under international law when the Treaty of Paris awarded the new nation all of the land between the Allegheny Mountains and the Mississippi River. The state of Virginia claimed the lion's share of this vast region, with the Ohio River serving as its major artery. Remember that George Rogers Clark's troops were part of the Virginia militia and that in 1778 the Virginia legislature established a temporary county for Illinois.

Near the end of the War for Independence, however, the Virginia legislature voted to cede its claims to the lands north and west of the Ohio River to the United States. Clark's Illinois regiment then disbanded, and the county law expired. So, when the diplomats in Paris signed the official articles of peace in September 1783, and the Illinois Country became part of the United States, Congress had the responsibility to establish a government for the region. This would take some time, a generation or two, and

some effort. The process would involve another war with the British and a continuing conflict with Native Americans, a struggle that would not end in Illinois until after the Black Hawk War of 1832.

Congress, operating under the Articles of Confederation, produced two pieces of legislation that became landmarks in the history of Illinois. The first, the Land Ordinance of 1785, established the procedure by which territorial land owned by the United States would be surveyed, sold in parcels to individuals, and turned into a commodity that could easily be identified, located, subdivided, bought, and sold. From the very beginning Congress had promised grants of land to soldiers as a "signing bonus" and had even promised similar rewards to deserters from the king's armies. Starting at the point where the western boundary of Pennsylvania met the Ohio River, the ordinance directed surveyors to systematically divide the territory into "Congressional townships," six miles square, and then subdivide some of them into thirty-six sections. The result, seen so clearly from an airplane in Illinois today, is the "checkerboard" pattern of land use.

The second landmark law, the Northwest Ordinance, dated July 13, 1787, established a governmental structure for the region, looking forward to the day when it would be purchased from the Native Americans, turned into farms and settlements, and organized into three to five new states. The ordinance spelled out a vision for the new American society that would emerge in the process, providing a long list of civil rights, freedom of religion, prohibition of slavery, encouragement of education, and insistence on a republican form of government. Although the document pledged that "the utmost good faith shall always be observed towards the Indians, their lands and property shall never be taken from them without their consent," the vision of the future it enunciated did not seem to have coexistence with the Native Americans as a priority.

Taken together, the Land Ordinance and the Northwest Ordinance implied

that the Indians would sell their territory to the United States, move on, and let the government divide and sell the land, nurturing new settlements and new states. The old French communities in the Illinois Country fared little better than the Indians, being largely ignored in the legislation. The basic idea was to erase the present situation and start designing the new America on a clean slate.

One historian has called the decade of the 1780s in Illinois "the period of the city states." An absence of authority forced the agricultural villages clustered in the Mississippi bottomlands to govern themselves and provide for their own safety. The rest of the future state, now outlined in the Northwest Ordinance, was Indian country, lands inhabited by newly arrived tribes as Native Americans adapted to new conditions. New tribes moved into Illinois from every direction, taking up residence as the Illinois Confederacy experienced a steep decline in numbers.

At the time, no one was sure what the future would hold. The fur trade, which animated life throughout the Northwest, remained under the control of the British, connected to the world economy through the St. Lawrence gateway. The Northwest Ordinance recognized the importance of these commercial networks, declaring "the navigable waters leading into the Mississippi and St. Lawrence, and the carrying places between the same, shall be common highways, and forever free."

To protect this trade and influence the Indians who were the foundation of the whole system, British troops did not evacuate some forts in the Great Lakes basin until after the War of 1812. When the U.S. Army erected Fort Dearborn at the mouth of the Chicago River in 1803, raising the stars and stripes for the first time that far north and west, almost the entire region beyond Lake Michigan remained under British influence.

When the military (in 1787) and civil authorities (in 1790) of the United States finally put in an appearance at Kaskaskia they witnessed a confused and shrinking populace. Many French

settlers had already moved across the Mississippi River into Spanish Louisiana. News of the antislavery provision in the Northwest Ordinance was undoubtedly one factor in encouraging this exodus, although the inhabitants were guaranteed their property, including slaves, by the treaties of peace.

Gradually, as more English-speaking pioneers arrived, often after stops in Tennessee or Kentucky, Illinois began to look more and more like the upland South. Corn grew in importance as a crop, soon overtaking the acres planted in wheat as the French settlers migrated to the right bank of the Mississippi River. In total acreage, corn plantings outnumbered wheat fields by a factor of five by 1800.

Most of this corn was sent to New Orleans by way of the Mississippi River. Corn found a market in the West Indies. The use of the port facilities in the Crescent City therefore became a top priority in the development of the nation's western land. Moreover, in the aftermath of the French Revolution, relations between France and Spain on one side and the United States on the other teetered on the verge of war. George Washington, called out of retirement to once again lead the army, followed the advice of Alexander Hamilton and directed that troops be concentrated near the mouth of the Ohio River. About 1801 a third of the U.S. Army occupied a large camp in the southern tip of Illinois. The soldiers used the post for only a few years because the Louisiana Purchase of 1803 removed the threat of war in the vicinity. New Orleans then became an American city and "the West" now referred to the vast territory across the Mississippi River. After 1803, Illinois may no longer have been on the western border of the nation, but it still was largely Indian country.

That started to change in 1795. The Indians in the Northwest Territory correctly viewed American Independence as a great threat to their way of life. They feared the thinking that led to the Northwest Ordinance and looked on in horror as thousands of white settlers entered Kentucky and turned it into a state

in 1792. Ohio would be next they feared. It was time to take a stand. Encouraged by the British, who continued to occupy Detroit and other posts around the Great Lakes, Indian warriors won several battles against U.S. troops sent out to defend the new settlements in the Ohio Valley. In a decisive battle in northwest Ohio, however, the U.S. Army, aided by the Kentucky militia, gained the upper hand in the struggle over the Northwest Territory.

Had Native Americans prevailed, and had British support materialized, perhaps the Ohio River would have been maintained as the boundary between Indian land and white settlements. Instead, by the Treaty of Greenville the Indians gave up most land in southern Ohio in addition to other small tracts upon which Americans could erect forts. Three of these sites, which were scattered around the region, traced the old French connection across Illinois: one at the mouth of the Chicago River, another at Peoria, and the last by the mouth of the Illinois River near the head of that extensive floodplain now called the American Bottom to distinguish it from the Spanish Bottom across the Mississippi River.

In 1803, the year of the Louisiana Purchase, a contingent of soldiers erected Fort Dearborn at Chicago. A French-speaking black trader and farmer who had an Indian wife had occupied the site for more than a decade. Jean Baptiste Point Du Sable, much celebrated in later years as Chicago's founder, stepped into the political void that marked the closing decade of the eighteenth century. He participated in the trading network that reached from the St. Lawrence to the mid-continent and also had close family ties to French settlements in the Illinois Country. He farmed, traded, and probably engaged in frontier industries at a key carrying place between the Great River and the Great Lakes. When he sold his post at the mouth of the Chicago River to another trader in 1800, he probably moved downstream to Peoria and spent his last days near his daughter's family in St. Charles, Missouri.

Du Sable departed from Chicago just

three years before the building of Fort Dearborn. He may well have witnessed the transfer of sovereignty ceremony in St. Louis occasioned by the Louisiana Purchase, or perhaps he shared some advice as the Lewis and Clark expedition passed through St. Charles the following year. When he died in 1818, Illinois was about to become a state. But statehood did not come because of his efforts at Chicago. The city's founding would not occur until 1833, fifteen years down the road. Instead, the swelling population that ushered in statehood occurred in the southern reaches of the state, a spillover from Kentucky and a movement that used the Ohio River as its gateway.

If Du Sable had wished to witness a pivotal event in Illinois history between 1800 and 1818, he might have journeyed to the mouth of the Ohio River in 1807 to witness a party of surveyors selecting a point at the waters' edge, where the two streams met, to mark the point of origin for the Third Principal Meridian. This imaginary line would eventually extend all the way to the state's northern boundary, measuring the township and range lines that would turn virgin land into private property, farm fields, and town lots.

The fact that surveyors were starting to lay out the Illinois meridian in 1807 indicated that Native Americans had sold the surrounding land to the United States. Between 1803 and 1805 by a series of such treaties the Indians had relinquished all land south of the mouth of the Illinois River and west of the same river up to the Rock River basin. The rest of Illinois would not be ceded by other tribes until after the conclusion of two more wars: the war of 1812 and the Black Hawk War.

The former was directly connected to statehood; the latter came fifteen years after Illinois was admitted to the Union. The War of 1812 started in the West. When British troops seized U.S. forts in the Michigan Territory, the outpost at Fort Dearborn, erected in 1803 at the mouth of the Chicago River, became untenable. Retreating from the fort, the garrison was soon massacred by angry Potawatomi warriors, who, like most tribes, were on the British side of the conflict. Previously, the British trad-

ers had suggested that the Illinois River would make a better boundary than the Mississippi because it would keep the United States out of the Upper Mississippi basin. The results of the war, however, were to maintain the legal status quo, and the British promised to make a full evacuation from American soil. The real losers were the Native Americans who had fought against the Americans. In Illinois, they surrendered a broad slice of land where a canal could be dug from the Illinois River to Chicago, thus tying the Great Lakes to the Mississippi River system.

The Illinois settlements benefited from the war because, as the Indian presence was reduced, more land became available for new settlers. Indeed, in 1815 Congress selected the region between the Illinois and Mississippi Rivers, south of Rock Island, as the Military District where veterans of the War of 1812 would receive land grants as a bonus for their service. This tract, recently ceded by the Indians, would swell the population of Illinois, it was thought, and propel it into statehood.

In reality, the expected pioneers did not arrive so quickly, but the statehood initiative proceeded anyway. Congressional leaders were anxious to finally control the land west of Lake Michigan. They also desired to maintain the balance between free and slave states in the Union, a balance threatened by admission of new states in the recently acquired Louisiana Territory. If Illinois could be admitted quickly as a free state, several national objectives could be met. In addition, political leaders in Illinois believed that statehood would speed settlement, stimulate economic development, and raise the value of their land. In January 1818 Illinois had only about thirty thousand inhabitants, but its territorial representative, Nathaniel Pope, got Congress to drop the required number of residents for its statehood from sixty to forty thousand. Next he maneuvered federal authorities into letting Illinois conduct its own census. Coming up well short of the needed numbers, territorial officials extended the census cut-off date and began to count travelers passing through Illinois,

sometimes several times. Finally, with a total of 40,258 on the census list but probably only thirty-six thousand actual citizens, Illinois slipped into the Union, the smallest state in terms of population ever admitted.

Moreover, Pope had found enough support in Congress to push the northern boundary of Illinois far enough north to include both Fort Dearborn on Lake Michigan and the lead deposits around the future city of Galena. Thus when statehood came on December 3, 1818, Illinois was still largely a hope and dream, at best a work in progress.

5.1 DU SABLE AND CHICAGO'S BEGINNING

Sometime near the end of the War for American Independence Jean Baptiste Point Du Sable built a home, trading post, and farm at the mouth of the Chicago River. It probably started as a pioneer effort, but Du Sable, enjoying the confidence of Native Americans, French traders, and *métis* (mixed-blood) families, grew prosperous enough to turn his complex into an outpost of European civilization, with oil paintings on the walls and a prized eight-foot cabinet made in France that featured four glass-windowed doors.

When Du Sable sold the complex in 1800, shortly after the death of his Indian wife, the buildings he left behind remained in commercial use. Fort Dearborn joined the settlement in 1803,

and, by 1832, the date the artist assigned to this portrayal, the Du Sable post had served as the home of the John Kinzie family for almost three decades. Friendship with the Potowatomi had spared the complex when they burned Fort Dearborn across the river in 1812.

This lithograph was not made until decades later, but it was informed by the memories of several old settlers. It is particularly noteworthy that the architecture resembles that of early French structures on the American Bottom and traditional houses in the French West Indies (e.g., figs. 3.7 and 6.10). Chicago's roots, like Du Sable's, seem to reach down to the Illinois Country to the Great River and perhaps on to the Caribbean.

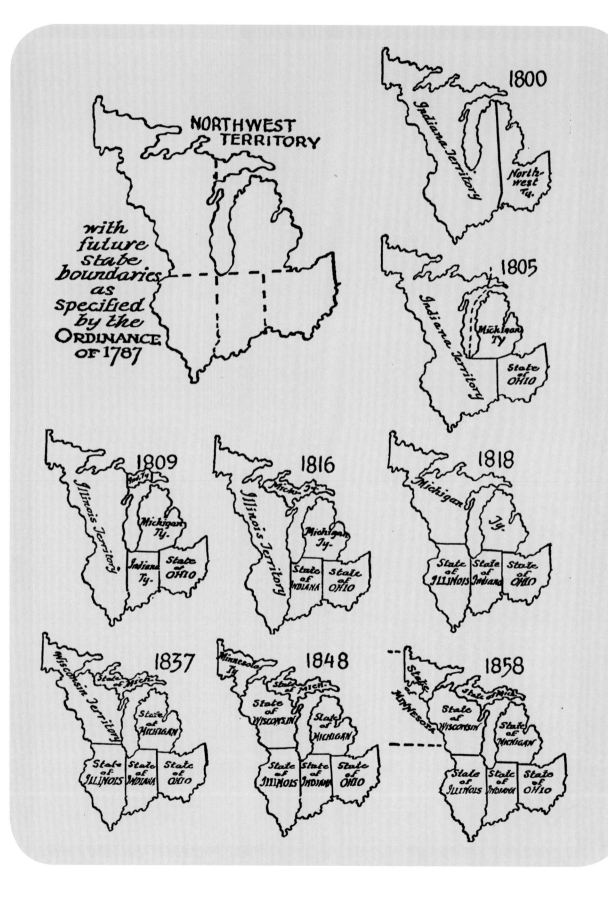

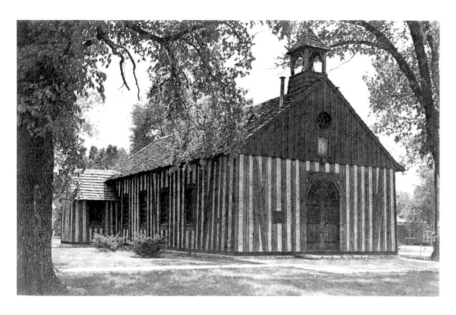

5.3 HOLY FAMILY CHURCH, CAHOKIA, 1799

Many French inhabitants left Illinois when it came under British and then American rule, moving to new settlements on the western bank of the Mississippi River. Other French-speaking immigrants arrived at the same time, however, some from Quebec and a few even from Switzerland and France. The modest Holy Family Church represented the continuing presence of the initial French settlers. When the structure was dedicated in 1799, the parish was a hundred years old.

The timbers of the log structure were placed vertically on a wooden sill set on a shallow foundation. These hand-hewn walnut logs were later covered with clapboards, but in 1971 the siding was removed to reveal the original construction. Even though the 1799 structure was the second parish church, it is still regarded as the oldest ecclesiastical structure in the Old Northwest.

5.2 THE NORTHWEST ORDINANCE AND THE CREATION OF NEW STATES (*LEFT*)

The Northwest Ordinance of 1787 specified certain conditions for statehood and set boundaries for between three and five new states, but limits of the new states never exactly followed the original legislation. In every case the territories of the Ohio River states were moved northward to secure an adequate presence on the Great Lakes. Ohio gained Toledo, Indiana received Michigan City, and Illinois seized the real prize, Chicago. The state of Michigan received compensation in the Upper Peninsula for its loss of lands in the Toledo strip. Wisconsin, however, surrendered territory to three states: Illinois, Michigan, and Minnesota.

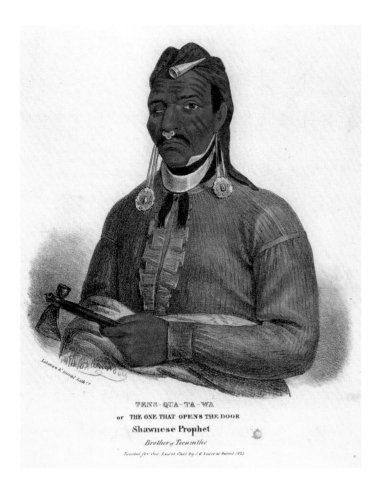

TENS-QUA-TA-WA
or THE ONE THAT OPENS THE DOOR
Shawnese Prophet
Brother of Tecumthe
Painted for Gov. Lewis Cass by J.O. Lewis at Detroit 1823.

5.4 TENSQUATAWA: THE SHAWNEE PROPHET

To read the story of the Territorial Period in Illinois as a grand inevitable march to statehood would be a serious case of reading history backward. No actors on the scene remind us of this more than the Shawnee Tensquatawa (The Prophet) and his brother, Tecumseh. Their tribe moved to the Wabash River Valley after losing its land in Ohio as an aftermath of the Battle of Fallen Timbers. Hence the new river town in the area was named Shawneetown (fig. 6.11).

The Indian losses in Ohio, proclaimed Tensquatawa, a fiery preacher, were a result of abandoning ancestral ways of life and adopting white man's guns, utensils, clothing, blankets, liquor, and views of land ownership. His brother used this message to unite the region's tribes in a formidable military alliance dedicated to resisting the advancing pioneers. Success depended on the degree of support the Native Americans would receive from the British, an answer not fully revealed until 1815, after the War of 1812. Tecumseh gave his life in that conflict, fighting for the British. The Prophet survived, and this portrait, done in Detroit in 1823, reveals a proud voice for a message that history was bypassing.

5.5 THE GREAT EARTHQUAKES, 1811–12

On December 16, 1811, in the early morning, the earth jolted along the Mississippi River. For the next four months a series of major earthquakes rattled the nerves of the Native Americans and pioneers scattered throughout the Mississippi Valley. Across Illinois, shelves were emptied several times as more than a thousand quakes and aftershocks jostled the land. No doubt the experience added urgency to the preaching of The Prophet and reflected the tentativeness of the political arrangements that people were trying to put into place.

As far away as Boston the earth swayed enough to ring church bells. The most dramatic results occurred on the Great River, pictured here as a raging torrent. In places the river reversed itself, created new channels, and transformed the landscape. In the third major shock, on February 7, 1812, the flourishing river port of New Madrid, Missouri, dropped fifteen feet and out of existence. It was the most costly episode in the whole series and so it is often referred to in the singular as the New Madrid Earthquake.

5.6 THE FORT DEARBORN MASSACRE, 1812

One of the first battles of the War of 1812 occurred a few miles south of Fort Dearborn as Potawatomi warriors ambushed the troops evacuating their exposed position at the outer edge of territory under the control of the United States. In 1893 George Pullman sponsored this monument commemorating the event that occurred literally in the back yard of his house only eight decades earlier.

Although the monument has a grisly title, and the fort's physician lies mortally wounded beneath the struggling figures, it actually depicts the rescue of Margaret Helm by Black Partridge, a friendly Potawatomi chief from Peoria. Helm was the stepdaughter of John Kinzie, the trader who lived in Du Sable's old complex across the river from the fort. She lived to tell this story. Black Partridge was a friend of the Kinzie family and favorably disposed toward accommodation among frontier people.

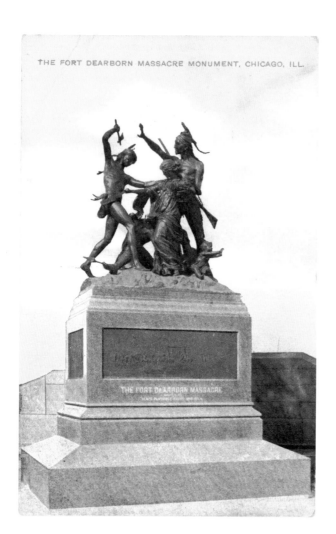

THE FORT DEARBORN MASSACRE MONUMENT, CHICAGO, ILL.

THE FORT DEARBORN MASSACRE

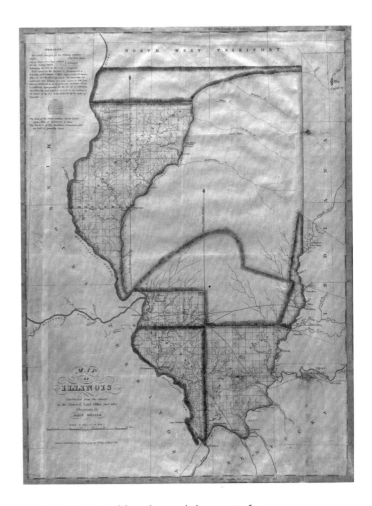

5.7 THE FIRST MAP OF THE STATE OF ILLINOIS, 1818

John Melish compiled a wall map of the United States in 1816, and it soon became a popular reference tool. His plan to follow it with a series of state maps received encouragement from Congress, which wanted maps of the new states: Indiana, Alabama, Mississippi, and Illinois. When Melish started work on the Illinois sheet he followed the boundary set in the Northwest Ordinance. Shortly before the final passage of the enabling act, however, Congress agreed to push the boundary forty-one miles northward to "offer additional security to the perpetuity of the union." In response, Melish in Philadelphia quickly began another Illinois map, which appeared in 1819.

The 1818 map, although grossly inaccurate for the northern reaches of the state, clearly shows the five surveyed regions open to settlement. The old French settlements embraced two districts, each with a center more than a century old: Cahokia and Kaskaskia. The opposite side of the state also had two centers: Shawneetown for the Ohio River region and Vincennes, in Indiana, for the Wabash River Valley.

Finally, the Military Tract set aside for veterans of the War of 1812, west of the Illinois River, is shown. Soldiers started to receive warrants to select land in this region in 1817, but Quincy, the town that would function as the first gateway to the tract, would not be settled until 1822.

A HISTORICAL CONTEXT	THE ILLINOIS EXPERIENCE	THE CHICAGO DIMENSION
1815 Macadam develops process for improving roads with crushed stone		**1815** Fort Dearborn rebuilt
	1818 Statehood, December 3	
1819 *Savannah* becomes the first steamship to cross the Atlantic Ocean. Financial panic depresses the economy until 1821	**1819** Galena mining boom. Black Laws enacted, function as a slave code	
1821 Missouri admitted as a slave state	**1820** Capital is moved to Vandalia. State's population only 55,211	
1824 Mexico becomes a republic	**1824** Movement to legalize slavery by a new constitution defeated	
1825 Erie Canal completed	**1825** Lafayette visits Illinois	
1828 Andrew Jackson elected president	**1830** Lincoln family moves to Illinois frontier	
1830 Indian Removal Act	**1831** Abraham Lincoln settles in New Salem	**1830** First lots platted
	1832 Black Hawk War	**1832** Cholera epidemic
1833 Britain abolishes slavery throughout its empire	**1837–40** Internal improvement program	**1833** Last council of the Potawatomi. Chicago incorporated as a city
	1837 Elijah Lovejoy, abolitionist, murdered in Alton. John Deere perfects his steel plow	**1835** Chicago River made a harbor
1837 Financial panic retards the economy until 1843	**1839** National Road reaches Vandalia. Mormons settle at Nauvoo. Capital is moved to Springfield	**1837** Early land boom crashes
		1838 First grain elevator
1840 Photographic cameras introduced	**1842** First railroad in Illinois: Springfield to Meredosia	**1840** Chicago Anti-Slavery Society founded
	1844 Joseph Smith murdered at Carthage	**1843** Roman Catholic Diocese of Chicago established
1845 Great Potato Famine begins in Ireland	**1845** Nauvoo becomes state's largest city	**1847** River and Harbor Convention. Stephen A. Douglas moves to Chicago from downstate
1846–48 War between Mexico and the United States	**1846** Mormon exodus. Bishop Hill settlement	
1848 Wisconsin admitted to the Union	**1847–48** Second Constitution adopted	**1848** Illinois and Michigan Canal opens. First railroad and first telegraph service
The *Communist Manifesto* published	**1847–55** Military Tract warrants given to Mexican War soldiers	**1849** Board of Trade chartered
1849 California gold rush	**1850** Illinois Central land grant	**1850** City ranked twentieth nationally with a population of 29,963

The Pioneers, 1818–50

IN DECEMBER 1818 the people of Illinois celebrated the achievement of statehood. But they faced a great challenge as well. The twenty-first star on the flag had become a state prematurely. It needed citizens. And it soon faced competition from another new state, Missouri, admitted as part of the Great Compromise in 1821. Indeed, in the federal census of 1820 Illinois was the weakling among its neighbors, with a population of only fifty-five thousand, fewer than Missouri and only a third of Indiana's total. Kentucky had more than ten times as many people as Illinois.

Illinois, everyone agreed, needed citizens, but not, most were convinced, Native Americans. On the issue of black slaves, people were about equally divided. The first Illinois constitution, unique among the states growing out of the Northwest Territory, did not include a permanent prohibition of slavery. Many people felt that in the future the state would become an extension of Kentucky, a border state that at least

tolerated slavery. Black slaves were already present in Illinois, some owned by former French subjects who had been guaranteed their property rights. In other cases, Kentuckians owned the slaves but leased them to Illinois residents. In addition, Illinois citizens could own the services of indentured servants, and lawyers were quick to put African American slaves permanently into that category.

One of the initial pieces of legislation enacted by the state of Illinois was a slave code, the first of several that remained in place up to the Civil War. At the same time, now that Illinois was a sovereign state some leaders pushed for a new constitution that would reconsider its "free state" status. The issue dominated Illinois politics between 1822 and 1824, ending only when the electorate voted to keep the original constitution and maintain the current status of an almost "free state."

When Illinois entered the Union, most of its territory was still in Indian hands. Native Americans held almost all of the land east of the Illinois River and north of Vandalia. Actually, there was no Vandalia in 1818, the site selected for the new state's capital in 1819 being located upstream on the Kaskaskia River at the edge of newly ceded land. By law, Vandalia would be the capital for twenty years. When the term neared its end in 1837 the legislature voted to move the capital northward once again, this time into the Illinois River basin. Abraham Lincoln, one of the Sangamon County legislators pushing for this change, immediately moved up the Sangamon River from New Salem to the new capital, Springfield.

By then the northward push of settlement, starting slowly in the Military Tract west of the Illinois River, sprang to life, propelled by two major economic moves on the part of the federal government. The first, a land grant in 1827 to finance a canal connecting Lake Michigan and the Illinois River, led to the birth of Chicago in 1833. In the second, the federal government opened the lead mining region in the 1820s, which created the bonanza city of Ga-

lena in 1829. Both initiatives were soon threatened by the last armed resistance of Native Americans to white advance in the Northwest Territory, the Black Hawk War of 1832. The defeat of Black Hawk's faction of Sauk and Fox warriors hastened the exodus of the other tribes that had not yet ceded their Illinois land. The Potawatomi, foremost among these people, signed the Treaty of Chicago in 1833. As a result, all of northern Illinois was flung open to settlement. Both Galena and Chicago received land offices in 1835. In a few years the population of the state would register nearly half a million citizens, a number that would double by 1850.

Illinois witnessed pioneers for about ten millennia before the last wave came between 1818 and 1850. These American pioneers settled the land and opened the state for others to follow. They felled forests and broke sod to establish farms; erected rough cabins and then comfortable houses; founded towns and villages; established counties, schools, and places for worship; and knitted every

part of the state together with a system of transportation embracing routes over land and by water.

By 1850 steamboats regularly called at river landings and the lake port, railroads had started full of promise, plank roads briefly flourished, and a new market economy had been put into place. The state government, it is true, made mistakes when pursuing grandiose schemes for internal improvements and banking facilities, but the result in the 1850s was that newcomers after that date could order manufactured furniture to equip their new homes. The pioneers generally made things themselves, did without, or sacrificed other comforts to pay enormous transportation costs. As Illinois stepped out of the pioneer period it put both feet in the era of a market economy and consumer goods.

The completion of the Erie Canal in 1825 opened a new way of passage to Illinois and the presence of New York and New England was felt almost immediately. Chicago emerged as the great conduit for eastern capital and for new

immigrants to reach the mid-continent. Illinois was ready for a take-off into national affairs.

Abraham Lincoln, who would become the timeless voice and symbol of American democracy, embodied the pioneer experience in Illinois. Born in Kentucky, Lincoln's parents moved to the Indiana frontier when he was seven. As he reached adulthood his father and stepmother headed for the northern edge of settlement in Illinois. After working with his father to set up a log cabin and develop a farm, Lincoln helped build a flatboat and navigated it down the Sangamon, Illinois, and Mississippi rivers to New Orleans. Returning, he joined the new village of New Salem, working a variety of jobs. After serving as captain in the Black Hawk War, Lincoln became a lawyer, was elected to the state legislature, moved to Springfield, and emerged as a leader of the state's Whig Party.

Elected to Congress in 1846, he made his first visit to Chicago the next summer to attend the River and Harbor Convention and arrived by way of a stagecoach. A year later he could have entered the city via canal boat. A few years after that, he would reach Chicago by rail. On each of these journeys the pioneer experience would recede more and more into the background. His life on the Sangamon frontier, however, became the classic story of Illinois, the land of Lincoln. But that is a parochial view. The years ahead would reveal that Lincoln's story was the story of America.

6.1 THE PIONEER DREAM, 1818

In 1816 John Melish pointed out the Military Tract that Congress had set aside in Illinois to provide bonuses for the soldiers in the late war. "This territory will soon become a state," he observed, "and it will be one of the most important in the Union." Illinois became a state two years later, and publishers issued a variety of maps to help veterans select their claims. This image, which Nicholas Biddle Van Zandt placed on his *General Plat of the Military Lands between the Mississippi and Illinois Rivers* (Washington, 1818), shows the grateful republic presenting a land warrant to a soldier, while his wife points to Illinois and his young son shoulders his scabbard. Everyone could relate to the scene, a patriot's reward and a pioneer's dream. Compare it with an urban counterpart from 1891 in figure 8.17.

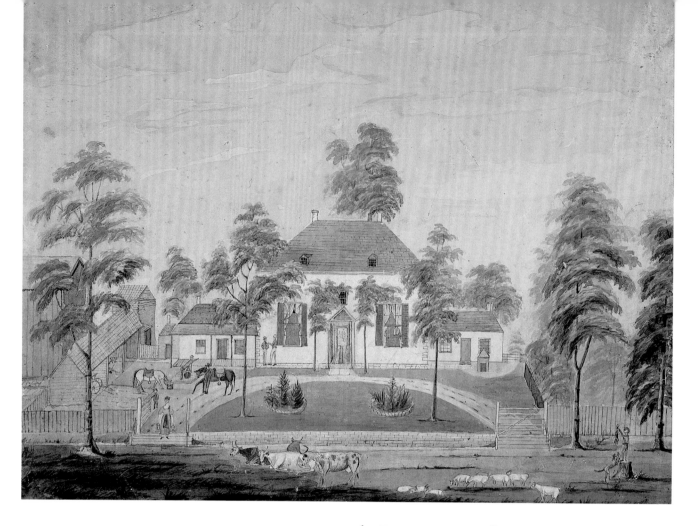

6.2 THE PARK HOUSE, 1819

George Flower, a well-to-do Englishman who led a group of settlers to the English prairie in Edwards County, Illinois, immediately started construction on an elaborate manor house for his parents. Finished in 1819, the eleven-room mansion was probably the most spectacular home in the Wabash Valley. It represented something beyond the achievement to which pioneer families aspired. Furnished with imported items lugged across the Allegheny Mountains, it had a music room with a piano, supposedly the first such instrument in the state. The fortunes of the Flower family, however, were lost in the colonizing venture, and Park House later burned to the ground. It was, after all, a log building with stucco covering to make it resemble stone. Compare it to the Lincoln log cabin in figure 6.7.

6.3 FORT ARMSTRONG IN THE EARLY DAYS

During the War of 1812 detachments of U.S. and British soldiers advanced and retreated up and down the river between St. Louis and Prairie du Chien. The Americans erected the first fortifications at the end of Rock Island in 1816. This sketch, made later from memory, shows the flag flying high above Fort Armstrong, the first of a string of military posts that would be placed along the upper Mississippi River.

Rock Island would eventually become the center of the Quad Cities metropolitan complex. The rapids, upstream on the right-hand side of the island in this view, promised waterpower for a significant industrial installation. John Deere moved his plow factory to the site in 1847, and the United States would follow with an arsenal for the West in 1863.

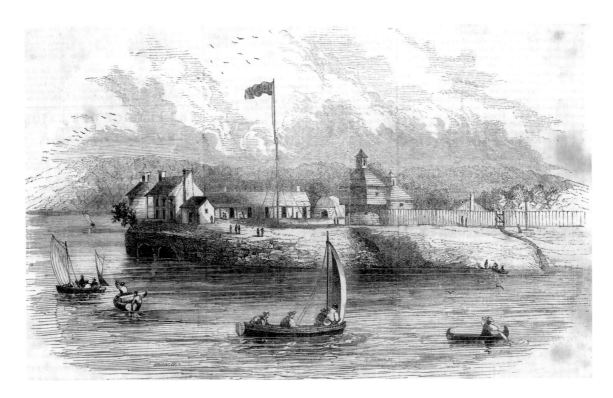

6.4 FORT DEARBORN IN 1820 (*ABOVE*)

Henry Rowe Schoolcraft, explorer, military advisor, Indian agent, and later celebrated as the father of Native American ethnology, visited Illinois several times during the pioneer period. Arriving via the lake in 1820, he sketched the new outpost at Chicago. Later Seth Eastman turned his sketch into a watercolor painting that was, in turn, used by an engraver for this plate in Schoolcraft's *Historical and Statistical Information Respecting the Indian Tribes*.

When Fort Dearborn was rebuilt after the War of 1812 it took the form of a frontier trading post. One of the blockhouses was omitted from the new fort, giving this appearance from the lakeside view. Du Sable's old homestead and trading post, still operated by the Kinzie family, was joined by facilities for the Indian agent and the homes of several traders and innkeepers. Supervision of the Indian trade in the area contin-

**6.5 "FOR SALE: A LIKELY
NEGRO GIRL," 1826 (*ABOVE*)**

The two ends of the state were worlds apart in the pioneer period, with the sale of black slaves receiving regular notices in Kaskaskia newspapers. A decade after these advertisements appeared a movement started to establish an antislavery society in Illinois. But only in the 1840s did Illinois courts hold that indentured servants could not be sold as property or that the descendents of the French slaves could no longer be held in bondage.

Free blacks were not welcome in pioneer Illinois. They were required to carry papers certifying their free status, and they could not vote or serve in the state militia. Some free black families, however, were able to get by in a variety of Illinois communities, in general finding more steps toward freedom the further north they were able to settle. In 1853 a meeting of the Colored Citizens of Illinois met in Chicago to protest their legal status.

ued under the governor of the Michigan Territory rather than the governor of Illinois. Schoolcraft, on a journey up the Illinois River in 1821, found only a few settlers' huts at Peoria in the entire course between Alton and Chicago.

This location a century later can be viewed in figure 9.12.

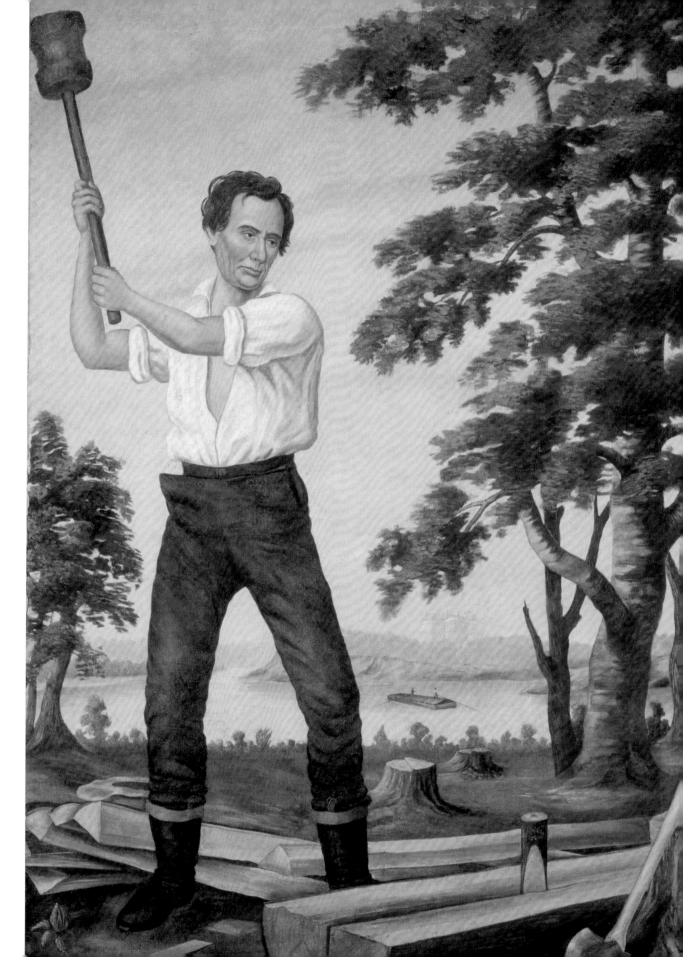

LINCOLN LOG CABIN.

6.6 LINCOLN THE RAIL-SPLITTER (*LEFT*)

Abraham Lincoln was a typical immigrant in 1830 when he accompanied his father and stepmother on their move from Indiana to the northern edge of the Illinois frontier. One of the first tasks of a pioneer farmer was to fence the area he had cleared for planting crops. The law at the time permitted farmers to graze their animals on public domain, requiring fences to keep animals out of planted fields. Karl Bodmer pictured such fences on a pioneer farm on the Illinois prairie in 1832 (fig. 6.10).

Lincoln, who had just come of age, helped his father get started and then took up a variety of jobs before locating himself in the new settlement of New Salem, which was on the Sangamon River about sixty miles downstream from his father's cabin. Lincoln's early life on the Illinois frontier became the stuff of many later legends. His skill as a rail-splitter had some basis in fact. This painting, issued to support the candidate for the U.S. Senate in 1858, features Lincoln putting in a hard day's labor as a community builder.

6.7 THE LINCOLN LOG CABIN (*ABOVE*)

In 1830 Abraham Lincoln helped his father erect this log cabin, shown here as it survived into the twentieth century. Only three sides were finished that year before winter set in, and the full double cabin did not appear until later. Neither his father nor Lincoln himself ever found much success at farming. In a few years the Lincoln family moved to a better location and the celebrated rail-splitter took a variety of jobs in New Salem before entering politics and embarking on a legal career. But the log cabin that he helped to erect near the new town of Decatur served his political career well as a symbol for his commonplace origins and his embodiment of the frontier spirit. Indeed, Lincoln Logs became one of the most popular toys of the twentieth century.

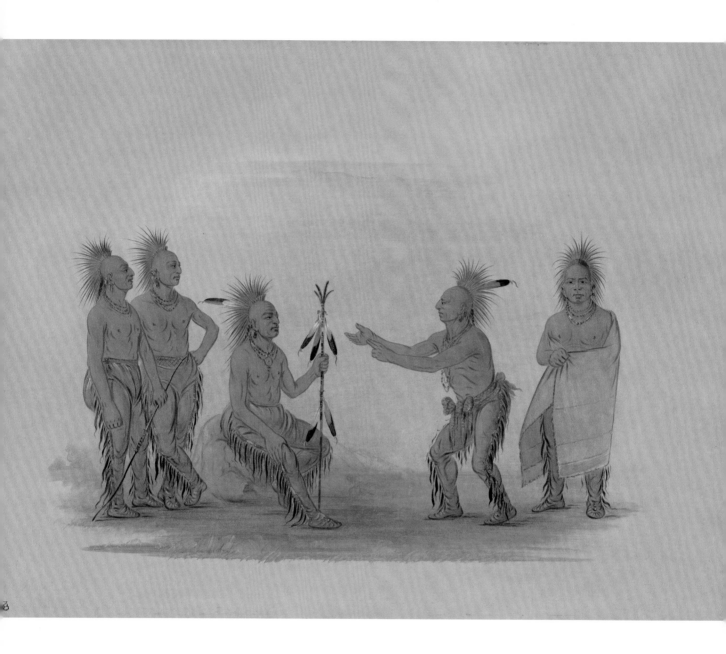

6.9 THE LAST COUNCIL OF THE POTAWATOMI, CHICAGO, 1833 (*ABOVE*)

6.8 BLACK HAWK AND THE PROPHET (*LEFT*)

Black Hawk was born near the mouth of the Rock River in Illinois in 1767 when the area was considered part of the British Empire. A gifted warrior, he emerged as a leader of the "British Band" of Sauk Indians who refused to accept the actions of another faction when, in 1804, the latter signed away the land they used for farming and hunting in Illinois. Black Hawk's big chance came in the War of 1812 when he fought against the Americans. Heeding the voice of the Winnebago Prophet, pictured here by George Catlin, Black Hawk tried to keep his people on their ancestral ground. Then pioneer squatters started moving into the region, which was now defended by Fort Armstrong nearby. In the tragic fighting that resulted neither the other tribes nor the British came to aid Black Hawk. In 1832 his people were slaughtered in Wisconsin, but some were captured rather than killed, including Black Hawk.

In the aftermath of the Black Hawk War, the Potawatomi, who held the last Indian rights to land in Illinois, gathered in Chicago. It was an annual event at which the U.S. Indian agent stationed at Chicago would present a payment to the Indians as part of a treaty for ceding land in Michigan. The Black Hawk War, however, had changed things. It became clear that all Indians would be removed from Illinois. Moreover, the arrival of troops from the eastern states had spread word of the opportunities available in northern Illinois. Finally, the federal government was prepared to pay unprecedented sums for Potawatomi land. To Native American leaders it looked like time to strike a deal and move on. Thus the signing of the Treaty of Chicago became a key event in Illinois history. It was later commemorated in this painting, part of a series that decorated a Chicago bank.

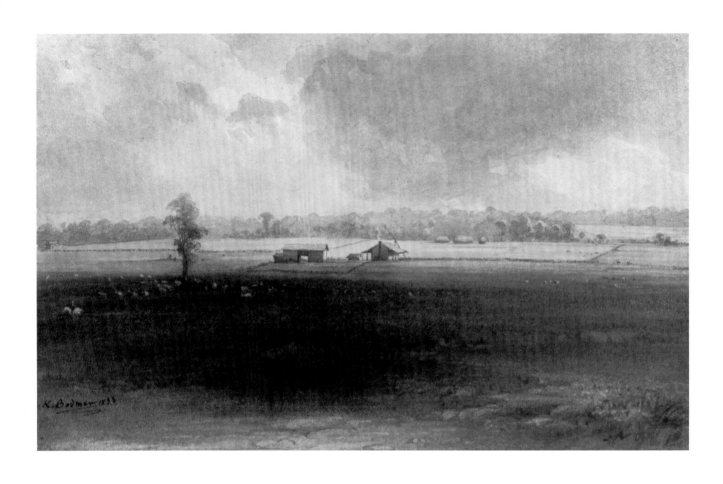

OLD SHAWNEETOWN BANK

ROSCOE
MISSELHORN

6.10 A FARM ON THE ILLINOIS PRAIRIE, 1832

Karl Bodmer, a young Swiss artist, painted this view of a farm on the prairie of southern Illinois in 1832. Bodmer accompanied Prince Maximilian on a study trip to record Native American life in the American West but first stopped in Indiana and Illinois to record the landscapes of the Ohio and Mississippi river valleys. The house in this picture follows the French style of architecture characteristic of American Bottom settlements. Ample wooded areas are located nearby, but the homestead occupies the center of the fields. The farmer has left a tree standing in the pasture, probably to provide shade for livestock. The fact that there is no road in the painting hints at the self-sufficient nature of the frontier farm. The tall apparatus behind the house substituted for a windlass to lift water from a well. Later in the century windmills would be used to pump water from the wells (fig. 9.2).

The exact location of this farm is not given, but it probably was on the English Prairie in Edwards County very close to Park House (fig. 6.2).

6.11 SHAWNEETOWN'S MONUMENT

When bankers in Shawneetown erected this classical revival building overlooking the Ohio River the waterway had long served as the gateway to Illinois from the eastern states. The French sponsored a Native American settlement on the site, but it was soon abandoned for higher ground. In 1803, however, the Indians ceded the salt-water springs in the area, and federal authorities laid out a town to ship the salt and settle the land.

Commercial interests started a bank as early as 1804, the first such institution in Illinois. A land office followed in 1812, and Shawneetown became the commercial center for the Illinois settlements in the Wabash River Valley. This impressive building, the "New Bank" at Shawneetown, points to the town's importance in the pioneer period of Illinois history. As traffic shifted northward with the opening of the Erie Canal and the development of the railroads, however, the function of an Ohio River port in the economy of Illinois faded away. This architectural jewel was left as a token of remembrance. A twentieth-century artist, Roscoe Misselhorn, captured its monumental posture in this engaging sketch.

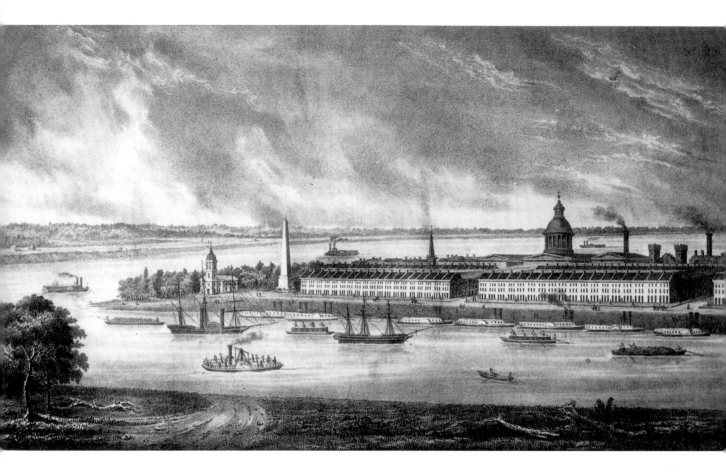

6.12 THE PROPOSED CITY OF CAIRO, 1838

The rush of pioneers into Illinois in the 1820s and 1830s pushed the population of the state up to 476,183 in 1840. In 1837 the state adopted a massive plan for internal improvements to spread railroads across the prairies. The Erie Canal, completed in 1825, had added another gateway to the Midwest. So did the National Road, completed to Vandalia, then the Illinois capital, in 1838. Supporters hoped that the federal government would soon extend the major highway to a Mississippi River port in Illinois. The transportation revolution was causing cities to spring up in Illinois and there seemed to be no better place on the map for a metropolis than Cairo at the mouth of the Ohio River.

William Strickland sketched this proposed city for investors in England. The idea was to sell lots at the flood-prone site, using some proceeds to build a levee and others to erect great public buildings that would "jump start" the city. Floods overwhelmed the levees, however, and Strickland's metropolis failed to materialize. In 1861, however, Cairo played a key role in the Civil War (fig. 7.8).

6.13 A VIEW OF GALENA, 1844

Native Americans mined lead along the upper Mississippi River before the arrival of white settlers. Julien Dubuque in the late eighteenth century started to develop these resources as the Mines of Spain along the river's right bank, but it was not until after the War of 1812 that the region was made safe for prospectors. In 1819 a large-scale effort to tap the lead ore (galena) included the use of slaves. The federal government started a leasing system to bring order to this new mining frontier, and a settlement started at Galena in 1823. Soon the region attracted thousands of miners, and the nation witnessed a mining boom. By the 1840s, when John Caspar Wild prepared this lithograph, Galena had become the largest steamboat port above St. Louis. The miner in the foreground uses a windlass to bring up spoil rocks or treasured ore.

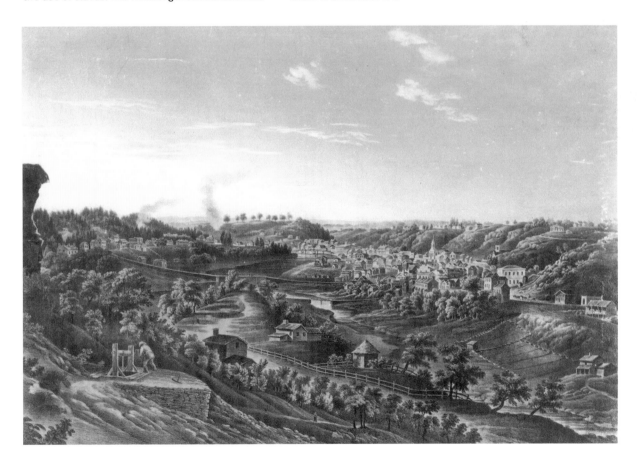

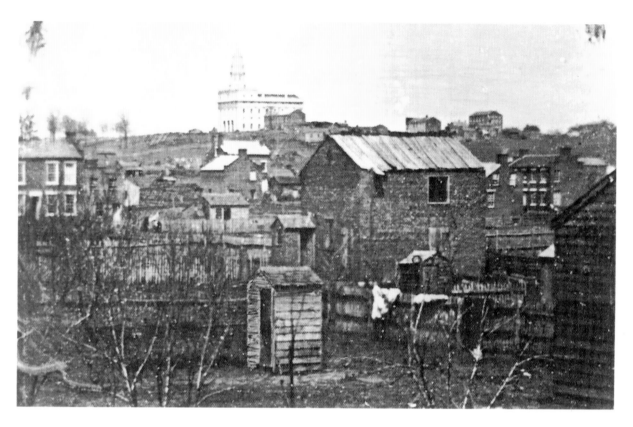

6.14 NAUVOO, CA. 1845

By 1844 Nauvoo had raced past Galena and Quincy to become the largest city in Illinois. This religious settlement marked the culmination of the Mormon experience in the state. Founded after Joseph Smith's revelation in upstate New York, the Latter Day Saints moved first to Ohio then to the far frontier in Missouri, where they faced persecution. Crossing the Mississippi west to east at Quincy in 1839, five thousand Mormons received a hearty welcome to Illinois, a state looking to increase its population. In 1840 the legislature provided a charter that granted their city such extraordinary powers as the right to have a militia. A few years later, on the banks of the Mississippi, the Saints started erecting their temple in the midst of Nauvoo, the "beautiful place." Conflict with their neighbors, however, led to the murder of Joseph Smith in 1844, and shortly thereafter a new Mormon leader, Brigham Young, started moving the majority of the Saints westward once again. They completed their Illinois temple during the exodus only to learn of its destruction soon afterward by a fire and a tornado.

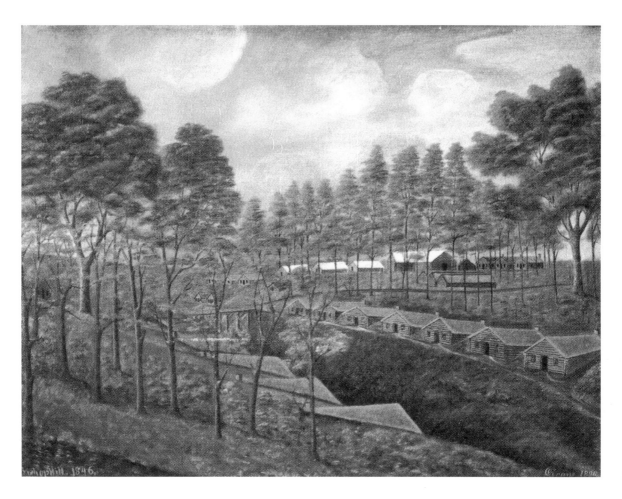

6.15 THE FIRST WINTER
AT BISHOP HILL, 1846–47

In pioneering, the first winter usually posed the most serious challenge. Olof Krans, a folk artist, recalled this scene in Henry County during the winter of 1846–47 in a later painting. Erik Jansson had led four hundred Swedish immigrants to Illinois in an attempt to create an ideal community based on biblical principles as he understood them. The crude makeshift shelters pictured here soon gave rise to a successful new community, but almost one-fourth of the newcomers died during the first winter. Jansson's utopia did not last long, but the town succeeded and Swedish immigrants continued to follow in his footsteps, arriving in the Prairie State by way of the Erie Canal and the Great Lakes. The first Swedish pioneers walked from Chicago to their destination; those who followed were soon able to take the train.

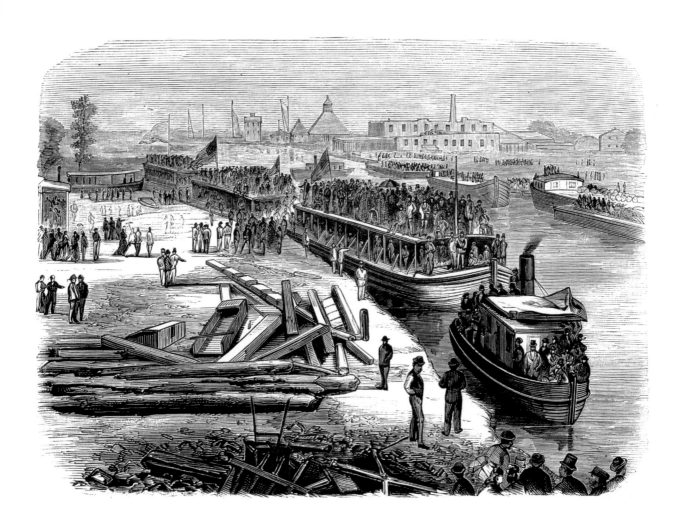

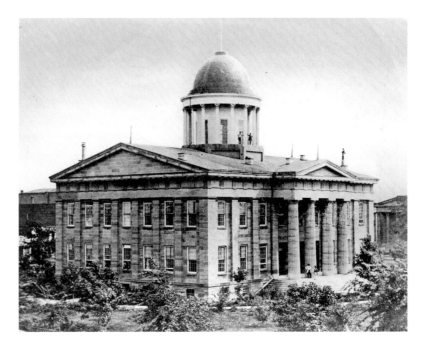

6.16 THE ILLINOIS AND MICHIGAN CANAL

Frank Leslie's Illustrated Newspaper, published in New York, featured this view of the Illinois and Michigan Canal. The waterway opened for business on April 23, 1848, but the illustration did not appear until August 26, 1871. By then the project was a success but had lost passenger traffic to the railroads. This view shows large canal boats, dangerously overloaded, leaving docks along the main stem of the Chicago River. Remnants of Fort Dearborn appear in the background, as they did in 1848 but not 1871. An industrial building just beyond perhaps suggests Cyrus Hall McCormick's new reaper factory, also dated 1848 but not 1871 and in a fanciful location, accuracy not being a strong point in this dramatic presentation. The passengers, pulled by the little steamboat, traveled to Bridgeport, where the canal met the South Branch of the Chicago River. Here, in 1871, they celebrated the deepening of the canal in an attempt to reverse the flow of the river. The attempt, however, was not really successful. Digging a canal deep enough to change the direction of the current had to wait another three decades.

6.17 THE STATE CAPITOL IN SPRINGFIELD

Workmen set the cornerstone for the new state capitol in Springfield on July 4, 1837. The stone for the new edifice came from a quarry only eight miles away. Designed by a local amateur architect, the building, with stately dome and porticos, looked to the future. Indeed, in 1848 the state's voters approved a new, forward-looking constitution that reduced the power of the legislature.

Even with the new document, not everyone was happy with the political situation in Illinois. Leaders in the northern tier of counties, feeling neglected by a government so far away, expressed interest in joining the Wisconsin Territory. The admission of Wisconsin as a state in 1848, however, ratified the northern boundary of Illinois, another signal that the fluid pioneer period of the state's history was reaching its end.

	A HISTORICAL CONTEXT	THE ILLINOIS EXPERIENCE	THE CHICAGO DIMENSION
1850	**1850** Compromise of 1850 and ascent of Stephen A. Douglas to national leadership	**1851** Jonathan Baldwin Turner advocates land grants for higher education	**1852** Michigan Central Railroad connects the city to the East
	1851 Great Exhibition at London		
	1852 *Uncle Tom's Cabin* published	**1853** First state fair, Springfield	
			1854 Cholera epidemic
1855		**1855** Public Education Act: tax support for schools	**1855–57** Streets raised in central city
	1857 *Dred Scott* decision	**1856** First railroad bridge crosses the Mississippi River at Rock Island	
	1857–58 Financial panic	**1857** State normal school founded	
		1858 Lincoln-Douglas debates	
	1859 Darwin's *Origin of Species* published		**1859** First streetcars, pulled by horses
1860	**1860** Lincoln elected president		**1860** City's first national political convention nominates Lincoln
	1861 Fort Sumter; Civil War fighting begins	**1861** Cairo becomes a key Union supply center	
		1862 Voters reject a new constitution	
	1863 Emancipation Proclamation		**1863** City receives a new charter
1865	**1865** Lee surrenders to Grant	**1865** Black Laws repealed	**1865** Union Stockyards established
	1866 Grand Army of the Republic founded in Springfield	**1866** First strip mine	
	1867 National Grange of the Patrons of Husbandry founded	**1867** Illinois Industrial University opens. Ground broken for new capitol in Springfield	
	1868 Grant elected president		**1868** Riverside designed as a model suburb
	1869 Suez Canal completed		**1869** Calumet Harbor improvements start
1870		**1870** Third constitution adopted	
			1871 Great Chicago Fire

Railroads and the Civil War, 1850–71

THE PIONEER period in Illinois ended with the coming of the railroad. At the very same time the nation's great struggle over the expansion of slavery came to dominate the agenda on every political level: national, state, and local. The two major themes, railroads and the future of slavery, were, of course, connected. The rails encouraged the rapid settlement and development of the Great West, and as these regions grew into statehood the balance of power in national government became unsettled. Moreover, railroads ushered in new ways of living based on wider markets, manufacturing, consumer goods, and ideas of progress, all of which seemed to challenge the established social order upon which a slave society and a tradition of national compromise had been erected. There was, however, expectation that railroads would bind the sections together, repeating the pattern of the Mississippi River, which by means of hundreds of steamboats stitched together the economies of northern and southern states in the Great Valley.

At mid-century many Americans sensed the dawn of a new day as steam power began to transform the nation and push established ways into obsolescence. This new era of canals and railroads, of steam engines and iron rails, of consumer goods and expanding commerce, raised searching questions about human bondage and the role of the national government. How should a democracy handle growth, expansion, new technologies, conflict, concerns about human rights, and divergent views of America's future? The questions were asked, and answers formulated, both in theory and in practice, in many states but particularly in Illinois.

The development of commercial capitalism in the 1850s has been overshadowed in the historical record by the great debate on slavery, especially its role in the development of the West. The stream of settlers entering Illinois via the Erie Canal route after 1825 firmly rooted the state in free soil, but many citizens of the Prairie State hardly considered questions about the place of black people in American life. After 1850 the issue of slavery, its expansion and future, came to dominate national politics. Once at the top of the national agenda, it led down a slippery slope into Civil War. Related issues on the place of blacks in a free country would continue to defy resolution over the next century and more.

With the closing of the Mississippi River to commercial traffic during the Civil War, the flow of commerce tilted northward to the Great Lakes. Chicago became the great collecting point. The rails also served as military supply routes throughout the war. The spectacular development of the state, so evident in the expansion of railroads in the 1850s, from 110 to 3,014 miles of track, continued unabated in the 1860s. The war years placed heavy demands on the productive capacity of prairies. The urgencies and exigencies of a national war fit the expansionist mode of the Illinois economy. Newcomers kept coming to its cities and prairies, taking up farms and jobs to fuel the wartime boom.

The story of the Civil War itself highlighted the contributions of the Prairie

State. Both the president and his leading general came from Illinois. U. S. Grant then carried a leadership role into the Reconstruction Era, serving as president between 1869 and 1877. In 1861 John A. Logan, a member of Congress from the Democratic Party, took a commission in the army and led many supporters into full support of the Union cause. After the war he served again in the national legislature, both in the House and three terms in the Senate. Next to Grant, he was the state's leading military hero.

The Illinois economy continued to expand after the war as business interests reconstructed pathways to the South, strengthened connections to the East, and forged new links to the Great West. The completion of the Transcontinental Railroad in 1869 may be cited as the crowning achievement in binding the entire nation within a network of rails. The tracks reaching from San Francisco Bay to New York Harbor ran across the state and met in Chicago, which became the pivot of the whole railroad system.

Railroad traction transformed the city as well as the state and the nation.

Horse-drawn streetcars extended the reach of the old walking city and "accommodation" cars made possible railroad suburbs that aimed to combine the best in urban and rural environments. Railroads and streetcars stretched the conception of a city into a metropolitan region, which began to sort itself into a central city, residential neighborhoods, large regional parks, industrial districts, transportation corridors, and suburbs of every description.

When the Great Chicago Fire destroyed the core of the old walking city in 1871 railroad tracks had extended Chicago's metropolitan reach in all directions, spreading its hinterland throughout the Midwest and linking the city to Atlantic, Pacific, and Gulf ports. That Chicago sprang up from the ashes like the phoenix after the Great Fire of 1871 was not so surprising because the railroad network remained in place.

In the 1850s, and in the 1870s as well, agriculture dominated the economy of Illinois. The big difference was that the state, by the time of the Great Chicago Fire, had filled with farms that benefited

from a remarkable transportation system. Centered on railroads, the setup put almost every field within reach of a market. The maturity of the state's development and its integration into the national economy explained, in large measure, Chicago's remarkable transformation after the Great Fire.

Cyrus McCormick's reapers, John Deere's plows, and a host of similar manufactured goods were key cogs in the drive wheels of agricultural progress. Selective breeding, sorting and cleaning seeds, clay drainage tiles, and the like also played important roles. The gigantic grain elevators that Sturges, Buckingham and Company erected in 1856 at the mouth of the Chicago River symbolized the transformation of the state. Here small shipments of grain arriving by railroad cars, plank-road wagons, and canal packets were graded, mixed, and turned into interchangeable commodities represented by slips of paper that functioned as money. A new day arrived after the Civil War. And it came on the train.

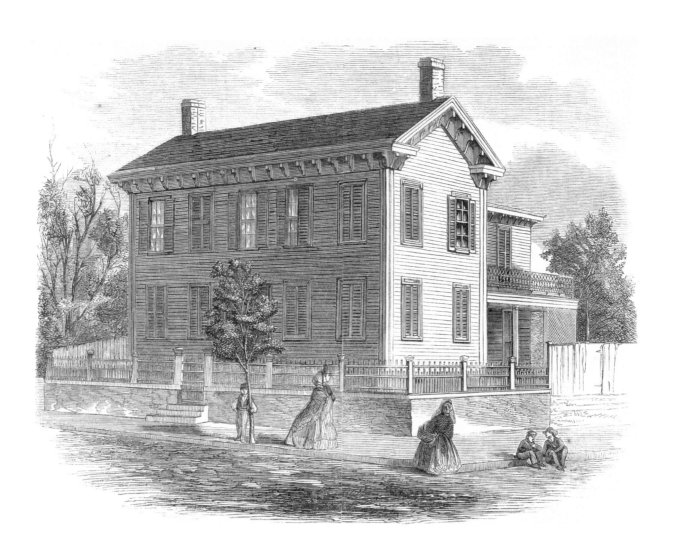

7.1 LINCOLN'S HOME, 1860

Abraham Lincoln came to the forefront of American life in the years following 1856. He embodied the spirit of Illinois, which later identified itself as the Land of Lincoln. Lincoln's home in Springfield, which marked his rise to middle-class status, symbolized not only the character of the man but also the advance of his adopted state to national prominence. This picture, which appeared in *Frank Leslie's Illustrated Newspaper* on November 17, 1860, introduced the nation to the newly elected president.

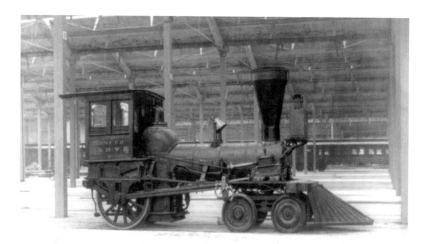

7.2 *THE PIONEER* (*ABOVE*)

The first locomotive to pull a train in Chicago was called the *Pioneer* by its owners, the Galena and Chicago Union Railroad. Purchased from the Rochester and Tonawanda Railroad in New York, the third-hand iron horse arrived on the brig *Buffalo* in 1848. It pulled an initial load of workers and construction materials from the forks of the Chicago River to the end of the tracks near the Des Plaines River. A bridge soon carried the rails across the river and into the heartland of the Upper Mississippi Valley.

7.3 OUTLINE MAP OF ILLINOIS (*LEFT*)

This map in several versions appeared as early as 1855. It was designed to show prospective purchasers of railroad land how the Illinois Central Railroad was part of a statewide transportation network. Its north–south orientation repeated the pattern of the Mississippi and Illinois rivers.

One version appeared in the *Illinois Central Directory* (1869), a guidebook that discussed the advantages of each town on the railroad and listed businesses and local institutions. Advertising made it the yellow pages of its day.

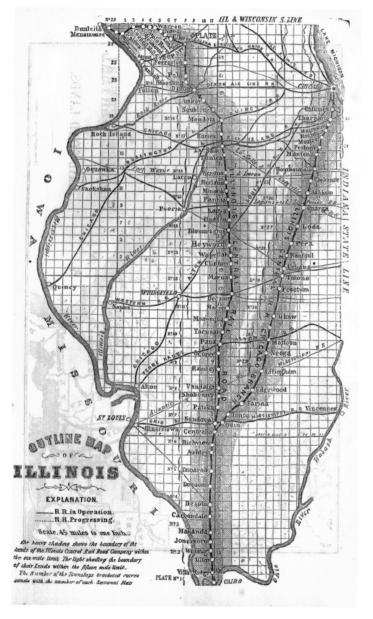

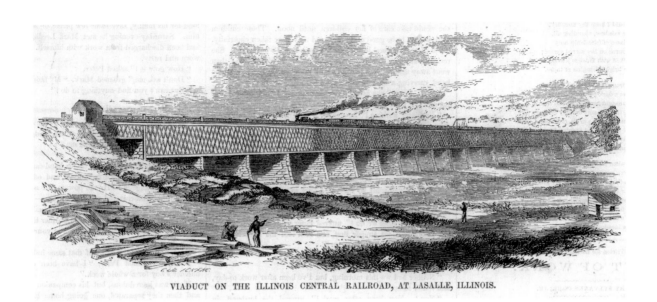

VIADUCT ON THE ILLINOIS CENTRAL RAILROAD, AT LASALLE, ILLINOIS.

7.4 VIADUCT ON THE ILLINOIS CENTRAL RAILROAD, AT LA SALLE

Ballou's Pictorial Drawing-Room Companion, a popular magazine published in Boston, reported that the Illinois Central Railroad had more than seven hundred miles of track in service. "Not many years ago the country . . . was unsettled and uncivilized . . . [with] no traces of the hand of man." But now "the whole country will soon be covered with an iron web-work of railroads." In this picture the bridge and viaduct over the Illinois River at La Salle supported a train headed toward Galena. One span of the bridge could be opened to permit steamboats to pass, but they rarely ventured further up the river than the town of La Salle. Here cargo and passengers usually transferred to canal boats.

The viaduct also carried the IC tracks across the Chicago and Rock Island Railroad and the beginning of the Illinois and Michigan Canal. On the viaduct there was space for both trains and wagon traffic. The timbers along the path in the foreground suggest that additional improvements will come soon with new construction.

The bridge represented progress and the promise of American life. But it also pointed to conflict. Bridges took a long time to construct, and most workers were foreign-born, Irish at this particular time. The concentration of people following a different way of life at construction sites provoked ethnic strife on more than one occasion. When a bridge was completed local folks often celebrated because the construction crew moved on.

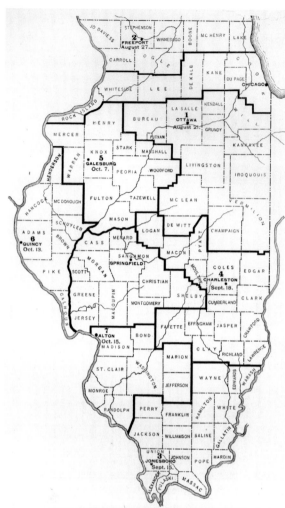

CONGRESSIONAL MAP OF ILLINOIS, 1858
Showing places where the seven debates were held, numbered in order

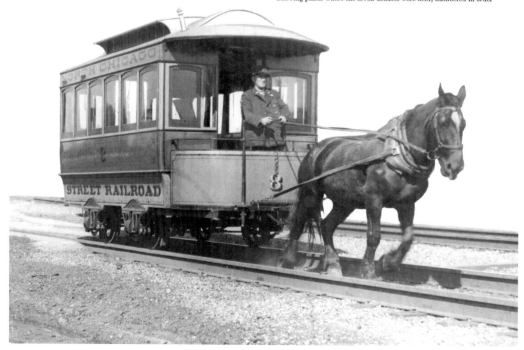

7.5 THE LINCOLN-DOUGLAS DEBATES

In July 1858 at a political rally in Bloomington, Douglas attacked Lincoln, who happened to be in the audience. Many in the crowd called for Lincoln to reply, but after coming to the podium "Honest Abe" declined because Douglas supporters had paid for the arrangements. He did not want to intrude.

The Republican then challenged Douglas to a set of debates. The senator agreed, and formal debates were held in the remaining congressional districts of Illinois between August 21 and October 15. Districts 2 and 6, which centered on Chicago and Springfield, were omitted from the schedule because of hometown affiliations and the fact that both candidates had already spoken in these cities.

In Galesburg, it was a cold, windy day, so the outdoor debate was moved to the sheltered side of a building, now called Old Main, at Knox College. In spite of the weather, the audience may have numbered more than fifteen thousand, a record for the series. The wind combined with Douglas's exhaustion to make it difficult for many to hear the speeches directly. They had to depend on summaries given by runners or later printed versions that newspapers produced from reporters' transcripts. Shorthand, railroads, and the telegraph transformed the Illinois debates into national events overnight.

7.6 THE GENESIS OF THE STREETCAR CITY

The expansion of the city increased the walking time needed to reach Chicago's central business district, but the invention of street railways helped solve the problem. For years, other eastern cities had used horse-drawn streetcars operated by private franchised companies. Chicago's first streetcar appeared on State Street in 1859, using a secondhand vehicle purchased from a New York line.

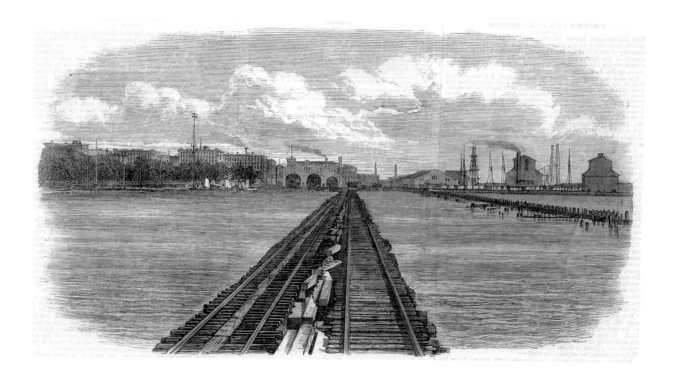

7.7 CHICAGO FROM THE MICHIGAN
CENTRAL RAILWAY, 1863

The Illustrated London News sent reporters and
artists to cover the War between the States and
assess affairs in North America for the British
public. One of its teams reported on Chicago,
arriving via the Michigan Central Railway that
entered the city on the Illinois Central's via-
duct. The visiting artist, impressed by his entry,
sketched the view.

There are huge grain elevators to the right
of the tracks at the mouth of the Chicago River,
tall masts of ships just beyond them, large ter-
minal buildings serving the railroads, and on the
left a dense cluster of large buildings devoted to
industrial, civic, and institutional purposes. The
lagoon between the trestle and the lakeshore
would be filled in eight years later with debris
from the Great Chicago Fire, creating land later
used for parks.

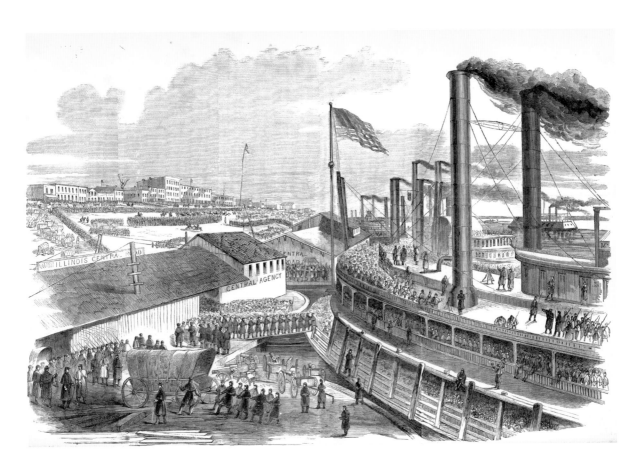

7.8 CAIRO: SUPPLY DEPOT
FOR UNION ARMIES IN THE WEST

This view, from *Harper's Weekly* of February 1, 1862, catches the frenzy of activities that brought the terminal to life. Troops from Gen. John A. McClernand's Brigade are boarding steamboats ready to invade the South. The city also served as a major training base for Union troops, as suggested by the crowded parade grounds in the background. The construction crane adds another substantial structure to the city's business district. Illinois Central warehouses cluster around the river bank, but bales of hay and teams of draft horses, often numbering in the thousands, do not appear in this view.

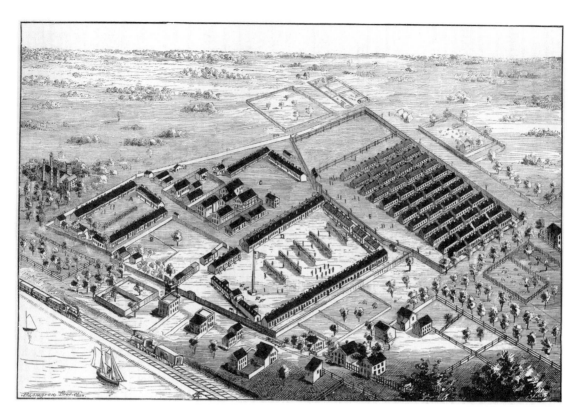

7.9 CAMP DOUGLAS

At first the camp on the outskirts of Chicago was seen as a temporary facility because everyone expected a short war. The prescribed drainage tiles and sewers were therefore not installed, a mistake that would later claim hundreds of lives. After the initial recruits left by train for Cairo, the hastily erected barracks for eight thousand troops and stables for two thousand horses were largely vacant. Then, after the battle of Fort Donelson, more than eight thousand captured Confederate soldiers were sent to the camp.

A few months later, veteran federal troops also arrived. These men were captured by Confederate forces but paroled by way of a prisoner exchange. Calls for more recruits brought severe overcrowding, and the facility spilled out of its original boundaries into the prairie. People were constantly coming and going, but hundreds died as a result of smallpox and the other diseases that ravaged the camp.

7.10 GENERAL GRANT

Ulysses S. Grant resided in Illinois for only a few years. He arrived in Galena in the summer of 1860 to take up an ordinary residence on High Street and work as a clerk in his family's leather store on Main Street. At the time he did not even own a horse. Alighting from the steamer *Itaska* with his wife and four children, one a baby, the thirty-eight-year-old former officer planned to embark on a new career. Grant did possess various gifts. His student paintings at West Point suggest that he could have been a competent artist, and his memoir, completed just before he died of cancer, ranks as a literary classic. At heart, however, he was a soldier.

At the onset of the Civil War, Grant, having experience in command, answered the call to arms. The governor of Illinois recognized these special talents and gave him command of the Twenty-first Illinois Volunteers. In August 1861, he wrote to his wife that he was "very grateful to the people of Illinois for the interest they seem to have taken in me and unasked too. . . . I shall do my very best not to disappoint them." After the war he was elected to the presidency in 1868 and again in 1872. The nation's highest honor, however, did not bring out his skills, common sense, or his essential humanity. He remained in memory the bravest of generals, the man on horseback, an officer from Galena, and a loyal and determined citizen of Illinois.

7.11–7.12 GRANT RETURNING TO GALENA, 1865

This drawing of Grant's homecoming on August 18, 1865, was based on the following photograph, which was taken at the event but not published until the twentieth century when technology made it possible for presses to reproduce photographs. Comparing the two images shows the advantages and limitations of each format.

The organizing committee estimated the throng at twenty-five thousand, but reporters from Chicago thought the figure was fewer than half that number. The artist also inflated the number of people compared to those in the photograph. He even placed a crowd on top of the arch, which in the photograph is occupied by thirty-six young women in white robes. Their function was to rain flowers onto the general as his entourage reached the DeSoto House, where a formal ball would be staged in the evening.

The artist also straightened the flags, added a dramatic sky, and simplified and tidied the cityscape. In doing so he made the engraving more legible than the photograph, clearly spelling out the series of Grant's victories in the Civil War as they appeared on the supporting arches.

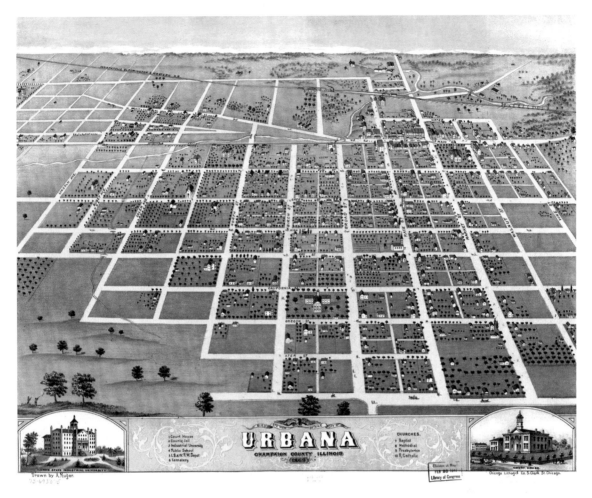

7.13 BIRD'S-EYE VIEW
OF THE CITY OF URBANA

Albert Ruger produced this view of Urbana, as well as a companion piece for its sister city of Champaign, in 1869. He caught both towns at the beginning of a growth spurt as the surrounding countryside developed into one of the state's most productive agricultural regions. The cluster of buildings along Main Street marks the business district. The Court House, at the lower right, occupies an adjacent square, but both the railroad station and the imposing hall for the Illinois State Industrial University (lower left) are on the outskirts of town. The school, renamed the University of Illinois, expanded over the years to take up all the area between Urbana and Champaign.

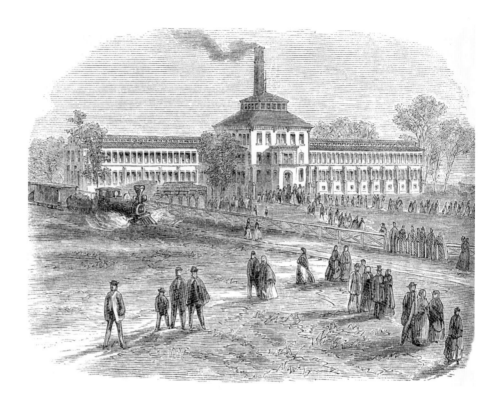

7.14 THE NATIONAL WATCH COMPANY
FACTORY, ELGIN, 1869

The developing transportation network in Illinois created an opportunity to construct a new watch factory, probably in Chicago. The site selected for the factory, however, was in the nearby town of Elgin on a waterpower location along the Fox River. Chicago, with its sluggish river, did not have manufacturing facilities powered by water; its factories used steam power. The older established waterpower sites, however, were thought to have a more skilled work force, and the need for machinists, along with several other inducements, led the watchmakers to Elgin.

When it set up a temporary factory to construct the machines needed to make watch parts, the company used waterpower. The new and larger factory, however, would be powered by steam, although it was also located close to the river should water power be desired in the future. This imposing new factory featured a tall chimney to service the huge boilers that generated steam for the engines. Compare the Elgin works to later factories pictured in figures 8.4, 8.5, and 10.10.

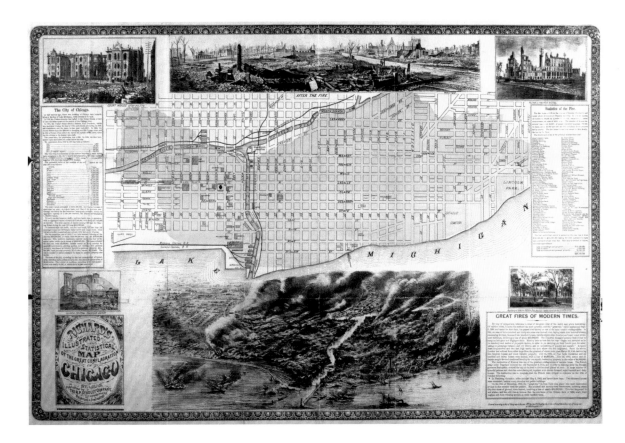

7.15 THE CHICAGO FIRE, OCTOBER 9–10, 1871

From start to finish the Great Fire lasted about thirty-six hours. It destroyed the historic core of the city, the entire central business district, most port facilities and railroad stations, and the homes of a hundred thousand people, a third of Chicago's residents. As Joseph Medill, the editor of the *Chicago Tribune* wrote the next day, however, "All is not lost. Though four hundred million dollars worth of property has been destroyed, Chicago still exists. The lake, the spacious harbor, the vast empire of production, the great arteries of trade and commerce all remain." It is also the case that Illinois, along with the other midwestern states, fitted together into an economic unit. The inland empire not only remained in place but also sprang up to quickly repair the damage to one of its key centers.

	A HISTORICAL CONTEXT	THE ILLINOIS EXPERIENCE	THE CHICAGO DIMENSION
1865			
1870	**1869** Transcontinental Railroad completed	**1870** Population: 2,539,891 **1870–73** Granger Laws **1872** Public Library Law Township High School Law	**1870** City has 19 percent of state's residents **1871** Great Chicago Fire **1872** Montgomery Ward and Company founded
1875	**1873** Financial panic leads to a depression in U.S. **1874** Early exhibition of Impressionist paintings **1876** Alexander Graham Bell patents the telephone **1877** America's "Year of Violence"	**1874** In De Kalb, Joseph Glidden receives a patent for barbed wire Lincoln's Tomb dedicated in Springfield	**1874** A second great fire south of downtown **1877** Great railroad strike
1880	**1882** First hydroelectric plant **1883** Railroads adopt standard time in Chicago meeting	**1880** Population: 3,077,871; ca. 29 percent in the Chicago area **1880–90** More than two thousand miles of railroad track added throughout the state	**1880** Chicago passes St. Louis to become nation's fourth-largest city **1882** Cable car system starts
1885		**1885** First bridge over the lower Ohio River at Cairo Illinois Industrial University becomes the University of Illinois The Illinois civil rights act is one of the nation's first	**1885** Home Insurance Building pioneers skyscraper construction **1886** Haymarket Affair **1889** Frank Lloyd Wright starts to design area buildings Jane Addams and Ellen Gates Starr found Hull-House Great Annexation
1890	**1888** Emancipation of slaves in Brazil **1893–97** Economic depression in U.S.	**1891** Women given right to vote in school board elections	**1890** Population more than a million; nation's second city **1893** World's Columbian Exposition
1895	**1896** William Jennings Bryan's "Cross of Gold" speech in Chicago **1898** Spanish-American War Annexation of Hawaii	**1894** John Peter Altgeld elected, first foreign-born governor **1898** "Mine Wars" at Virden and Pana lead to victory for the United Mine Workers	**1894** Pullman Strike **1896** Municipal Voters League founded to spearhead reform
1900		**1900** Sanitary and Ship Canal completed	**1900** Immigrants from Europe raise city's population by six hundred thousand during the past decade

EIGHT

The Industrial Surge, 1870–1900

IN 1870 the census recorded that Illinois had a population of more than 2.5 million. Thirty years later the number reached 4.8 million. The pertinent fact about this surge, however, is that the majority of the increase, exceeding 1.4 million, occurred in one city: Chicago. The bulk of the other additions were in smaller cities, from Rockford to Cairo and from Danville to Quincy. What made these cities grow in such dramatic fashion? There were many factors, but all were rooted in the industrialization of society.

Each of the ingredients in the Industrial Revolution supported the others: the expanding use of machines, the use of coal to harness the full potential of steam power, the development of production techniques that required large facilities and an army of workers, the use of railroads to assemble raw materials and distribute finished products, the development of mass markets and a consumer society, and the accumulation of large amounts of capital to pay for every-

thing. These factors, working in concert after the Civil War, remade America in a generation.

Illinois could transform itself into an industrial state in three decades because it was blessed with productive farm land, a central location, plenty of coal, the ability to attract people, and a full measure of good fortune. Mark Twain said it best. In 1874, observing how the city sprang up like magic after the Great Chicago Fire, he observed, "They are always rubbing the lamp, and fetching up the genii, and contriving and achieving new impossibilities."

The city and the state, of course, simply participated in the great transition in the national and the world economy during these years, but they were such newcomers that the recasting of their landscapes, their ways of life, and the very mindset of their people exhibited a stark quality. The raw newness of industrial Illinois, showcased in Chicago, engendered a sense of awe.

Chicago spelled out what the future would be like. Industrialization seemed to telescope history on the shores of Lake Michigan. There, where the Great Lakes met the prairie, a stage set appeared for the city to come. Painted white, it demonstrated how electricity could light the night. Humanity was astounded at the World's Columbian Exposition in 1893. Some thoughtful tourists considered the city itself to be the prime exhibit, and many were horrified at the human cost extracted by the emergence of this new industrial world.

The 1890s, one historian observed, was the first decade of modern times. Commentators then and ever since have pointed to the fecundity of the central city's hinterland, how steel rails funneled the produce of the mid-continent into Chicago and sent trains back loaded with manufactured goods made in Chicago or brought to its warehouses from places around the world. Money made it happen in the capitalist economy, and the quest for increased profits pushed changes at a dizzying speed.

The general outlines of how Illinois became an industrial state are clear and straightforward, but when one looks closely, zeroing in on the details, lis-

tening to the stories of individuals, it becomes evident that development was quite uneven, that experiences varied, that reactions were mixed, and that losses accompanied gains no matter how things were measured, a fact acknowledged by industry's advocates as well as its critics. The business cycle swung back and forth, booms were panicked into busts time and time again, but the economic swings came at shifting tempos no one fully mastered. That made adjustment to the big changes difficult. Indeed, the responses to industrialism were so varied that a simple, coherent narrative would not be truthful.

Large corporations, labor unions, farmers' efforts at joint action such as the Granger movement, political machines and their bosses, anarchists and reformers, settlement houses and melting-pot imagery, harvest wagons and bicycles, main street shopping and mail-order catalogs, silver coins and the gold standard, barbed wire and refrigerator cars, streetcars and harvesting machines, skyscrapers and grain elevators, even baseballs and dime novels—all of these

had parts in the pageant of industrialization. You put them together by looking for connecting threads: new machines, new material, new sources of energy, new patterns of organization, and underneath it all, new ways of thought.

Accommodating the new was difficult because it displaced long-held habits and created needless suffering. The people of Illinois started with a new constitution in 1870 and women received the suffrage in school elections twenty-one years later, but neither innovation in politics came close to the ideas architects employed to break precedents and erect modern structures.

James B. Eads seized a new material, alloy steel, and spanned the Mississippi with a simple yet immense structure to shuttle trains between Illinois and Missouri. Dedicated in 1874, it was the world's largest bridge. Louis Sullivan, an architect newly arrived in Chicago, viewed the Eads Bridge and immediately got the idea: form follows function. Another bridge builder, William Le Baron Jenney, suggested that bridges could be stood on end and curtain walls hung

around them to fashion skyscraper cities. He demonstrated how to do it on La Salle Street in Chicago. Not so fast, a young apprentice thought, houses in Illinois should follow the prairie rather than reach for the sky. Frank Lloyd Wright then started remodeling his adopted hometown, Oak Park, one of Chicago's new suburbs, in a style called the Prairie School.

Some of the changes to Illinois as it entered the industrial age were often counted as pure gains. Take wetlands, for example. The outwash plains and old lakebeds of the glacial epoch were notorious for poor drainage. The federal government could not sell these damp areas. Therefore, in 1850 the United States turned most of the wetlands already surveyed over to the various states. Illinois received more than a million and a half acres. It did not know what to do with the questionable gift, so it turned the land over to counties with instructions to sell the parcels at no less than ten cents per acre and use the proceeds to solve the drainage problem.

Progress in utilizing this land was slow, hence a series of legal changes were implemented to stimulate progress. Four wet years, 1875–78, destroyed many plantings and put farmers in a mood for improvements. The real breakthrough came in 1878 when an amendment to the Illinois Constitution led to the Drainage District Act. These new units of local government could henceforth tax landowners to set up large-scale drainage systems. Local tile factories sprang up near wetlands, supplying material needed to turn soggy prairies into productive fields. By 1900 usable farmland in Illinois increased by almost 20 percent as the drainage districts did their work.

Drainage improvements also benefited cities and towns, especially Chicago, which lifted itself out of its wetlands by raising the level of the streets, bringing in fill, and laying sewers to take away rainwater. Public health became a major concern during these decades, and large-scale engineering projects addressed sanitary concerns. In 1892 Chicago started digging a new canal to meet both sanitary and shipping needs,

an immense undertaking that was immediately recognized as one of the engineering wonders of the world. It required moving more earth than the Panama Canal, which soon benefited from the digging experience gained in Chicago.

When the Chicago Sanitary and Ship Canal was started, the city's annual death rate from typhoid fever was sixty-five fatalities for every hundred thousand residents. After the entire project was completed, the comparable rate dropped to only one death. In the process the flow of the Chicago River was reversed. The stream became a tributary of the Illinois and Mississippi rivers, sending Chicago's rainwater to the Gulf of Mexico. Relieved of polluting discharge from the river, the city's lakefront could become one of its crown jewels.

If developments on the drainage front pointed in the direction of progress and expanded governmental powers were keys to promoting the general welfare, could the state government be used to regulate other aspects of life in similar ways for the general welfare? When the state legislature in the 1870s enacted a series of laws to regulate railroads, warehouses, and grain elevators, vested interests took the issue to the U.S. Supreme Court. The decisive ruling came in 1877, *Munn v. Illinois* upholding the state's regulatory power.

The same timeframe went down in history as the "Year of Violence," when striking railroad workers across the nation clashed with strikebreakers. Labor unions struggled for public support as they used strikes to force employers to pay adequate wages and provide safe working conditions. In 1886, a peak year for the number of workers on strike, national attention focused on Illinois when a bomb exploded among police dispersing a protest meeting. This so-called Haymarket Riot was blamed on anarchists, and seven leaders were eventually given death sentences. Public protests were to no avail, and four were executed. In 1893, however, Gov. John Peter Altgeld pardoned the other three, pointing to the lack of evidence presented at the trial. The three men seemed to melt back into the working class, but attention to the plight of workers surfaced once again, in

1894, during the Pullman Strike in Chicago. The large size and nationwide reach of the Pullman Company quickly turned a local protest into a national disruption. Federal troops were dispatched to Illinois to reestablish order.

Illinois coal mines adopted larger machinery, expanded in size, and increased the number of workers employed. Disasters became a regular feature in the mining industry, and modern machinery seemingly did little to improve conditions. As coal production in Illinois doubled in the 1890s, and as the mines shifted southward in the state to the richer, deeper veins, the industry witnessed rapid changes. Not the least of these was the growing strength of and public support for the United Mine Workers Union. Their victory in a contest with the Chicago-Virden Coal Company in 1898 seemed to finally bring some balance to the dispute. But the disasters and the violence continued.

Thus, at the turn of the century, Illinois was the third most populous state and housed what has been termed the nation's second city. It was a prime exhibition of the costs and promises of an industrial society. It was a place full of energy and innovation on one hand, of violence and struggle on the other. It still spoke with the voice of agriculture. Chicago's leading attractions were the stockyards and the Board of Trade. Grain elevators marked villages and towns across the state. And in 1896 one of the state's native voices, William Jennings Bryan, reduced the emergence of modern life to a simple proposition as he addressed the Democratic Party meeting in Chicago: "The great cities rest upon our broad and fertile prairies. Burn down your cities and leave our farms, and your cities will spring up again as if by magic, but destroy our farms and the grass will grow in the streets of every city in the country." The Illinois experience in the decades following the Chicago Fire seemed to have proven his case.

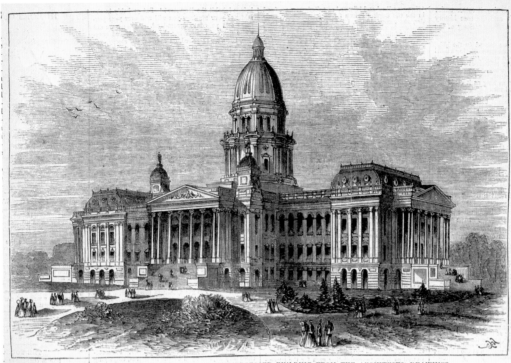

THE ILLINOIS STATE HOUSE—VIEW OF THE PROPOSED BUILDING FROM THE ARCHITECTS' DRAWINGS.

8.1 CONSTRUCTING A NEW STATEHOUSE, 1867–87

After the Civil War it was obvious that Illinois needed a new statehouse. The old one (fig. 6.17), built for another era, proved to be much too small. The city of Springfield, anxious to remain the capital, made the state an offer it could not refuse. The city would purchase the old capitol for city and county use, purchase land for a new statehouse and donate the parcel to the state, and allow the state to use the current capitol until the new one was completed, rent free.

In 1867 the state accepted Springfield's offer, appointed a building commission, and issued invitations to newspapers in Springfield, Chicago, New York, and Philadelphia for architects to submit plans. A Chicago firm won the bid, and the proposal received national attention as a leading example of "the highly commendable spirit of fine and massive public buildings." On August 24, 1867, *Harper's Weekly* supplied readers with this picture of the proposed edifice.

Masons laid the eight-foot-long cornerstone in October 1868, but it cracked two years later, leading to a legislative inquiry. The new state constitution in 1870 put a limit on the funds that could be expended on a capitol, and Chicago and other cities invited the state to move its operations to their business districts. Both houses of the legislature planned to move to Chicago to complete their 1871 session, but the Great Chicago Fire kept them in Springfield. Finally, in 1875 the state started occupation of the new building in Springfield. The monumental structure would not see completion until 1887, however, when the capitol was finally opened to the public.

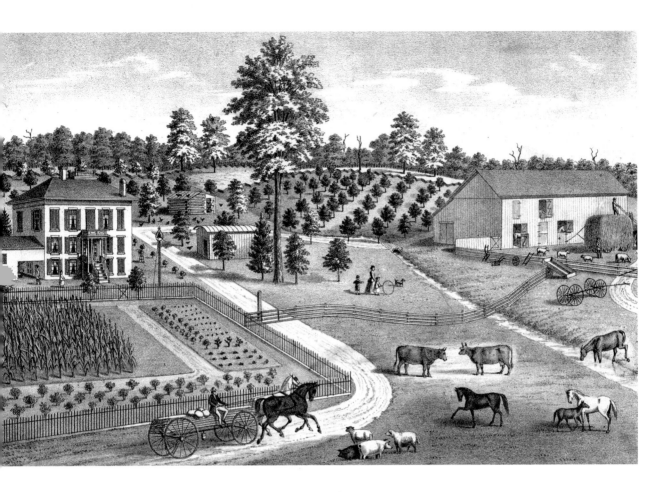

8.2 A FARMSTEAD IN OGLE COUNTY, 1872

This lithograph, as well as the next two illustrations, appeared in *The New Combination Atlas of Ogle County, Illinois*. The artist presents the Hoffhine family farm as a model of progress and good order. All of the crops are flourishing, row after row. The fruit trees in the orchard are of uniform size and shape. The farm animals stand in profile to reveal the excellence of their breeding. The children at play in the yard seem ready to turn and race to the gate to greet their father, returning home after purchasing lumber to expand one of his barns.

The small log cabin in the background is a reminder of pioneer beginnings and contrasts with the large, stately homestead that faces the garden. The largest building is the barn which, given the size of the hay load in the view, will need to be expanded to store the bountiful harvest. Although there are elements of self-sufficiency in the view, it seems obvious that this farm is part of a market economy and enjoys benefits from an expanding industrial society.

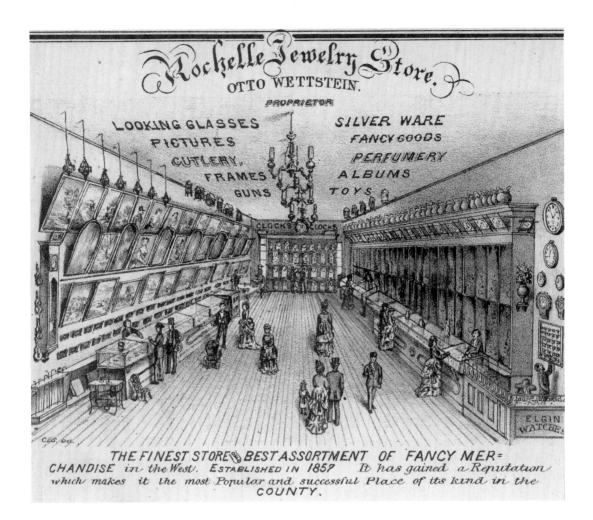

8.3 ROCHELLE JEWELRY STORE, 1872

Otto Wettstein's jewelry store in Rochelle, Illinois, was a place of splendor where every member of the family could find some type of luxury goods manufactured far away but readily available, at a price, in rural Ogle County. The opulent emporium is loaded with oil paintings, fancy lighting fixtures, gilded picture frames, clocks, guns, and toys. The store offered the "best assortment of fancy merchandise in the West." Although there was an illusion of fine, individual craftsmanship in the artistic items offered for sale, everyone knew that such wares were mostly factory products, such as the Elgin watches advertised at front right. The Elgin Watch Factory is pictured in figure 7.14.

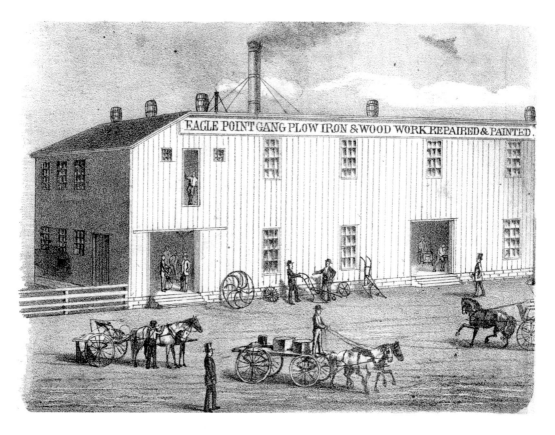

EAGLE POINT GANG PLOW IRON & WOOD WORK REPAIRED & PAINTED.

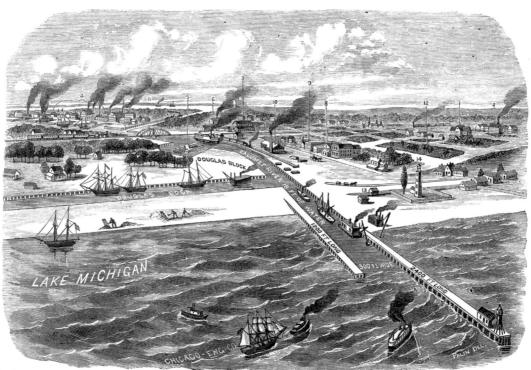

DOUGLAS BLOCK

DOUGLAS DOCK

LAKE MICHIGAN

CALUMET RIVER & SLIP WATER

1200 FT. LONG

300 FT. WIDE

2400 FT. LONG

CHICAGO ENG. CO.

PALIN DEL.

8.4 THE PLOW MANUFACTORY OF NAAMAN SPENCER, 1872

This small factory was located in Eagle Point Township in Ogle County. Although the artist has pictured a busy scene, the days of such a small-scale manufacturing firm were limited by 1872. There is not a railroad in sight, but plows at a better price due to mass production would become available as soon as one would come nearby. Then the repair and painting side of Spencer's business would be forced to carry the whole load to support the enterprise. Why would farmers in 1872 want to keep plows in a good coat of paint? Perhaps pride of ownership would supply part of the answer.

In his day, however, Naaman Spencer's plows gained a wide reputation for their excellent design and workmanship. He received credit for a number of improvements that made gangplows more efficient, enabling farmers to turn several furrows at one time.

The barrels on the roof may have been an early type of fire extinguisher system, another example of Spencer's ingenuity, but he needed a more suitable location for the factory of the future, such as the Caterpillar plant (fig. 10.10).

8.5 SOUTH CHICAGO HARBOR, 1873

The mouth of the Calumet River became a hub of industrial Chicago in the decades after 1869 when federal funds became available to improve and maintain the harbor. Cargo ships used the facilities as early as 1871. Two years later this view included a woolen mill, a machine manufacturing company, two cotton mills, a sawmill, and several blast furnaces and rolling mills. Soon steel mills would grab every inch of available space.

Plentiful fresh water, a convenient harbor, superb rail connections, and the ready availability of Lake Superior ore, Illinois coal, and local limestone combined to make the Calumet region one of the world's great centers of heavy industry by the early twentieth century. The promise of an industrial state is fully evident in this early portrayal. But globalization would change the picture at this site. Obsolete buildings would be razed and part of the lake filled in to create new uses for the land, such as the golf course pictured in figure 12.2.

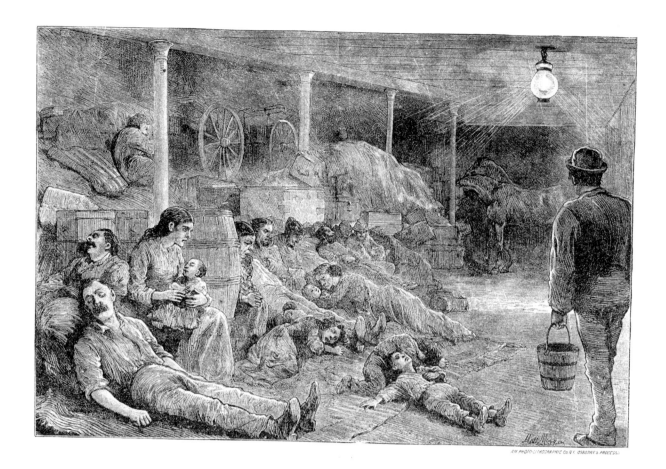

8.6 STEAMBOATS AND CHOLERA

Studies of the cholera epidemic of 1873 in Illinois confirm that one major source spreading the disease was the close quarters occupied by steamboat passengers. Such vessels were no longer widely patronized by the middle class, but the poor continued to use the cheap fares of "deck passage" to reach river port destinations. The artist for this government report showed what these conditions were like. In Chicago alone 116 people died from this cholera outbreak, the last major appearance in the city as public health measures were put into place and sanitary concerns taken to heart. Digging the Chicago Sanitary and Ship Canal (fig. 8.20) became a centerpiece of these reform efforts.

8.7 "A REVOLUTION AT WORK": THE FARMERS OF ILLINOIS AND RAILROAD MONOPOLIES

This dramatic scene, sketched by R. W. Wallis, appeared in *The Land Owner,* a Chicago real estate journal, in April 1873. It pictured the rise of the protest movement on the Illinois prairie that pointed to the high shipping fees charged by railroads as the root of the agricultural depression. An accompanying article quoted an Iowa newspaper: "It costs the farmer two loads of potatoes to buy a pair of winter boots. . . . His wife wears five acres of wheat, and the children each ten acres of corn. . . . The profit which a farmer should realize goes to the railroad corporations for carrying his crops to market."

The Chicago reporter pointed out that "these men are organizing secret societies to crush the vile political thieves who make bad laws, and give the monopolists control of the country. There is coming a day of reckoning." On the next page another article, discussing a protest petition of the McLean County Board of Supervisors, uses for its title a question the Rev. Henry Ward Beecher had raised in a recent Chicago speech: "Is it a question of reformation or revolution?" The artist seems to have put the issue into his portrayal of a bridge and train in ruins at the left while children file into a school at the right. The speaker points to revolution, encouraged by a woman's flag-waving gesture. Meanwhile, the men, rifle and ax at the ready, consider what to do. Other children, out of school, look in wonder at the violence across the fence while their parents ponder the future.

A similar scene, in the city, thirteen years later, appears in figure 8.15.

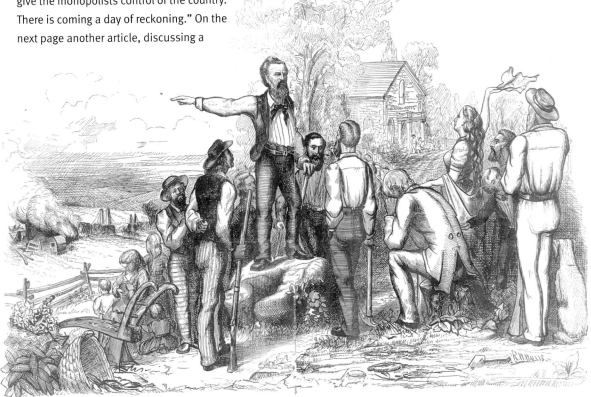

8.8 A GRAIN FARM SOUTH OF HIGHLAND, 1873

Oliver Hoyt paid for a full-page pictorial map in the *Illustrated Encyclopedia and Atlas Map of Madison County, Illinois,* published in St. Louis in 1873. His land enjoyed the same general location on the upland prairie as the pioneer farm Karl Bodmer sketched in 1833 (fig. 6.10). Only a portion of the Hoyt operation is pictured. Extensive wheat fields appear at the bottom of the bird's-eye view along with a sectional map to indicate the operation's true extent and exact location. The homestead was located in a parklike setting back from the road. This was obviously a commercial farm supplying wheat, dairy products, and livestock to markets in the nearby city.

Starting in 1836, Hoyt was one of the first pioneers in Madison County to break the sod of the upland prairie and turn his holdings into acres of grain rather than using the grassland for pastures and hay fields. Over the years he supported agricultural experimentation and scientific farming. This image, at the end of his life, proclaimed his success.

8.9 THE EADS BRIDGE, ST. LOUIS

The city of East St. Louis, founded just before the Civil War, was a product of the railroads. St. Louis, across the river, was the great port for the Middle Mississippi region, but until 1874 locomotives from the East had no way to cross the great river and reach the metropolis. They stacked their cars on the riverbank in East St. Louis. In 1868, however, interests in St. Louis started building a bridge to carry trains, and wagons as well, from Illinois into Missouri. They wanted a high bridge that would not interfere with steamboat traffic. Compare the early railroad bridge pictured in figure 7.4.

James B. Eads, a local expert on the river, designed a simple but enormous structure. Using pneumatic caissons for the first time in the

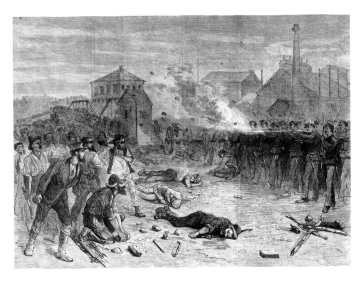

8.10 VIOLENCE AT THE
HALSTED STREET VIADUCT

United States, workers excavated through the deep Mississippi mud to place two masonry piers and two abutments on the bedrock below. Eads then used high-quality alloy steel to span the spaces between them with a two-level bridge deck, one for trains and one for wagons. The use of steel for building the great structure, which opened in 1874, set a precedent that would be pushed to full advantage a decade later in Chicago. Meanwhile, the cluster of steamboats in the view emphasizes the continuing importance of river traffic in the nation's economy in 1874. The future, however, belonged to the iron horses crossing the bridge and the steel trusses that supported them.

The great railroad strikes of 1877 started in eastern states along the Baltimore and Ohio Railway and soon spread to many other lines and cities, flaring up with the most severity in Pittsburgh. A major confrontation in Chicago at the Halsted Street Viaduct made national news. This sketch appeared in *Harper's Weekly* on August 18, 1877. Military forces were called to clear strikers out of the way.

The workingmen's Viaduct Hotel by the bridge seems sad and forlorn as it witnesses society's vengeance directed against the strikers. Smoke rises from gun barrels, not from the chimneys of the huge factories and mills standing silent in the background. Protest movements were part and parcel of Illinois history (e.g., figs. 8.7 and 8.15).

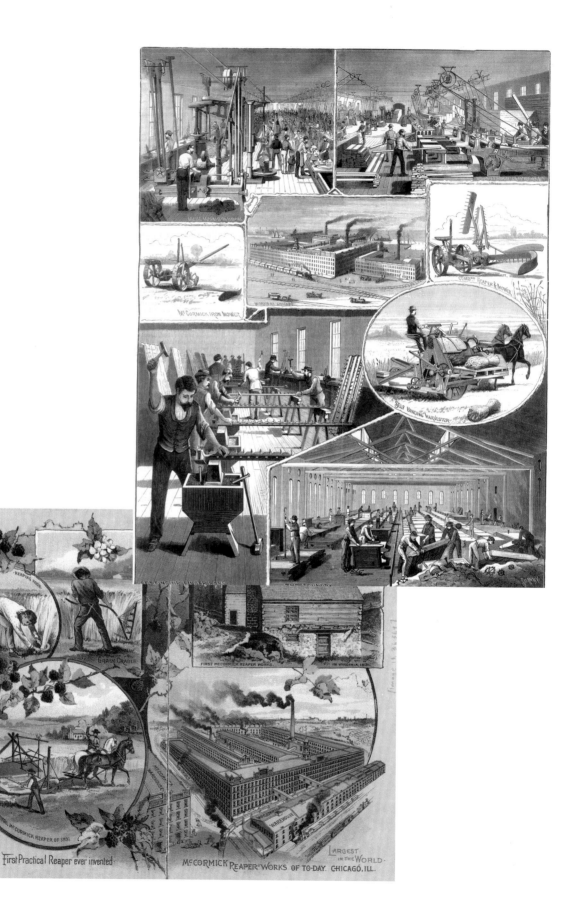

First Practical Reaper ever invented

McCORMICK REAPER WORKS OF TO-DAY. CHICAGO, ILL.

LARGEST IN THE WORLD.

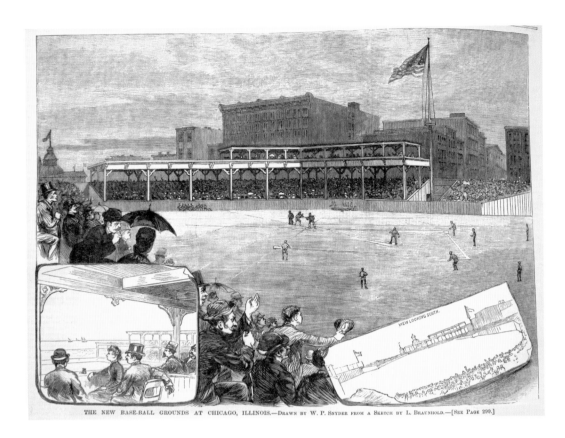

THE NEW BASE-BALL GROUNDS AT CHICAGO, ILLINOIS.—DRAWN BY W. P. SNYDER FROM A SKETCH BY L. BRAUNHOLD.—[SEE PAGE 299.]

8.11 THE MCCORMICK HARVESTING MACHINE COMPANY, CHICAGO, 1881 AND 1886 (*LEFT*)

The *Scientific American* for May 14, 1881, devoted its entire cover page to scenes of the McCormick Harvesting Machine Company in Chicago. The 1886 advertising card illustrates the development of harvesting technology and the McCormick Reaper Works factory, "Largest in the world." Cyrus Hall McCormick moved his factory from Virginia to the midwestern city in 1847. After it was destroyed in the Chicago Fire, he erected the large modern facility pictured here along the South Branch of the Chicago River. McCormick died in 1884, and soon the firm faced the protests of workers seeking an eight-hour day. A strike in 1886 was associated with the explosion in Haymarket Square (fig. 8.15), which became a landmark in labor history.

8.12 THE NEW BASEBALL GROUNDS AT CHICAGO, 1883 (*ABOVE*)

The first major professional baseball grounds in Chicago dated from 1871, but the field later moved to the site of today's Millennium Park. After winning three National League pennants in a row, the Chicago White Stockings replaced it with a new baseball grounds in 1883. *Harper's Weekly*, which supplied this drawing, hailed the park as "the finest in the world," complete with eighteen private boxes as pictured at the lower left. Organized sports played increasing roles in society as the Industrial Revolution gradually freed time for individuals to participate and attend events. Professional sports became significant elements in civic pride. See figure 11.6 for a portrayal of Wrigley Field as part of symbolic Chicago in the 1960s.

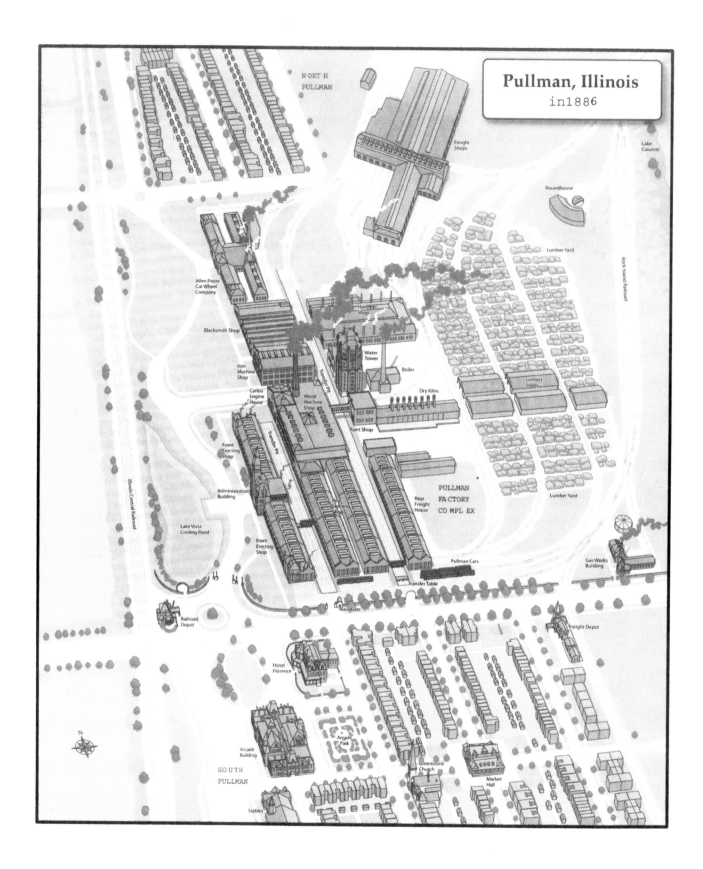

Pullman, Illinois
in1886

8.13 PULLMAN: A PLANNED INDUSTRIAL COMMUNITY, 1885

Pullman occupied a strip of land between the Illinois Central Railroad tracks and Lake Calumet, which was part of the South Chicago Harbor complex. An internal railroad would shuffle material between factories while the finished products, railroad cars, would leave the factory complex via several sets of tracks.

The artist's sketch shows the parklike setting for the main car works and the communities for housing workers in North and South Pullman. Several "towers" defined the Pullman skyline: the clock tower of the Administration Building, the huge chimneys for the furnaces, and an elaborate water tower. A huge Corliss engine, recycled from the Centennial Exposition in Philadelphia, supplied power.

The Illinois Central Railroad tracks, on the left-hand side of the view, trace a right-of-way dating back to the 1850s. See the map in figure 7.3 and two terminals for the line in figures 7.7 and 7.8.

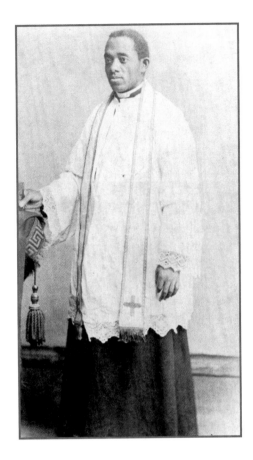

8.14 FR. AUGUSTINE TOLTON

Augustine Tolton was born a slave in Ralls County, Missouri, in 1854. With the outbreak of the Civil War his mother escaped with three of her children to Quincy, Illinois. After attending Catholic schools and receiving private instruction at Quincy College, the gifted student studied for the priesthood in Rome. Ordained at St. John Lateran in 1886, he returned home to pastor a recently founded parish for black people in Quincy. He came to Chicago in 1889, and shortly thereafter a wealthy woman funded a similar parish in Chicago. Father Tolton became its founding priest, serving at St. Monica's on South Dearborn Street until his death in 1897. His tomb in Quincy notes that he was the first black Catholic priest in the United States, underscoring the significance of the church in the Illinois experience (e.g., fig. 5.3).

8.15 "THE ANARCHIST RIOT IN CHICAGO," 1886

The credits for this illustration from *Harper's Weekly* of May 15, 1886, indicate that the wood engraver in New York followed both sketches and photographs supplied by journalists in Chicago. These were not, however, eyewitness accounts no matter how vivid the final picture might seem. Everything was pushed together in time and space so the fiery speech, blinding explosion of the bomb, and police firing weapons all seem to occur simultaneously. Another firing gun is even placed in the hand of a man on the workers' side of the field.

Photographs made it possible to record the buildings in the background with some accuracy. They were warehouses used for wholesaling in Chicago's Westside market area, known as the Haymarket. This was the same neighborhood to which Jane Addams and Ellen Gates Starr came in 1889 to set up a settlement house that would address the needs of working-class families in the vicinity (fig. 9.17).

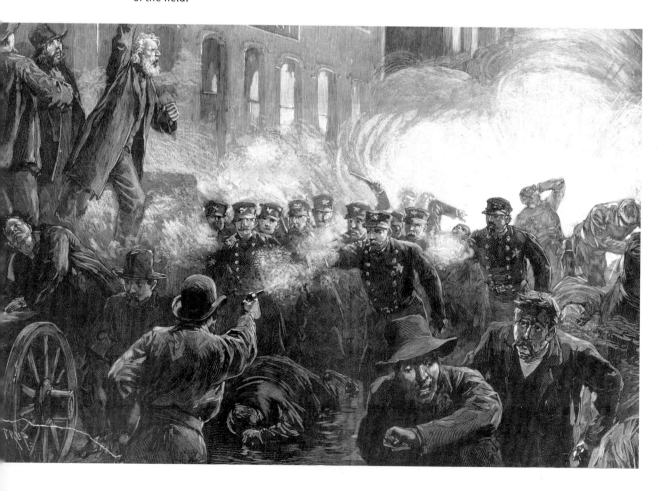

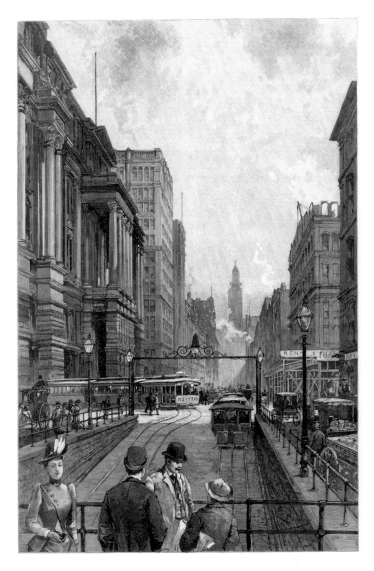

8.16 LA SALLE STREET, CHICAGO, 1890

Charles Graham, a noted journalist and artist, drew this scene to give readers of *Harper's Weekly* "a good idea of the solidity and business of the central portion of Chicago." He elaborated on the wonders of the architecture and the many functions served by the buildings, but he was most impressed by the roof-top restaurant on the thirteen-story structure at the left-hand side of the street. At the time it was the highest commercial building in the nation. La Salle Street south to the Board of Trade housed "some of the finest office buildings in the world."

Cable-car trains, usually three or four cars long, dominated the city's transportation system at the time. Indeed, the efficient operation of Chicago's extensive cable car lines encouraged voters in outlying townships to vote for annexation to the city in 1889, tripling Chicago's area and bringing in enough suburbanites to push its total population past that of Philadelphia. Cable cars helped make Chicago's reputation as the nation's second city.

The city's public transportation had come a long way in the years since the purchase of a second-hand horse-car in 1859 (fig. 7.6).

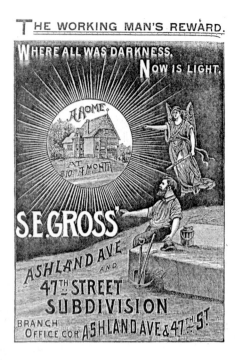

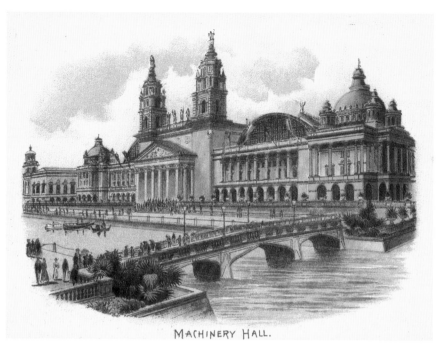

MACHINERY HALL.

8.17 THE WORKER'S REWARD: A HOME FOR $100, 1891

Samuel E. Gross applied the lessons of industrialization to building houses and developing communities. Recognizing the value of planning, large-scale operations, advertising, and mass-production techniques, Gross pioneered the single-developer approach to new subdivisions. He purchased tracts of land, divided them into lots with a cookie-cutter, offered a few basic floor plans for moderately priced models, and financed a packaged deal of so much down and so much a month for a period of years.

As this 1891 catalog of his extensive offerings put it, a worker could receive a home after saving $100 for the down payment. The monthly payments of $9 to $11 would then be the same as rent. Where working people formerly faced only darkness, now there was light. The angel, herald of the good news, carries the sword of justice similar to the sword carried by the son in the cartouche in figure 6.1.

8.18–8.19 THE WORLD'S COLUMBIAN EXPOSITION

Although the focus of the world's fair held in Chicago was to be the four-hundreth anniversary of Columbus's voyage of discovery, plans for the exhibition became so ambitious that it took an extra year to get things ready. The memory of the "Admiral of the Ocean Sea" was indeed honored, but a host of architects and artists created the "Great White City" to lift the soul, strengthen the mind, and provide a foretaste of future possibilities. Visitors reported that at least a week was necessary to explore more than two hundred acres of exhibits. "It's too much for my mind," one person exclaimed. "It fills you up with more ideas than you've got room for."

One major building in Spanish Renaissance architecture displayed machinery, the foundation of an industrial society. When architects laid out the proposed exhibits they discovered the building could not contain them all, and an annex had to be constructed.

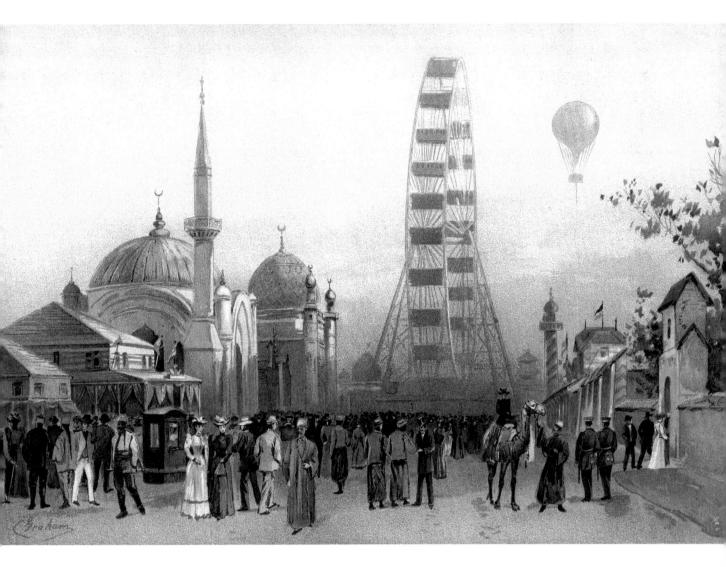

The leading industrial nations of the world filled all twenty-three acres of exhibit space in these two structures with modern wonders. On the south wall the gigantic Corliss engine, the largest in existence at twenty-four-thousand-horsepower, ran the machinery plus the dynamos that generated the electricity that turned the Great White City into a wonder at night. The circuit board for this electrical system was two stories in height. The grandeur of the machinery inside the buildings matched the splendor outside.

Another section of the fairgrounds, separated from the Great White City by the Illinois Central Railroad tracks, stretched for a mile along the Midway Plaisance. Here foreign countries staged a "whirlwind tour of the globe" and private ventures offered a host of entertainments for an additional fee. The towering Ferris wheel dominated the scene, its thirty-six cabins capable of carrying 1440 riders 264 feet into the sky.

Forty years later Chicago would host another world's fair to celebrate its centennial, the Century of Progress Exposition (fig. 10.1).

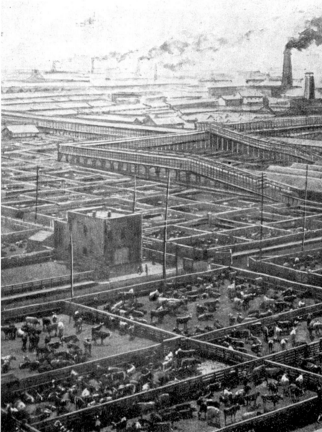

8.20 THE GREAT CHICAGO CANAL: A WORK IN PROGRESS, 1894

Scientific American devoted its cover to "The Great Chicago Canal" on October 20, 1894. The digging, alongside the old Illinois and Michigan Canal, started in 1892 and was not completed until 1900. More than eight thousand workers labored on the twenty-eight-mile project, removing more material than in the construction of the Panama Canal. In the middle of the twentieth century the Chicago Sanitary and Ship Canal was still a marvel, being honored as one of the seven wonders of American engineering alongside the Golden Gate Bridge and Hoover Dam.

The project, unlike its predecessor, was able to reverse the flow of the Chicago River (fig. 6.16).

8.21 UNION STOCK YARD, 1891

During the Civil War, Chicago meatpackers expanded their facilities to take advantage of contracts to supply the Union Army with provisions. Scattered throughout the city, these operations would gain many efficiencies if consolidated into a single location that was outside the city's congestion and had good connections to the railroads reaching out from Chicago in every direction.

The Union Stock Yard opened in 1865, and twenty-five years later, when this photograph was taken, had tripled in size. In the process, a group of notable business titans led by Gustavus Swift, Philip Armour, and Nelson Morris created the modern meatpacking industry. Six deep artesian wells, tapping water that went back to the melting of the

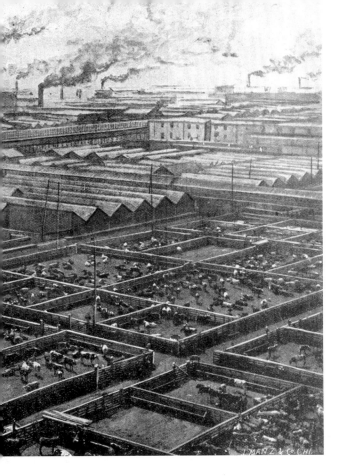

8.22 EDGAR COUNTY COURTHOUSE, 1896 (*BELOW*)

Edgar County joined in the movement to create impressive public buildings when it decided to erect this imposing courthouse in the 1890s. Construction took two years, from 1895 to 1896. Compare this monument with its medieval look to the Roman appearance of the Illinois statehouse in figure 8.1.

Courthouses and county fairs were important institutions throughout Illinois history. Imposing new edifices, like this one in Paris, the county seat, rose from the prairie to mark, in rural areas, the surge of the state into the industrial era.

glaciers, supplied the pure water upon which the enterprise depended. In 1890 a new "complete electric light plant [was] . . . so perfect that business" could be "done by night as well as by day."

Many visitors to the World's Columbian Exposition (figs. 8.18–8.19) also wanted to see the contrasting Union Stock Yard, both places awash in light at night. The industrial use of electrical illumination furnished a precedent for the world's fair. This was indeed the industrial era.

A HISTORICAL CONTEXT	THE ILLINOIS EXPERIENCE	THE CHICAGO DIMENSION
1900	**1900** Sanitary and Ship Canal completed	**1900** Chicago River reversed
1903 Panama Canal Zone established	**1904** Great Lakes Naval Training Station opens	**1903** Iroquois Theatre fire kills 602
1905		
1906 Upton Sinclair's *The Jungle*	**1907** Local Option Temperance Law	**ca. 1906** Great Migration of blacks from the South begins
	1908 Springfield Race Riot	**1906–11** Sears, Roebuck and Company sells automobiles
1909 First Model T automobile	**1909** Fire at Cherry Mine No. 2 kills 259 men	**1909** *Plan of Chicago* by Burnham and Bennett
1910 Outbreak of the Mexican revolution		
1910	**1911** William Lorimer rejected by U.S. Senate, case leads to direct election of senators	**1911** Carter Harrison Jr. begins last of five terms as mayor; Progressive reform is at its height
	1913 Women's Franchise Act	**1913** Modern art exhibited at the Art Institute
1914 Panama Canal opens	**1914–15** Edgar Lee Masters publishes *Spoon River Anthology*	**1914** Carl Sandburg's *Chicago Poems*
1915	**1917** Gov. Frank O. Lowden leads streamlining of state government	
1917–18 U.S. in World War I	Illinois Council of Defense	
	East St. Louis Race Riot	
1919 Worldwide influenza epidemic	**1918** State celebrates its centennial with ceremonies, buildings, and monuments	**1919** Race riot
1920		
1920–22 Postwar economic adjustments	**1920** Census records 6,485,280 inhabitants, two-thirds of whom live in metropolitan areas	**1920** City's black population doubled since 1910
	1921 Gov. Len Small leads highway paving program, putting state into a leadership role in the good roads movement	**1924** Soldier Field opens as Grant Park Stadium, name changes in 1925
1925	**1922** "Massacre" of nineteen strikebreakers, Herrin coal mine	
	1924 Bonds issued for paved roads	
1927 Talking motion pictures	**1927** State legalizes betting at horse racing tracks	**1927** Municipal Airport dedicated. "Big Bill" Thompson elected mayor for third time
1928 First Five-Year Plan launched in the USSR		
1929 Stock market crash in New York		**1929** St. Valentine's Day Massacre (gangland killing)
1930	**1930** Mary Harris "Mother" Jones, crusader for the labor movement, dies at age one hundred	

Structures of Modern Life, 1900–1930

IN THE 1890s Emil Mensching and
Martha Geils were born in rural Du Page
County, west of Chicago. Descendants
of German immigrants who came to Illinois in the middle of the nineteenth century, they married in 1916, the year Emil
moved from his father's farm to take
over the dry goods section of a general
store in a nearby small town. Itasca was
in the "dairy belt" or "milk shadow" of
Chicago. Martha's parents originally operated a creamery in Itasca, but with the
development of the railroad network and
the use of refrigerator cars the milk and
dairy business migrated to Wisconsin.
The Geils family then built a greenhouse
to ship plants and flowers to Chicago.

The dry goods store operated by the
Menschings became the life's work of
both Emil and Martha. When the store
finally closed in 1969, it still sold much
of the same type of merchandise that it
carried in 1916—shoes and clothing, fabrics and thread, stationery and toys. But
the way the Menschings lived had been
transformed. The structure of their rural
life had dissolved into a modern world.

Every aspect of their everyday lives had changed. To take an obvious example, an automobile had replaced their horse and buggy.

In their lifetime, industrialization had reached another stage, this one largely driven by the production of consumer goods. To be sure, the items on the shelves of the Mensching store, in 1900 as well as 1930, were almost all manufactured in factories, but they were similar to comparable objects used by their parents. But think of the new things that people like the Menschings acquired in their lifetimes: telephones and automobiles, electric lights and gas stoves, running water and indoor plumbing, kitchen appliances and refrigerators, radios and television sets, clothes washers and dryers, air conditioners and dishwashers. These "necessities" for modern living worked their way into the lives of Emil and Martha even if as large-ticket items they did not appear in the merchandise offered for sale in their store.

When Martha died in 1969 the local newspaper reported that the town had lost part of itself: "She was part of the village scenery just like the 'old steeple church.' . . . As a storekeeper she served her customers like they were part of her family." The Mensching store then went out of business. It was no longer needed. Time had passed it by. The ways of doing business had shifted.

The transition to modern life did not happen all at once. The movement went way beyond the first decades of the twentieth century, and changes did not happen everywhere and to everyone at the same time or at the same pace. No one, however, escaped the reorganization of life. Similar shifts occurred in other areas such as the role of government, organization of the economy, expression of culture in every medium, and arrangement of social groupings.

The new economy functioned in larger units. Business titans consolidated individual factories or corporations into large trusts, receiving the necessary funds from financiers. Mass production demanded large markets and an efficient distribution system. Advertising stimu-

lated consumption at one end of the process while a regimented labor force using better, electrically powered machines introduced efficiencies at the other.

In 1900 railroads constituted the largest segment of the state's economy. Thirty years later the automobile industries had taken their place. The former conveyed the public in groups and merchandise in large lots. An automobile culture encouraged individual trips, traveling alone, in pairs, or in small groups. In the 1920s the Menschings built a new building to house their store, one with modern conveniences and friendly to customers who arrived by car. They witnessed the power of the automobile as it turned their rural village into a distant suburb that the local realtor labeled "the golf center of Chicago." It would take another generation to work out the full impact of an automobile culture, but signs pointing the way to a new era cropped up everywhere. The Chicago Fire, for example, took on a symbolic role. *Barriers Burned Away,* the title of a popular novel about the great confla-gration, echoed the dedication of the new Grant Park Stadium. On October 9, 1924, the proceedings started by burning a replica of the O'Leary Barn. The flames removed the old so that a new structure could rise out of the ashes. By 1930 there were 1,630,816 automobiles in Illinois, an average of about one per family.

Chicago was at the apex of the state's economy. Sometime during the 1920s its metropolitan population exceeded the number of people living in the rest of the state. But Chicago was part and parcel of Illinois, the place where the productivity of mid-continent came into focus and, as a result, exerted a worldwide impact. As *National Geographic Magazine* summed up the situation in 1919, it was "a city whose industries have changed the food status of the world and transformed the economic situation of a billion people," half of the world's population. The city's influence depended on the "broad and fertile plains," and its rapid growth put it up against "harder problems than ever."

The nation's experience in World War I

brought together many trends in American society, providing a focus and patriotic impetus for structuring things on a national scale. Railroads had pointed the way with uniform gauges, standard time, and common work rules. The wartime emergency put all of the separate railroad lines together under unified control to mobilize troops and material. Wartime needs suggested other ways standardization and consolidation could benefit the nation. These tendencies were evident in the decades before the war, but they accelerated between 1917 and 1919 to what historians called the take-off stage. The 1920s witnessed America in flight, the decade roared, and "New Era" ways took over American communities. When a presidential candidate promised "a chicken in every pot and a car in every garage" he combined a traditional measure of well-being with an idea beyond the dreams of previous generations: the vision of an automobile society.

The New Era would need paved roads, and the rationale of national defense led to federal aid for a national highway system. Airplanes, employed for military use during the Great War, rapidly found civilian functions in the 1920s. On every front, transportation improvements for both passengers and freight became essential keys to unlocking future improvements. Illinois, in the middle of the nation, was at the center of things. America pivoted around its great city. "Make no little plans" Daniel Burnham advised as he illustrated how thought and action could create a magnificent Chicago. In fact, the city he envisioned would by 1930 be almost lost under a cluster of towers amid the changes wrought by the automobile society. But the confidence the great architect expressed in introducing the *Plan of Chicago* in 1909 endured. Thought and effort, he was convinced, could make the city "an efficient instrument for providing all its people with the best possible conditions of living." The same conviction extended to the state of Illinois as a whole. Indeed, it was the central, load-bearing girder in the structure of modern life.

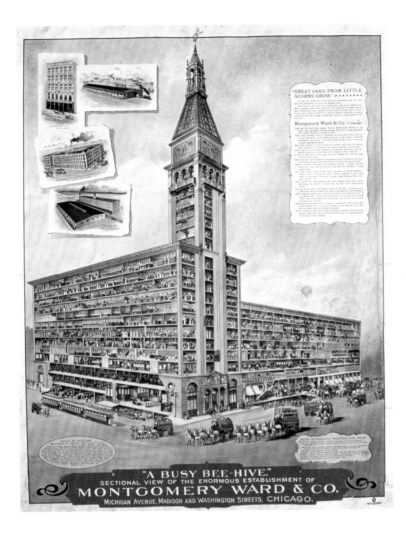

9.1 "A BUSY BEE HIVE"

The tower of Montgomery Ward and Company had no rival on the Chicago skyline between 1899, when it was built, and 1922, when the Wrigley Building shot up, four feet higher. The company started in 1871 by selling goods of every type to farmers who belonged to local granges. The idea was to send out catalogs advertising low prices for merchandise that would be ordered by mail and then shipped by rail to customers in rural areas. If an item was not satisfactory it could be returned for a full refund.

By 1900 this little acorn of an idea had grown into the mighty oak pictured here in full operation. At this time Ward's had no stores, but cus-tomers were invited to visit the tower when in Chicago and view the city and the lake from the ornate observation deck in the tower. Note the cable car on Madison Street, the parade of the firm's horse-drawn wagons on Michigan Avenue, and the statue "Progress Lighting the Way for Commerce" crowning the edifice. As chain stores and Main Street shopping gained popularity in the early twentieth century, Wards, Sears, and other mail order houses entered the retail business, setting up stores across the country. For example, a Sears Roebuck and Company store appeared on Main Street in Belleville (fig. 11.10).

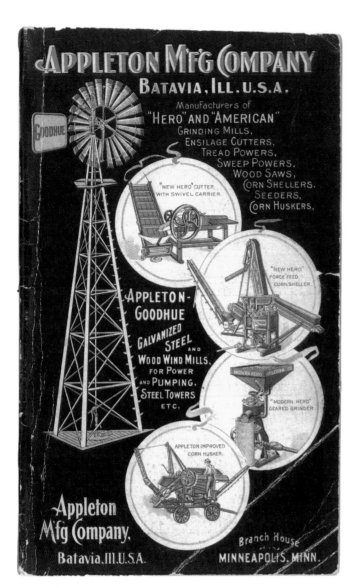

9.2 APPLETON MANUFACTURING COMPANY, 1902

Water-powered mills clustered at favorable locations along the Fox River in Kane County even before Land Office surveyors arrived to divide the land in the 1800s. Mill sites received special privileges in government land sales and led to a string of manufacturing towns along the river, west of Chicago. In 1902 many factories flourished at these locations but now used mainly electricity to power their machinery.

The Appleton Manufacturing Company produced machines and equipment for modern farms. Goodhue windmills pumped water from wells to watering troughs while New Hero equipment cut corn stalks for silage, shelled corn cobs, ground the kernels into feed or flour, and, under the Appleton brand name, husked corn cobs.

Illinois remained a leading state in the manufacture of agricultural implements, production of grain and livestock, and processing of foodstuff. "First in corn, first in farm crops, and first in aggregate farm wealth" boasted the state's farmers' organization in 1918. "That is Illinois—Uncle Sam's greatest and most productive farm."

The windmill continued to symbolize the state into the twenty-first century, as on the postage stamp in figure 12.11.

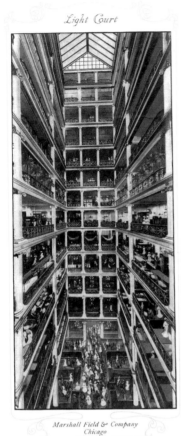

Light Court

Marshall Field & Company
Chicago

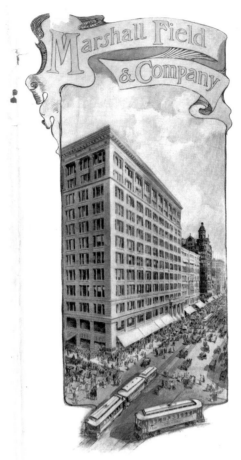

9.3 MARSHALL FIELD'S STORE, 1905

A new twelve-story store expanded the emporium of Marshall Field and Company in 1905 and made shopping an experience. A tall atrium brought light and ventilation to a multitude of departments, and elevators and escalators took shoppers from the crowded main floor to specific areas of interest. It was worth a trip to Chicago to view the variety of goods on display and experience courteous service from a staff working under the motto "give the lady what she wants." Here the consumer economy was on full display.

A three-unit cable car and a new electric streetcar powered by way of overhead wires and a trolley are shown in the exterior view of the State Street ediface. Down the street are several older buildings that also housed departments for Fields, as well as the turret of the Columbus Memorial Building, an office complex erected in 1892.

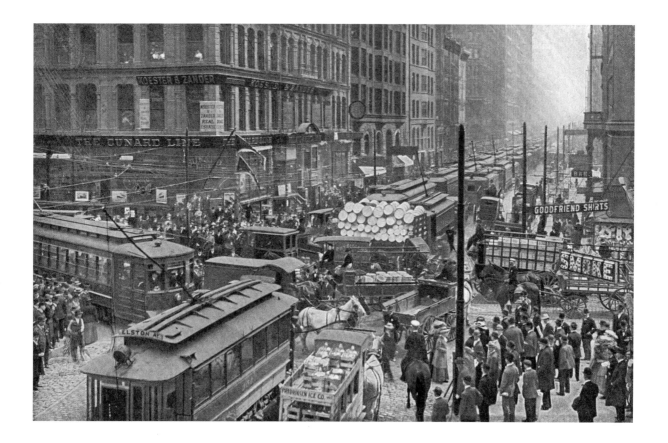

9.4 A CHICAGO TRAFFIC JAM, MAY 25, 1909

Some accounts indicate that this traffic jam was staged for the benefit of a photographer. He apparently wanted a good postcard view, so he persuaded the police regulating traffic at Dearborn and Randolph streets to leave their posts for five minutes. When they returned, they faced this scene and called for help. All traffic control officers were mounted on horses, one of which is at the lower right. It took nine law officers only seven minutes to untangle things. Meanwhile, shoppers continued purchasing the vast array of consumer goods available in State Street's celebrated stores and shops.

By 1909 streetcars had replaced cable cars on these streets. The poles at the edge of the streets supported wires reached by the trolley, clearly seen on the Elston Avenue car in the foreground. Almost all of the other vehicles were horse-powered. In 1908 Chicago had licensed only 5,475 automobiles and trucks. Traffic control lights and the rapid multiplication of motor vehicles soon made mounted officers unnecessary in most locations, but the downtown contingent was not eliminated until 1948 and then was reinstated in 1974 to patrol lakefront parks.

Traffic engineering became a necessity as the automobile took command of life in Illinois later in the century, resulting in complex public works such as those evident in figures 11.1 and 11.13.

9.5 A CONCRETE HOUSE OF WORSHIP AND AN ARCHITECTURAL GENIUS, 1908

In 1905 a fire destroyed the Universalist church in Oak Park and opened the door of opportunity for Frank Lloyd Wright to display his genius as an architect. Working with a tight budget, he replaced the traditional steeple reaching up toward the skies with light that entered from above via a skylight and windows under the eaves. Instead of brick or stone for the walls he used a new kind of concrete poured into wooden forms. A common entrance hidden behind a huge planter led to two structures: a house of worship and a parish hall. Over each door he placed the church's motto as an inscription: "For the Worship of God and the Service of Man."

The use of cement concrete came out of the ground in the early twentieth century with the growing use of artificial (Portland) cement. Used for decades in foundations, architects and engineers began experimenting with concrete's use in a wide variety of applications, from factories and warehouses to towers, monuments, houses, silos, and highway pavement. Reinforced concrete became the primary construction material in some skyscrapers such as Marina City (fig. 11.6).

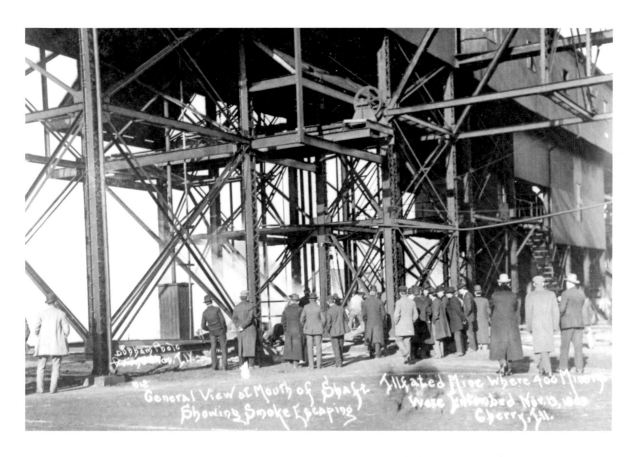

General View of Mouth of Shaft Showing Smoke Escaping Ill-fated Mine Where 400 Miners Were Entombed Nov. 13, 1909 Cherry, Ill.

HOME OFFICE

MONARCH FINER FOODS

TELEPHONE: SUPerior 5000

9.6 THE CHERRY MINE DISASTER, 1909

Disasters often bring historical forces into focus. The widespread use of coal for generating steam and heating buildings pushed mining companies to tap new sources of supply. In 1909 almost all buildings in the towns and cities of Illinois were heated by coal. Many immigrants from Europe found jobs exploiting deeper veins in central and southern Illinois around the turn of the century. On November 13, 1909, a dripping lantern ignited a cart of hay in the St. Paul mine near Cherry, Illinois. After a series of mishaps, the mine filled with smoke, eventually killing 259 men trapped inside. The photograph shows smoke emerging from the shaft on the first day of the disaster. A few miners walled themselves off from the smoke and were able to survive by drinking seep water until they were found eight days later. The last bodies, however, were not brought out of the mineshaft until April 1910.

The Cherry mine disaster made headlines across the nation. Concerned people also sent postcards like this one around the nation, hoping the heartbreaking story would lead to improved safety in mining activities. Amid relief contributions for the families of the bereaved, Illinois and other states did improve safety regulations and workers' compensation programs.

9.7 REID, MURDOCH AND COMPANY, 1913

Chicago firms supplied coffee, tea, canned goods, and other provisions to small grocery stores across the Midwest. Many of these groceries were located in villages and small towns throughout Illinois, pointing to another link between the primary city and the rest of the state. Reid, Murdoch and Company sold its products under its own name as well as under the Monarch brand. The Mensching stores in Itasca, like thousands of similar establishments throughout Illinois and the Midwest, stocked their shelves from the Reid, Murdoch firm and similar wholesalers in Chicago.

Although this large warehouse faced the Chicago River, it received and shipped goods by train. The offices in the tower faced the river, and a "hanging sidewalk" extended over the water for the length of the building to take advantage of the river view. In this respect it was a pathbreaking building. Most Downtown structures turned their backs to the smelly, polluted stream, but the Reid, Murdoch Building looked forward to fresher waters now that the Chicago River had been reversed. The river, even as viewed in 1913, could become an amenity. River traffic demanded that the bascule bridges lift their leaves to let the boats pass, which not only created an exciting spectacle but also snarled traffic in the Central Business District (figs. 9.4 and 9.12).

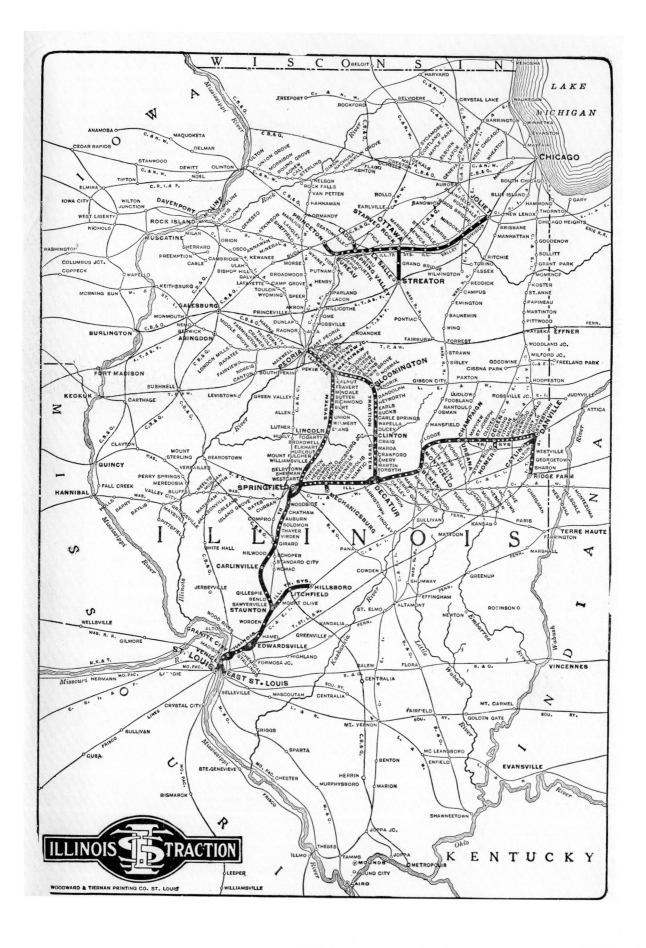

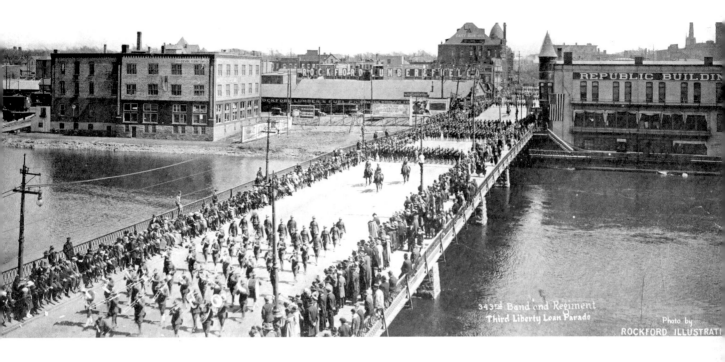

343rd Band and Regiment
Third Liberty Loan Parade

Photo by
ROCKFORD ILLUSTRATI

9.8 THE INTERURBAN NETWORK, CA. 1914

The Illinois Traction System published this map to highlight its service linking dozens of Illinois villages and towns. Springfield and Decatur served as the hubs of the light rail system. Similar to streetcars, the trains did not use a locomotive but were powered by electricity supplied by overhead wires.

This map may be confusing because, by design, it features the lines of the Illinois Traction Company in the context of major railroads in the state and omits other, sometimes-competing, interurban lines. Passengers could use Illinois Traction service to reach St. Louis, but the company did not have access to Chicago. Nevertheless, the system provided cherished service to many cities and towns before the 1950s, by which time the automobile had put almost all interurbans out of business.

Railroad maps tend to exaggerate the importance of areas along the tracks of the sponsoring companies. Compare this map, for example, with the Illinois Central Railroad map in figure 7.3.

9.9 A LIBERTY LOAN PARADE, ROCKFORD

This view of Rockford and one of its bridges over the Rock River appeared on a large folding postcard. The entire picture encompasses a larger section of the city, but this detail shows the 343rd Regimental Band leading a parade supporting the Third Liberty Loan. To help finance World War I the government asked citizens to purchase bonds, called liberty loans, which would later be paid off with interest. Purchasing the bonds was an act of patriotism. Later, families cashed in wartime savings to help make large purchases like home appliances and automobiles.

Many spectators lined the street, some seated on chairs and others standing behind. A vacant lot filled with large billboards is in front of the Rockford Lumber and Fuel Company. At the time, coal was the primary fuel used for heating Rockford homes.

9.10 SAILORS SALUTE THE FLAG, 1917

In March 1917, the navy assembled thousands of recruits stationed at the Great Lakes Naval Training Station to create a giant American flag. The picture was taken to accompany a message by former president William Howard Taft supporting the military effort. Reproduced in newspapers and magazines, it became part of the campaign to bolster patriotism in its midst of wartime sacrifices. The Chicago photographers Arthur Mole and John Thomas later created similar patriotic images at military bases across the nation.

The Great Lakes Training Station occupied a large tract of shoreline north of Chicago. The navy liked the location because recruits could be easily assembled from across the country due to the city's superb railroad connections. In addition, trainees had no need to worry about enemy submarines in Lake Michigan.

The patriotic song "Old Glory Goes Marching On" by Paul B. Armstrong and F. Henri Klickmann, which used the 1917 photo on its cover, proclaimed that the flag "never knew defeat."

9.11 MAIN STREET, PIPER CITY

Main streets across the state and nation were the focus of community life during the early twentieth century. Cars apparently were moved out of the line of sight for this postcard view of the west side of the street, and someone named Sugar listed all the stores on the reverse. Piper City had two grocery stores, two restaurants, a meat market, a hardware store, a drug store, and a variety store. In addition, the street housed a beauty salon, a bank, a pool hall, and a shop that sold and repaired radios and "electrical stuff." The building close by marked by the barber pole had the post office on its second floor, above the barbershop.

Future highways would bypass main streets, and businesses would follow to locate on the outskirts of towns. Compare this rural main street with those in figures 10.2 and 11.10.

CHICAGO
"THE PULSE"
OF AMERICA"

The Spirit Of Black Partridge
Seeking Old Fort Dearborn

Take this home with the compliments of
Mayor William Hale Thompson as a souvenir
of a pleasant day spent as his guest at Riverview Park

9.12 CHICAGO: THE PULSE OF AMERICA

In 1922 Mayor William Hale Thompson sponsored a day of recreation for Chicago public school students at Riverview Park, a popular amusement center along the North Branch of the Chicago River. The tradition started in 1919, and each student received a copy of the Constitution of the United States to take home for family study and reference. The 1921 outing featured a pamphlet on the history of Illinois. In 1922 the souvenir booklet recounted the history of the city and pointed to Chicago's current role as "the pulse of America." The cover pictured the spirit of Black Partridge returning after a century to camp at the mouth of the river (fig. 5.6). Looking upstream, he could not believe what had taken the place of Fort Dearborn.

The spirit of progress is evident in the scene. A large lake steamer passes the double-deck Michigan Avenue Bridge, completed only two years earlier, and two ornate new skyscrapers flank the bridge, the London Guarantee Building on the left and the Wrigley Building on the right.

9.13 A NEW SUBURBAN DEVELOPMENT, 1922

A real estate developer published *The Story of Skokie Heights* in 1922 to present the latest project on the North Shore, a string of fashionable sub-urbs along Lake Michigan north of Chicago. The brochure illustrated what the subdivision in Glen-coe would look like when houses appeared on the spacious lots then offered for sale.

In this view, children play in an ample yard while adults bring a new automobile up the drive-way. The house itself recalls the historic archi-tecture of England, and the entire setting celebrates nature. A garage to house the automobile does not appear in this front view, but a special portico to receive passengers arriving by car is attached to the house on the right. George W. Maher, a noted architect, planned this development "to be free from noise, smoke, crowds, through auto traffic, and all things that detract from a perfect home environment." Moreover, "there will be no fences in Skokie Heights." Suburban views from the 1950s and 1960s appear in figures 10.13 and 10.17.

9.14 THE DEDICATION OF MEMORIAL STADIUM, 1924

Spectator sports became an important ingredient of modern life in the early twentieth century. Football teams emerged as the primary focus of intercollegiate athletics, and huge stadiums were needed to accommodate crowds of spectators. Many alumni returned to campus by private automobile, special trains, and chartered busses to witness the Saturday afternoon games every fall.

When the University of Illinois dedicated Memorial Stadium on October 18, 1924, thousands of fans had to be turned away. A Chicago radio station broadcast a play-by-play account of the game, one of the most storied in the annals of the sport. Harold "Red" Grange, soon to become the nation's football hero, ran for five touchdowns en route to a 39 to 14 victory over a powerful Michigan team. Earl Britton was lead blocker on this play, a reminder that a star's thrilling performance depends on everyone on the team doing their job. It was a point that Ronald Reagan, another collegiate football player in Illinois during the 1920s, would make throughout his lifetime (fig. 9.18).

9.15–9.16 CRIME IN THE CITY AND THE COUNTRY

Prohibition in the 1920s, a great experiment in social engineering, created new opportunities for gangsters already flourishing in the nation's cities. Al Capone soon emerged as the most powerful mobster in Chicago and perhaps the most famous, or infamous, citizen of the state. When his henchmen shot the wrong person on April 27, 1926, thousands of Chicagoans turned out for the funeral. William H. McSwiggin, the victim of the assassination, was an assistant prosecutor who remained on cordial terms with friends from his old neighborhood. They, in turn, were engaged in underworld activities in competition with Scarface Al.

Huge and elaborate funerals became a hallmark of the Chicago crime scene. But the notoriety of the gangland life spilled out to the countryside as well, as shown by this commissioned photograph of the Charlie Birger gang from Williamson County. The Shady Rest, a roadhouse that served as the gang's headquarters, is in the background. Note the variety of clothing the men wear and their audacity in posing for such a photograph. Birger took the central position and is seated on the roof, feet planted on the window ledge. It is one of several different poses taken by a professional photographer that the gang used "for publicity purposes."

9.17 JANE ADDAMS: LEADERSHIP BY PRECEPT AND EXAMPLE

Jane Addams was born in 1860 to a prominent family in Cedarville, Illinois. Educated at Rockford Female Seminary, she found her vocation when visiting Toynbee Hall in London. Deciding to develop a similar institution in Chicago, she and her friend Ellen Gates Starr opened Hull-House. She spearheaded the settlement house movement in the United States, helping newcomers to the city, especially immigrants, come to terms with urban life.

Gaining a national and international reputation by her writing and public speaking, she rooted her precepts in personal experiences. Wallace Kirkland took this evocative picture in the 1920s, recording Addams listening intently to neighborhood children rather than just reading to them.

Kirkland, who directed the boys' and men's clubs at Hull-House, learned to take pictures by using a camera that had been donated to the settlement house, and he soon became one of America's leading photographers. Simple cameras in the hands of ordinary families also documented the lives of children throughout the state.

9.18 RONALD REAGAN IN 1929: THE ILLINOIS YEARS

Ronald Reagan, elected president of the United States in 1980, spent the formative years of his life in Illinois. Born in 1911, his childhood years in Dixon on the Rock River furnished him with many happy memories. He was closer to the Mississippi River than to Chicago, he later observed. A scholarship student at Eureka College near Peoria, he would joke about majoring in athletics and extracurricular activities. He was a leader on the football team and in student dramatic productions. After graduation he became a radio announcer and broadcast Chicago Cubs baseball games to a rural audience. Later he starred in various films, including one in which he portrayed a football player. His presidential campaign committee circulated photographs of the young athlete to recall his Illinois years.

9.19 *MIRRORS OF ILLINOIS*, **1929**

H. E. Young, the secretary of the Illinois Farmers' Institute, produced "a pocket book of facts" entitled *Mirrors of Illinois* to celebrate the accomplishments of the state, particularly the agricultural sector of its economy. This image of Illinois adorned the cover of the leaflet, which began with the state's broad and fertile plains that supported the magnificent city rising to the sky. Agriculture provided the sturdy foundation for culture and civilization. A coalmine, oil wells, factories, and warehouses occupy the middle space between the fields and the skyscrapers. A church steeple and the dome of the state capitol flank the image, and an airplane crowns the view.

The text emphasizes the importance of the state's cement highways, a "network unsurpassed by any other State in the Union." Continued leadership in such improvements made it the "cap-sheaf" of the American Republic: "Illinois leads in Progress, and holds foremost rank in the Big Parade of modern achievement." It was an ominous boast; the challenges of the Great Depression, World War II, and cold war stood immediately ahead. The dominance of the city in this symbolic composition is interesting given its agricultural sponsorship. Compare the image of the state on the 2008 postage stamp (fig. 12.11).

9.20 MOTHER JONES: END OF AN ERA, 1930

In many ways the burial of Mary Harris "Mother" Jones in the Union Miners Cemetery at Mt. Olive marked the end of an era. She devoted her life to inspiring the working class and requested that her eternal resting place be alongside her "boys," the victims of a violent struggle between strikers and guards employed by the Chicago-Virden Coal Company.

Often called the "Miners' Angel," Jones went from place to place to encourage, organize, and unite workers. This undated photograph was taken about 1910, just after the Cherry mine disaster (fig. 9.6). At the time, she opposed woman suffrage, fearing it would divert attention from the exploitation of workers. Politics, she held, was not as important as economics. But her funeral took place in the midst of the Great Depression, and the New Deal lay just ahead, a political platform that focused on the economic well-being of rank-and-file workers.

Jones, like Jane Addams (fig. 9.17), created public leadership posts in a society that was just coming to recognize new roles for women.

A HISTORICAL CONTEXT	THE ILLINOIS EXPERIENCE	THE CHICAGO DIMENSION
1930		
1930 Great Depression follows stock market crash of 1929	**1930s** Route 66 enters American folklore	**1931** Merchandise Mart opens
1932 Franklin Delano Roosevelt elected president	**1930–33** Special sessions of the legislature deal with the depression	**1932** Collapse of Samuel Insull's financial empire. Al Capone sent to federal penitentiary
1933 March financial crisis ushers in the New Deal	**1932** Illinois Emergency Relief Commission (state-funded unemployment relief) lasts less than six months	**1933–34** Century of Progress Exposition
1935		
1935 Social Security Act	**1935** Half the state's population receives federal aid	
		1937 Outer Drive Bridge dedicated by President Roosevelt
		Memorial Day "Massacre" at Republic Steel Mill
1939 Germany invades Poland; outbreak of World War II	**1940** State's population increases only 3.5 percent since 1930	
1940		
1941 Japan attacks Pearl Harbor; U.S. enters World War II	**1941–45** Illinois leads all states in manufacture of ammunition; University of Illinois becomes known as the West Point of the West	**1942** Japanese Americans relocated from California
1942 First controlled atomic reaction in Chicago		**1942–45** Great Lakes becomes world's largest naval training facility
		1943 Dodge Factory employs thirty thousand workers
1945		
1945 War ends in Europe and then in Asia		Chicago's first subway opens
1947 Marshall Plan for economic recovery in Europe	**1947** Congressional districts realigned for first time since 1901	**1947** Argonne National Laboratory created
1950		
	1950 Everett Dirkson elected to first of four terms as U.S. senator	**1950** City's population peaks at 3,620,962
1952 Gen. Dwight D. Eisenhower elected president	**1952** Adlai Stevenson runs for presidency on Democratic ticket, loses to Dwight Eisenhower	
1954 Segregated schools declared unconstitutional	**1954** Constitutional amendment equalizes representation in Illinois House of Representatives	
1955		
		1955 Richard J. Daley elected mayor, first of five consecutive terms
1956 Interstate Highway Act	**1956** Adlai Stevenson again runs for presidency on Democratic ticket, again loses to Dwight Eisenhower	O'Hare Airport opens
1957 *Sputnik* launched		
	1958 East-West Tollway, state's first toll road, opens	**1959** Queen Elizabeth arrives to dedicate St. Lawrence Seaway
1960		
1960 Chicago site of first televised presidential debate	**1960** Half of Chicago area's manufacturing jobs are in the suburbs	

TEN

Depression, War, and Recovery, 1930–60

HISTORIANS have called the generation that came to adulthood in the 1930s and the 1940s America's "greatest generation" because they triumphed over the twin challenges of the Great Depression and World War II. Then, in the 1950s, came the cold war and the communist threat. These were all global movements in which the people of Illinois participated, and it seemed that outside forces increasingly controlled their destiny. Big plans developed in the 1920s, whether on the personal, local, or state level, had to be put on hold. Even the Illinois baker who had the idea of putting filling inside shortcakes had to wait a while before his idea caught on, and then the wartime shortage of bananas forced him to switch to a vanilla flavor. By 1960, however, his Twinkies were selling by the millions.

Yet the deprivations of the depression and wartime shortages did not hold back the forces of change or the march of modernization. In 1930 only about 1 percent of the farms in Illinois had electrical service, but by 1960 almost everyone did. Thanks to the Rural Electrification

Act of 1935, town and country came together in the quest for modern conveniences. In some ways the suburban ideal tried to capture the best of both worlds: enjoying urban advantages in a more natural, semirural setting.

In the early 1930s, even as the depression spread from one segment of the economy to another, most Americans thought of the hard times as a temporary inconvenience that would soon pass. The automobile culture continued to spread, and tractors were replacing horses on the state's farms, freeing hay fields, pastures, and plantings of oats for other uses, especially cash crops. Moreover, the spreading use of hybrid seeds boosted crop yields to new highs. There were good reasons for the glut of agricultural products in the market place. Modern farming was very productive.

By 1932, however, the economic situation had become desperate. Samuel Insull's financial empire, centered in Chicago, collapsed. Soaring unemployment led Illinois to set up a relief fund of $20 million, but by July the money was gone. The state now had to depend on federal loans. Then, in 1933 there was the run on the banks. The world's fair in Chicago, called the Century of Progress to commemorate the city's founding in 1833, could not have opened at a more inauspicious time. And yet the exposition proved to be a success, attracting additional support to open for a second season in an expanded version in 1934. Its bright visions of the future took the nation's mind off of the dim prospect of the present.

As New Deal relief and recovery programs started to kick in during the mid-1930s half the state's citizens received some form of federal assistance. To make ends meet, the state's leading private universities, the University of Chicago and Northwestern University, considered merging, with undergraduates to go to Evanston and graduate students to Hyde Park. Then the war came, and massive expenditures to support the Allied effort quickly turned a labor surplus into a shortage. Illinois led all the states in the manufacture of ammu-

nition. The Great Lakes Naval Training Station became the nation's largest such facility, and so many officers received accelerated training at the University of Illinois that it was called the West Point of the West.

The war years brought changes to the state. Wartime disputes, such as that between the leader of Montgomery Ward and Company and the National War Labor Board, grabbed headlines, but families in Illinois quietly planted almost a million victory gardens to address the food shortage. Housing also reached a crisis stage as black workers stepped up migration from the rural South to find jobs in the North. The war accelerated research and development efforts, none with more far-reaching results than those that led to the first splitting of the atom, an event that occurred under the University of Chicago's football stadium. Scientists in Illinois ushered in the Atomic Age.

The Dodge automobile factory on the South Side of Chicago converted in wartime to producing the B-29 Superfor-

tress bombers employed thirty thousand workers, making it the world's largest factory. In the conversion to peacetime manufacturing, Chicago led the nation in capital investment for industrial expansion. As factories started to produce modern agricultural equipment at a record pace in the postwar decade, Illinois agriculture experienced "the greatest transformation in its history." Farms were consolidated, soybeans became a major crop, federal price support and soil bank programs changed the way farmers conducted business, and the rural population in Illinois sharply declined. In 1930, 13 percent of the state's population lived on farms; by 1960, the figure had dropped to 6 percent. The actual number of farmers was cut almost in half.

Patterns in the consumption of food were about to change as well. In 1955 a traveling salesman from Illinois came across a thriving hamburger restaurant in California run by Mac and Dick McDonald. He bought into their business, developed a franchising plan, and

opened the first fast-food McDonald's in Des Plaines, a Chicago suburb astride a popular route to the Lake District northwest of the city. Chicago once again influenced the world's eating habits.

The architecture of a McDonald's restaurant reflected the car culture. The Golden Arches had to be large enough to be spotted some distance from the restaurant and through a windshield. The arches always marked a place to drive in. They accompanied the most far-reaching aspect of the automobile age, the emergence of a national system of limited-access superhighways. Created in the interest of national defense in 1956, the interstate system soon transformed every aspect of the Illinois landscape: city, suburban, and countryside. Moreover, the new ribbons and cloverleaf ties seemed natural in the Prairie State. The highways conquered distance and extended one's range of vision. It was an old theme. Gov. Adlai Stevenson repeated it when welcoming the Democratic National Convention to Illinois in 1952: "Here, my friends, on the prairies of Illinois and the Middle West, we can see a long way in all directions. We look to east, to west, to north and south. Our commerce, our ideas, come and go in all directions."

10.1 A CENTURY OF PROGRESS, 1933

In 1893 Chicago's first world's fair honored the past (figs. 8.18 and 8.19), but the 1933 exposition looked to the future. It is true that a replica of Fort Dearborn was squeezed in between the modern air-conditioned buildings, but almost all of the exhibits looked beyond the present and into the future. Houses of the future were popular exhibits, constructed in many styles and a variety of material: masonite, steel, glass blocks, common brick, lumber, cypress, and Rostone, a cement-like product. The House of Tomorrow, a glass-enclosed octagon on top of a hangar for a private airplane as well as a garage, predicted that dishwashers and air conditioners would soon be common appliances.

This spectacular view of the fairgrounds was created by H. H. Pettit in cooperation with the Kaufmann and Fabry photo studio. In 1932 Rufus Dawes, the president of the exposition, commissioned Pettit to paint an image of what the fair would look like when construction was completed. The photographers then recorded each portion of the twenty-six-by-forty-inch picture, enlarged them, and pasted them together on the wall of the Administration Building's reception room to create the world's first photomural, twenty by thirty-five feet in size. Rand McNally and Company then obtained the right to reproduce the original image in their guidebook to the Century of Progress.

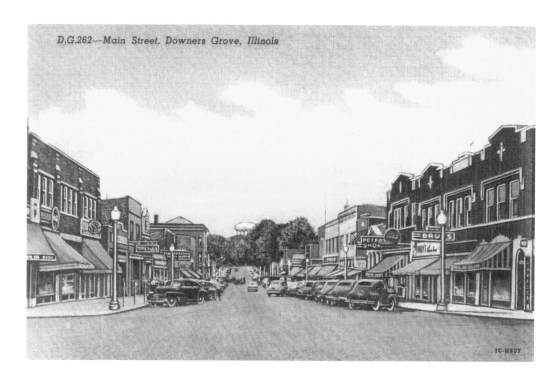

D.G.262—Main Street, Downers Grove, Illinois

IC-H307

10.2 MAIN STREET, DOWNERS GROVE

This postcard view of Main Street in Downers Grove gives a small-town look to the Chicago suburb. There are, however, signs of progress: streamlined cars, electric streetlights, a large water tank at the end of the street, and parking meters clicking away so everyone had a chance at convenient parking. Downers Grove carried a landscape name assigned by the early pioneers. It became a town when the Chicago, Burlington, and Quincy Railroad built a station next to an early subdivision in 1864. In 1908 Sears, Roebuck and Company went into the ready-cut housing business and located their plant in town. More than two hundred of these houses were erected in Downers Grove, and thousands more were shipped to other towns throughout the state and nation. Compare this main street view with that of the one in Belleville from 1973 (fig. 11.10).

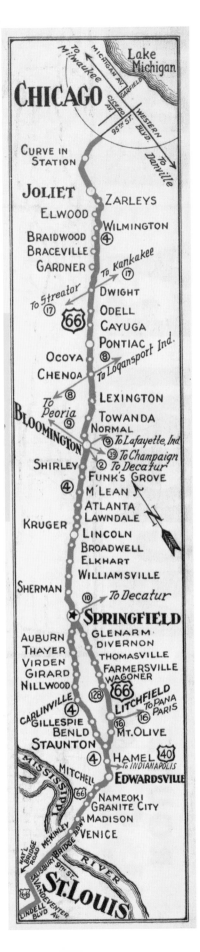

10.3 ROUTE 66

This strip map from the 1930s features Route 66, which connected Chicago and St. Louis with a ribbon of concrete across Illinois. The new U.S. highway designation largely followed routes formerly named the Mississippi Valley and the Lone Star Highways. Illinois State Route 4 used the same pavement for most of the distance but cut off to use a different bridge to cross the Mississippi River into Missouri. Because the toll bridge, named after President McKinley, published this piece, only one way to cross the river is shown.

Historically, Route 66 started at Michigan Avenue and Adams Street in Chicago and ended on a California beach. It began where the Art Institute is located, a site facing the original shoreline of Lake Michigan and location of Lorado Taft's *Fountain of the Great Lakes* (fig. 12.15). Route 66 thus connected the Great Lakes with the Pacific Ocean.

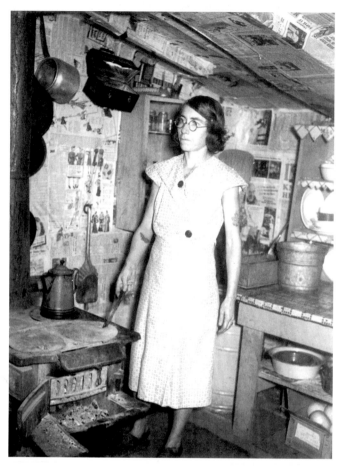

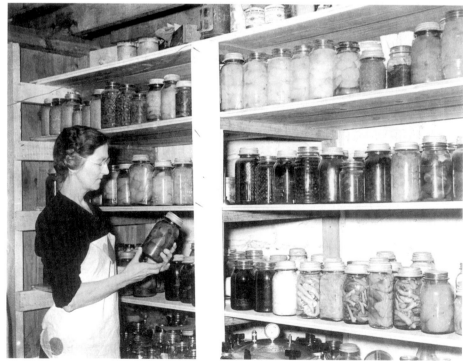

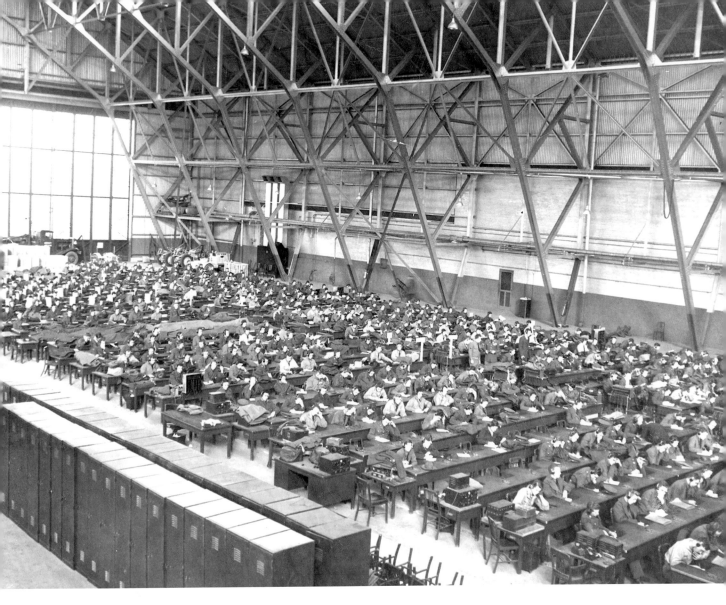

10.4–10.5 TWO WOMEN IN SOUTHERN ILLINOIS, 1939 (*LEFT*)

Arthur Rothstein, a photographer for the Farm Security Administration, took these photographs of two women in their homes in neighboring Saline and Williamson counties. According to his notes, the woman in figure 10.4 was married to a man on relief. The woman in figure 10.5 was more fortunate. She and her husband, former tenant farmers, had been able to acquire a farm with livestock and equipment through a program of the Farm Security Administration.

10.6 SCOTT FIELD (*ABOVE*)

In 1917 the U.S. Army purchased a private airfield near Belleville to expand its capacity for training pilots and air support troops. After Japan's attack on Pearl Harbor in 1941, the facilities at Scott Field were taxed to the limit because it became the major communications school for the Army Air Force. Here, a huge class of future radio operators meets in a hangar constructed to house a dirigible, the only room on the base large enough to accommodate that number of people.

10.7 SENATOR DALEY'S WAR MEMORIAL

Richard J. Daley, later the celebrated mayor of Chicago, served in the Illinois Senate during World War II. He got his start in political leadership in 1924, when at the age of twenty-two he was elected president of the Hamburg Athletic Association, a post he held for fifteen years. The young men's club bore the name of a neighborhood in the Bridgeport community area of Chicago, where the mayor lived his entire life.

Similar war memorials could be found in many neighborhoods, towns, villages, and country crossroads throughout Illinois. Their common characteristics were a flag, some patriotic decorations, and a list of local people serving in the Armed Forces. This example, sponsored by Daley, listed the members of the club serving their country.

One criticism of the suburban subdivisions that emerged after the war was that they lacked informal public spaces for neighborhood landmarks such as these memorial gardens. Where, for example, would neighbors place such a memorial in the suburbs pictured in figures 10.13 and 10.17?

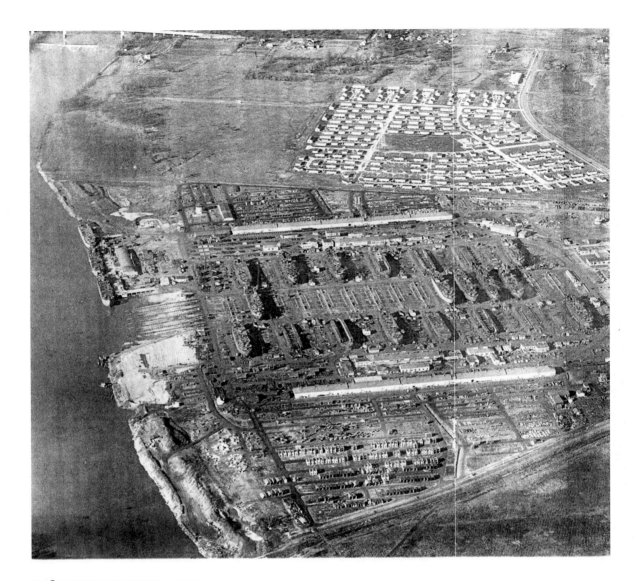

10.8 SENECA SHIPYARD, 1945

Illinois and the Midwest were favorite locations for the production of arms and equipment during World War II. Existing industry, a highly skilled work force, a developed transportation system, and the safety of a mid-continent location led to new facilities like the Seneca Shipyard. Based on a factory that previously manufactured municipal water tanks, the site expanded along the Illinois Waterway to produce landing ship-tanks (LSTs). The first keel was laid on June 15, 1942, and more than 1,950 followed before the shipyard closed in 1945. At its height, the labor force at the shipyard reached twenty-seven thousand workers, who were housed in tight quarters around the yards. Many ship builders were women, nicknamed Rosie the Riveter or Winnie the Welder.

Seneca is located eighteen miles upstream from Starved Rock, the scene of the historic encounter between the French and the Indians in 1673 (figs. 3.3–3.6).

10.9 BACK TO NORMAL, 1947

In the years after World War II the annual reports of the Illinois Department of Agriculture regularly used pictures such as this one to recall the traditional family farm. This winning image, from the 1947–48 report, seemed to say that things were back to normal on Illinois farms. In reality, however, agriculture had become an industry and it was in 1949 that large-scale agricultural interests lobbied Congress to defeat the Brannan Plan for American Agriculture, which they felt gave too much support to family farms.

10.10 CATERPILLAR TRACTOR COMPANY, PEORIA, 1950 (*RIGHT*)

Benjamin Holt developed his idea for a crawler tractor in the soft delta soils in Stockton, California, in the late nineteenth century. In 1909 he moved his operation to this site across the river from the city of Peoria. The firm eventually merged with several other manufacturers of farm equipment.

In the rebuilding after the Great Depression and World War II, the demand for Caterpillar equipment took off, increasing nearly twelvefold between 1946 and 1966. By then "Cat" was an international company with twenty plants producing machines for the agricultural, construction, and road-building industries. Five of these plants were located in Illinois, at Aurora, Decatur, Joliet, Oswego, and this one, the largest, at East Peoria. W. A. Holling took this air view of the huge Caterpillar Tractor Company on April 26, 1950.

The sprawling factory is just a mile or so downstream from the village of Black Partridge, the Potawatomi chief (figs. 5.6 and 9.12).

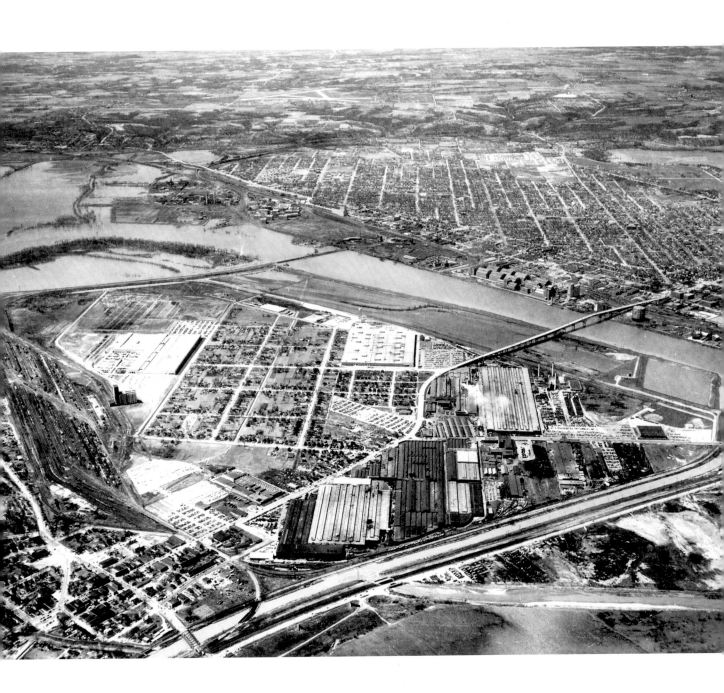

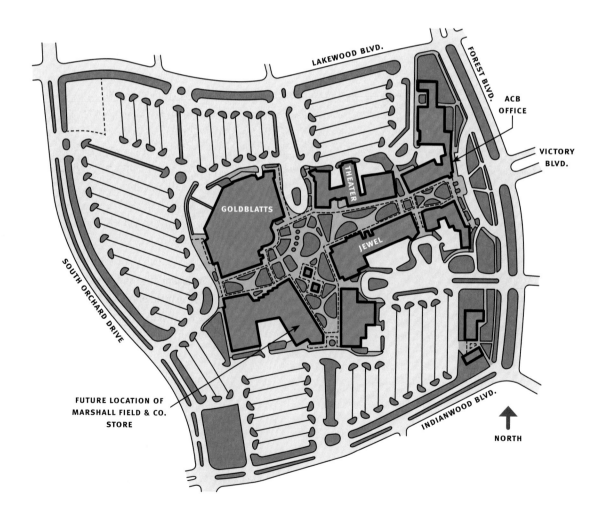

10.11 SPRINGFIELD WELCOMES STEVENSON, 1952

When Gov. Adlai Stevenson II welcomed delegates to the Democratic National Convention in 1952 he had set his sights on reelection to his current position. A "draft Stevenson" movement turned his mind, however, and he accepted instead his party's presidential nomination. When he returned to Springfield a week later supporters gave him rousing support.

Although born in Los Angeles, Stevenson came from an established Illinois family. He was raised in Bloomington, eventually earned a law degree at Northwestern University, and settled down on a gentleman's farm near Chicago. The Man from Libertyville then spent a lifetime in public service; he was ambassador to the United Nations when he died in London in 1965. Honored in American politics as the "great voice of reason," he was also recognized as the personification of the best in Illinois.

This is one of several "campaign images" in this book; see also figures 6.6, 11.17, and 12.12.

10.12 THE PLAZA AT PARK FOREST, 1953

Park Forest was first designed as a golf center, but years of depression and war derailed that plan. In 1946, however, another development team announced plans to house five thousand families in a new community featuring a variety of residences, ample parks, a village manager type of government, and one of the nation's first shopping centers. Edward Bennett, coauthor of the celebrated *Plan of Chicago* and a major figure in the design of cities in twentieth-century America, provided plans for many of the first homes, stores, schools, and public structures. The town received national attention and was later hailed as America's first "GI town."

Families started to arrive two years later, and in 1953 Goldblatt's Department Store moved into the shopping center as anchor tenant. At that time the Plaza had forty-four stores, including the largest grocery store in the Jewel Tea Store chain. A soaring clock tower reminded shoppers that the Plaza San Marco in Venice inspired the Illinois center. The office of American Community Builders, the developer, is marked at the main entrance to the Plaza at the end of Victory Boulevard.

The shopping center would soon address many of the same functions that main streets served in the small towns of previous generations (e.g., fig. 10.2).

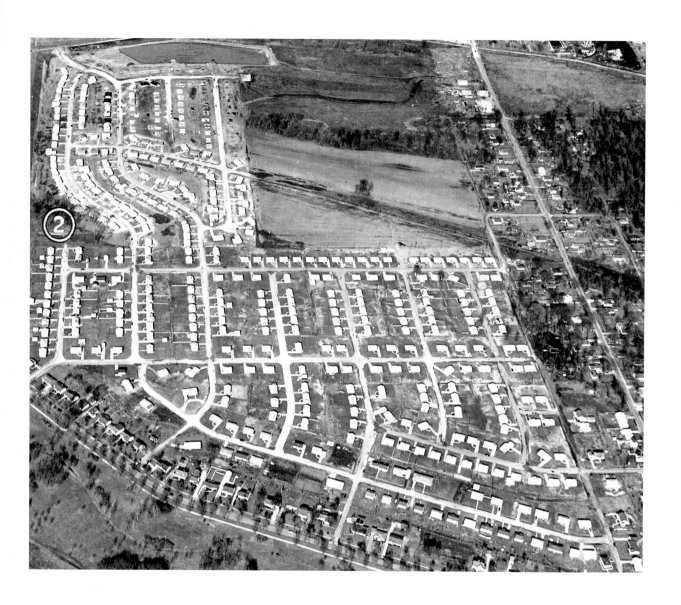

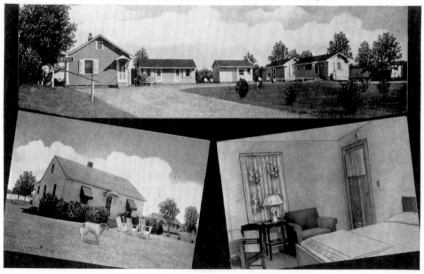

McCormick's Court . . . Vienna's Best . . . Vienna, Ill.

10.13 THE PARKSIDE SUBDIVISION, EAST ST. LOUIS, 1956

When the *East St. Louis Journal* published a similar view of this housing development a year later, all the vacant land shown here was filled with similar houses. The heading for the picture asked whether suburban sprawl was a "preview of the future." Would the city be transformed into one large suburb as subdivisions such as this were annexed to East St. Louis?

At this stage the Parkside Subdivision consisted of 365 homes. Illinois Homes, Inc. then added 111 more houses of the three-bedroom type in the undeveloped tract at the upper right. Most of the new houses in the earlier phases of construction were less-expensive, two-bedroom models. The vacant land at the lower left was a drained backwater lake that was to become part of a state park. The housing tract is located in the American Bottom, midway between two notable historic sites: the Cahokia Courthouse (fig. 3.7) just south of East St. Louis and the Great Mound of Cahokia (fig. 2.8) situated just north of the city.

10.14 MCCORMICK'S MOTOR COURT, VIENNA, 1954

This postcard sent in 1954 records a pleasant overnight stay in Vienna, a stop on U.S. Highway 45. The road led from the Ohio River, crossed the entire length of Illinois, and passed by the new Chicago airport (figs. 11.2–11.3), which would begin commercial flights in 1955. At the same time, the first McDonald's restaurant would open on this highway, a mile north of the airport.

The tourist cottages in southern Illinois had a warm, homelike feeling; travelers could even relax in lawn chairs in front of their home away from home.

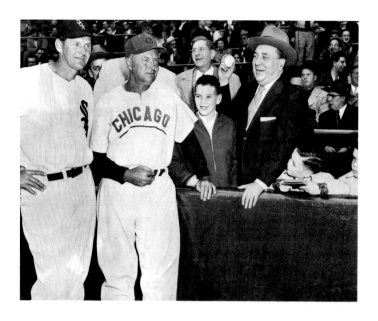

10.15 RICHARD J. DALEY, 1955

In the year of his first election as Chicago's mayor Richard J. Daley threw out the first ball at an exhibition game between the city's two major league teams. His four sons joined him for the occasion. Richard M. Daley, the eldest and future mayor (fig. 11.17) stands at his father's right hand as the two managers, Marty Marion of the White Sox and Stan Hack of the Cubs, look on. Family values were at the heart of the Daley's way of life. At the end of his career, Robert Cross, a reporter, pointed out that Daley "drew his own joy from a devoted family, the God with whom he communed each morning, and the city itself."

10.16 CALUMET RIVER COAL PORT, CA. 1957 (BELOW)

The coal loading facility of the Calumet Harbor in Chicago received trainloads of Illinois coal and shipped it to other Great Lakes ports and even to some foreign countries. Here, the Rail to Water Transfer Corporation's operation is at the height of activity. Some of the coal came from the Braidwood area near Chicago, but those strip mines became unprofitable by the 1960s, and coal shipments on the Calumet River gradually declined. Eventually, new uses, such as a golf course, were sought for land in the Calumet area (fig. 12.2).

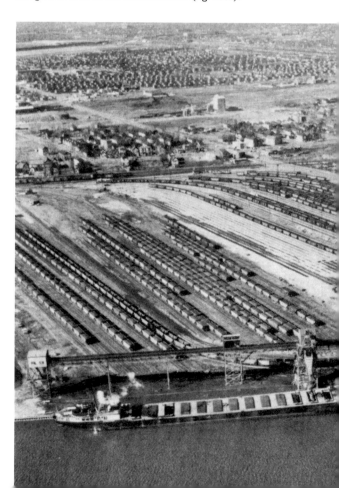

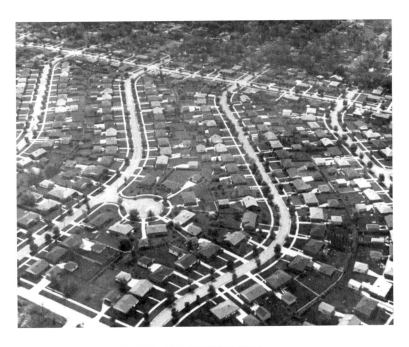

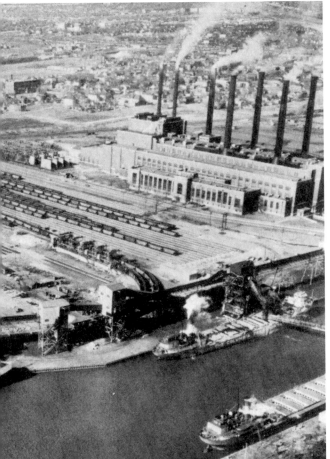

**10.17 EMERY MANOR
SUBDIVISION, CA. 1960 (*ABOVE*)**

This Elmhurst subdivision dates from the same time as the Parkside development in East St. Louis (fig. 10.13) and featured more expensive homes that usually came complete with a garage and more mature landscaping. Elmhurst was a well-established community offering schools, churches, and community services that reached back to its founding a century earlier. The development as it appears here is six or seven years after build-out. The developer has employed various approaches to avoid the "cracker-box critique" that some critics leveled at subdivisions such as Parkside.

A HISTORICAL CONTEXT	THE ILLINOIS EXPERIENCE	THE CHICAGO DIMENSION
1960 Seventeen African nations gain independence	**1960** Illinois population 10,081,158	
1962 Cuban missile crisis		**1962** Robert Taylor Homes completed
1963 President Kennedy assassinated	**1964** Lyndon Johnson proposes Great Society program in Chicago speech	
1964 Civil Rights Act		
1965 Medicare Act	**1965** Junior College Act	**1965** University of Illinois at Chicago Circle opens
	1967 Gov. Otto Kerner vetoes bill outlawing dumping dredging into Lake Michigan	**1966** Martin Luther King in Chicago
1968 Martin Luther King assassinated		**1968** Protests at Democratic National Convention
1969 Neil Armstrong walks on the moon	**1969** State income tax adopted	**1969** Black Panther raid
1970 Students killed in antiwar protests	**1970** Fourth constitution ratified	**1970** African Americans account for one-third of the population; 15 percent of city Spanish-speaking
1971 First e-mail sent	Paul Powell, late secretary of state, shoebox scandal	**1971** Stockyards closed
1972 President Nixon visits China	**1971** Woodfield Mall opens First Illinois Minimum Wage Law	**1974** Sears Tower completed
1974 Watergate crisis; President Nixon resigns	**1974** Fermilab dedicated	
		1976 Mayor Richard J. Daley dies
	1977 James R. Thompson elected governor, serves until 1991	
1978 Camp David Accords between Egypt and Israel		**1979** Jane Byrne becomes first female mayor
1979 Iran hostage crisis		
1980 Ronald Reagan elected president	**1980** Task Force on the Future of Illinois	
1981–83 Economy in recession		**1983** Harold Washington becomes first black mayor
1985 U.S. becomes a net debtor to foreign creditors	**1986** State employees win collective bargaining rights	**1987** Mexican Fine Arts Center opens
		1988 Chicago School Reform Act
		1989 Richard M. Daley elected mayor
1989 Savings and loan crisis	**1990** State adds only 4,084 citizens in the 1980s, the slowest growth in its history	
1990–91 Persian Gulf War	State legalizes riverboat gambling	

Timeline markers (left column): 1960, 1965, 1970, 1975, 1980, 1985, 1990

ELEVEN

Suburbanization and Globalization, 1960–90

TO SEE what was happening in America, one commentator advised in 1983, "head out to the mall." Shopping malls met the needs of an automobile society. Surrounded by sprawling parking lots, they recast main street shopping so that street traffic disappeared. Many were enclosed to banish unfavorable weather. Others took advantage of outdoor settings with pleasant landscaping. Although often maligned as cultural wastelands, most Americans in the decades after 1960 loved malls. They were clean, safe, and prosperous, and they brought people together. They provided shopping, services, entertainment, and jobs.

Malls were a suburban institution. They needed acres of land, broad roads to provide convenient access, and a lot of shoppers to support a multitude of stores. These prerequisites dictated suburban locations. Both city dwellers and those in rural areas used automobiles to reach these central markets for the booming consumer economy. If a rural town was too small to support a mall, its chances of survival grew dim. Cities that wished to hold their own had to

adapt, providing space for automobiles and other suburban amenities. One Chicago skyscraper even surrounded itself with a lawn and gardens.

Illinois malls also underscored the extent to which the state was embedded in a global economy. The merchandise available in the shops came from all over the world. It was seldom locally made. As the decades passed, more and more cars in the parking lots carried foreign labels. Manufacturing, especially the production of consumer goods, seemed to be leaving the state and nation. The steel mills along the Calumet River, now past their prime, shut down one by one. Farms specialized more than ever, and, adopting modern technology, they became larger, more efficient, and more productive. The number of farms and farmers steadily declined across the state. Every county lost dozens of farms. Many even lost population, although the state as a whole continued to grow at a modest pace.

People were on the move. With the widespread use of air conditioning, the Sunbelt states accounted for the great leaps in America's population. Thousands left Illinois to live in California, Arizona, Texas, Florida, and the like. The state's cities, especially Chicago, witnessed a mass migration from older neighborhoods to suburbs. And newcomers, most often black or Hispanic but including immigrants from every continent as well, moved into older neighborhoods. Slum clearance and urban renewal led to massive public housing programs that in turn seemed to compound urban problems. They cleaned the slums but strengthened the ghettos.

Thus, as many families were discovering the good life in suburbs, others faced crime, poverty, racism, and a general sense of loss. In 1977 the legislature created the Task Force on the Future of Illinois. "If existing trends continue," it concluded in 1980, "Illinois will be left behind in the national quest for opportunity in the future. The spotlight now seems to shine elsewhere, leaving Illinois in the shadow."

Looking at the state, community by community, revealed many shadows. Some cities, like East St. Louis and Cairo, were mired in deep poverty. Racial tensions simmered in these towns and in many others across the state. Chicago's problems received national notice in the 1960s: race riots, police raids, a Rustbelt economy seemingly wasting away, and, to top it all, a jarring clash between the establishment and the new generation of baby-boomers. The latter was put on display in classic terms during the protests at the Democratic National Convention in 1968.

Two years later the census of 1970 recorded that Illinois gained a million people in the 1960s, but it dropped in rank from fourth to fifth place among the states. In the next decade the state's population growth slowed to a snail's pace, increasing by less than 3 percent. "People in Illinois are worried about what the future holds," the task force reported in 1980. In taking its inventory of the state's resources, the commission found areas of great strength and urged

every citizen to shoulder responsibility, planning and working to use these assets so that "Illinois can have a future as bright as its past."

The task force, however, had little impact. Changes were already underway on many fronts that would transform the state. Chicago closed its stockyards in 1971 but was erecting the Sears Tower. The same year, IBM offered its first personal computer. It expected to sell 250,000, but the number soon exceeded three million. A new age had dawned. In 1976 long-term Chicago mayor Richard J. Daley died in office. His successors in the years ahead included the city's first female mayor and its first black one. In Springfield, James R. Thompson, a Republican from Chicago, became the state's longest-serving governor, holding office between 1977 and 1991. His gregarious personality and pragmatic approach to politics served him well, as did his focus on improving public safety and boosting the economy. Thompson's Build Illinois initiative, launched in 1985, used bond issues to

fund capital improvements throughout the state. He also supported a variety of cultural activities as a way to improve the quality of life and boost the economy.

To put the period from 1960 through 1990 into perspective, suburbanization benefited many, technology continuously refashioned life, color television became commonplace, machines took over the washing and drying of clothing and dishes, air travel came into reach for most, and computers demonstrated the capacity to dramatically increase productivity.

The world seemed to shrink as transportation and communications pulled far-away places close together. The spread of Western technology and the English language encouraged a global economy. New markets opened for crops, products, services, and ideas made in Illinois. As the state became more suburban it also became an integral part of the global economy. There were significant costs associated with these changes along with marked advantages,

but neither sacrifices nor rewards were evenly distributed. Not everyone could move to the suburbs; many who could not afford to do so lost their jobs as manufacturing industries departed for the Sunbelt or moved overseas. Others were shut out of the good life by racism and prejudice. Still others lost family farms, often mortgaging the land at the wrong time to pay for modern equipment.

The black ghettos of the nation's cities became focal points of protest against society's problems in the 1960s. Racism and poverty combined to exclude African Americans from sharing in the American Dream symbolized by suburbs, almost all of which were white. Urban riots during the hot summers underscored what Otto Kerner, a former governor of Illinois, called the "sadness of our time." President Lyndon Johnson had asked Kerner to head a national commission to investigate the causes of the urban disorder. "Our nation is moving toward two societies," the task force reported in 1967, "one black, one white—separate and unequal." Many of

the commission's specific recommenda-
tions were not followed due to the grow-
ing distractions of the Vietnam War, but
its overall message pushed society to
recast its thinking on race and poverty
and begin changing its practices. Like
the rest of the nation, the response of
Illinois to the Kerner Report brought
mixed results over the next decades. In
1990, observers noted that the problems
spelled out in the document had deep
roots, making reform especially difficult.

A reporter studying the state in 1967
decided at the end of his investigation to
search for the state's fundamentals. Ev-
erywhere he went, he wrote, the license
plates on cars reminded him that he was
in the "Land of Lincoln," so his article
ended as he stood on a windswept knoll
overlooking the Sangamon River. There,
where Lincoln helped his father put up
a log cabin, Robert Paul Jordan looked
beyond the trees outlining the river's
banks to "this good land spreading to
the horizon. I think I came closest then
to knowing him, and Illinois." If the
challenges ahead had deep roots, so did
the resources available for mastering the
situation. That seemed to be the Illinois
story: great problems, enormous chal-
lenges, substantial resources, and bound-
less possibilities.

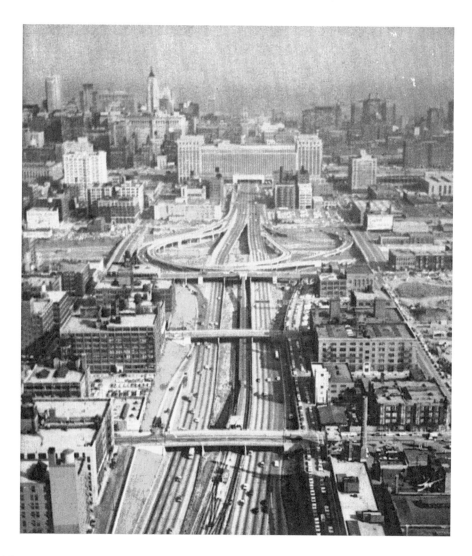

**11.1 CHICAGO: AN EXPRESSWAY
INTERCHANGE, 1964**

The cover of the 1964 Official Highway Map of
Illinois featured this photograph. It shows what
would be named the Eisenhower Expressway's
interchange with Interstate 90, portions of which
were later named for President John F. Kennedy
and Dan Ryan, a popular local political leader.
The freeway from Chicago's western suburbs
passed through the city's main post office to
reach the central business district. Where the
road met Grant Park, a mile east of the inter-
change, protesters would clash with police during
the 1968 Democratic National Convention.

The message from Gov. Otto Kerner on the
map reported that the state had completed 711
of the planned 1,585 miles of its interstate high-
ways. Meanwhile, the factories in the foreground
continued to produce a wide variety of goods:
children's books, men's overalls, women's
undergarments, boxes, labels, and electrical
equipment. By the time the interstate system was
finally completed, about 1990, all of these facto-
ries would be closed.

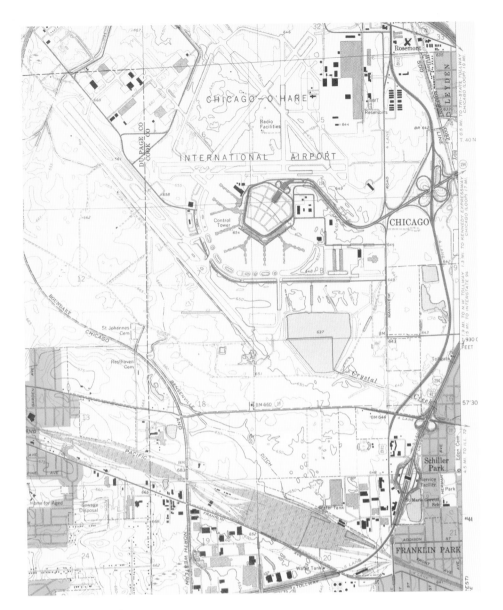

**11.2 CHICAGO-O'HARE
INTERNATIONAL AIRPORT, 1963**

The Elmhurst Quadrangle of 1963 carefully traced the topography of Chicago's airport and its surroundings. Parts of the Interstate Highway System can be seen on the right-hand side of the map, with an extension of Interstate 90 reaching a huge parking facility surrounded by the airline terminals. O'Hare had only one long runway at the time to service large jets. The extensive Bensenville railroad yards just south of the air-

port assembled freight trains for trips across the continent.

Several creeks and ditches appear on the map. These waters flow into the Des Plaines River, which, in turn, becomes part of the Illinois River system (fig. 1.7). Water from O'Hare flows across the state and then under the Eads Bridge (fig. 8.9) on its way to the sea.

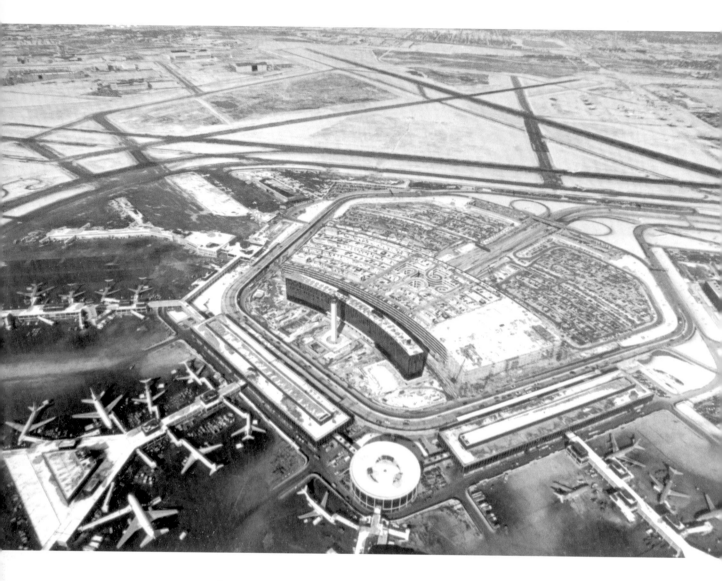

11.3 CHICAGO-O'HARE INTERNATIONAL
AIRPORT, 1970S

The airport, about a decade later, reveals a strik-
ing clarity in the original design that would be
qualified by later expansion of facilities. The
airport seems to pivot around the control tower,
with the crescent of a hotel on one side and a for-
tresslike terminal complex on the others. Aircraft
line up at the spokelike gates extending toward
the runways beyond. Behind the hotel stood the
world's largest garage, four curving ramps at its
center. An overflow parking lot completed the
scene, with the access highway stretching like
an umbilical cord to connect the airport, and the
world beyond, to the city center. In 1970 mass
transit facilities joined the expressway to provide
a light rail connection to Chicago's comprehen-
sive public transportation system.

11.4 METRO EAST, 1964

Illinois Power Company officials admire the new logo for the region east of the Gateway Arch. The arch, a soaring tribute to the Louisiana Purchase and national expansion, was about to be erected on the west bank of the Mississippi River on the original site of St. Louis. Illinois is therefore at the top of the stylized map on the logo, and the river runs between the states. The Illinois side of the metropolitan area was referred to as the region's Industrial Center. Given this perspective, Illinois and the Mississippi Basin look toward the Atlantic Seaboard, just the opposite of Charles Nordhoff's westward orientation in figure 1.10.

11.5 GLOBAL CONNECTIONS, 1967

The age of suburbanization was also a period of globalization. Scott Air Force Base, just beyond the Metro East region in 1967, housed the Military Airlift Command. On a map the base looked like a suburb of the suburbs, but it was also a window to the world. Founded in 1917 at the entry of the United States into World War I, Scott Field (pictured here in 1942) was named after the first enlisted man to die in an airplane crash, which had occurred five years earlier.

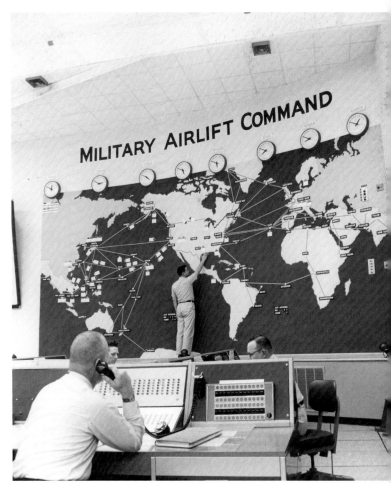

11.6 COME TO CHICAGO (*LEFT*)

This cover for a promotional brochure points to the many ways visitors could enjoy sun and fun in the late 1960s: sailing on Lake Michigan, golfing, watching Major League baseball, attending museums, and shopping on the Magnificent Mile. The image, however, seems to revolve around the twin towers of Marina City, suggesting that the best attraction may have been the city itself, especially its spectacular architecture.

Marina City begins with a marina at the river's edge and then devotes several floors to restaurants, stores, and entertainment venues. Next come eighteen floors of parking topped by several hundred wedge-shaped apartments.

11.7 A METROPOLITAN MODEL, 1967

The Comprehensive Plan of Chicago, developed during the mid-1960s, used this image in its summary report in 1967. It was one of ten models that explained the dynamics of the city in a very generalized fashion. A major point of the planners was that the resources concentrated at the center of the city should be readily accessible from all parts of the metropolis. The plan warned against "directionless sprawl" and urged that excellent transportation facilities should help make housing, jobs, and other opportunities equally available to everyone. The hub and spokes pattern features larger suburbs along the wheel's rim, the Tri-State Tollway on a real map. An alternative model of the metropolis is presented in figure 11.13.

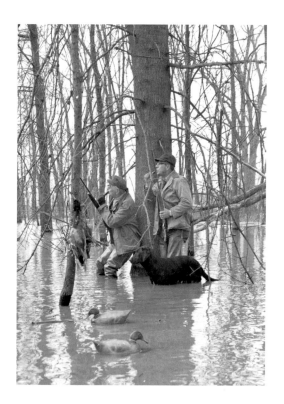

11.8 LAKE CARLYLE, 1968

In 1953 agricultural interests formed the Kas-
kaskia Valley Association to advocate a flood con-
trol plan for the entire basin. Five years later the
U.S. Congress approved a proposal developed
by the U.S. Army Corps of Engineers in coopera-
tion with the association and local residents. The
Carlyle Dam, completed in 1965, created a lake to
store flood water and provide recreational oppor-
tunities, including duck hunting, pictured here,
at the far end of the impoundment. The dam was
only one part of a comprehensive plan that in-
cluded levees, other reservoirs, parks, and locks
to open the lower course of the river to barges.
Cheap water transportation, it was thought,
would encourage use of the area's coal mines.

11.9 THE RELIGIOUS CENTER DOME, EDWARDSVILLE, BUILT IN 1971 (*LEFT*)

Illinois established the Edwardsville campus of Southern Illinois University in 1965 to provide a school for commuters in the St. Louis metropolitan area. A nonprofit group then hired R. Buckminster Fuller to design a suitable building for the religious needs of the students. Fuller, an SIU professor known around the world for his creative ideas, turned to one of his favorite innovations, a geodesic dome, to be the focal point of the center. The glass dome would outline the continents and the world ocean, a decorous covering for a sacred space dug into the Illinois soil and a fitting image to contemplate the state of the earth in the modern age. Fuller continued a long-established tradition of using innovative architecture for worship in Illinois; see figure 9.5.

11.10 MAIN STREET, BELLEVILLE, 1973

Belleville's Main Street, running east and west, is aglow with lights beckoning shoppers on this November evening. The city with a French name ("beautiful town") and a German heritage became the county seat of St. Clair County four years before Illinois became a state. Here, however, it presented an up-to-date shopping mecca just before the focal points of retail sales would move to suburban malls.

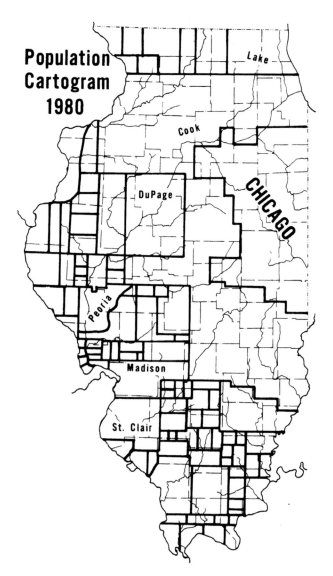

Population Cartogram 1980

Lake

Cook

DuPage

CHICAGO

Peoria

Madison

St. Clair

11.11 ILLINOIS: A CARTOGRAM OF POPULATION BY COUNTIES, 1980

A cartogram is a graph that is shaped like a map to resemble an outline of a geographical entity. Here the image looks like Illinois, but the interval divisions, following a generalized geographical pattern, reflect the relative sizes of their populations. The city of Chicago and Cook County dominate the state. If one includes the collar counties, Lake, McHenry, Du Page, Kendall, and Will, the metropolitan region accounted for almost two-thirds of the state's citizens in 1980. The actual geographical extent of each county is presented by the lighter lines, along with the state's major rivers.

11.12 A RALLY FOR EQUAL RIGHTS, JUNE 6, 1982 (BOTTOM/RIGHT)

Illinois became a major battleground over the Equal Rights Amendment in 1972 when Congress passed the measure and sent it to the states for ratification. A constitutional provision, it was thought, would advance women's rights in a sweeping way rather than piecemeal reforms on the state and local level. In the first year supporters garnered twenty-three of the thirty-eight needed votes, but Illinois rejected the amendment. Moreover, Phyllis Schlafly, a spokesperson for the conservative wing of the Republican Party, founded Stop ERA in her hometown, Alton. Stop ERA was a national organization, but it proved to be most effective in Illinois, which repeatedly voted no. Congress even extended the deadline for ratification until June 30, 1982.

In spite of numerous demonstrations, marches, and even a hunger strike in the state capitol, the amendment fell four states short of passage. Illinois has a long tradition of protest and political action (e.g., figs. 8.7 and 8.15), but it was the only large industrial state to reject the Equal Rights Amendment.

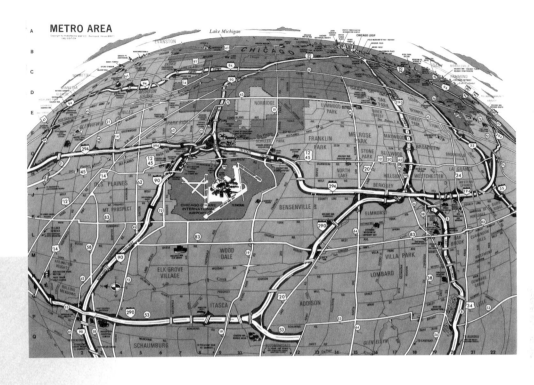

11.13 THE CHICAGO METRO AREA, 1982 (*ABOVE*)

The growing importance of Chicago's suburbs and the centrality of the O'Hare Airport in the air age led to a novel presentation of the Metro Area in 1982. This image from the Perspecto Map Company used the city's expressways as a way to connect the various suburbs, with O'Hare taking the central focus. East is therefore at the top of the map. In 1982 the expressway system in view was not yet completed, which explains the stub of State Route 53 at the lower center.

Chicago's Loop, the central business district, is at the map's periphery on the edge of Lake Michigan, which functions like the ocean sea in tracing the curve of the globular planet. Set this portrayal alongside the metropolitan model in figure 11.7.

Suburbanization and Globalization, 1960–90 **196** • **197**

11.14 CHICAGO NEIGHBORHOOD FESTIVALS, 1986

In 1986 Harold Washington, the mayor of Chicago, supported various neighborhood festivals around the city. Some were in ethnic neighborhoods, featuring particular cultures, while others recognized the significance of a certain location. All Chicagoans, and visitors from other areas as well, were welcome to join in any celebration. In this image for the cover of the summer's schedule of events, the stand at the beginning of the jammed street sells a variety of food. The elevated train that brought many people to the festival as well as the downtown skyline at the center of the city are pictured as well.

The four stars on the banner echo Chicago's flag in recalling four milestones in the city's history: Fort Dearborn (fig. 6.4), the Great Chicago Fire (fig. 7.15), the World's Columbian Exposition (figs. 8.18–8.19), and the Century of Progress (fig. 10.1).

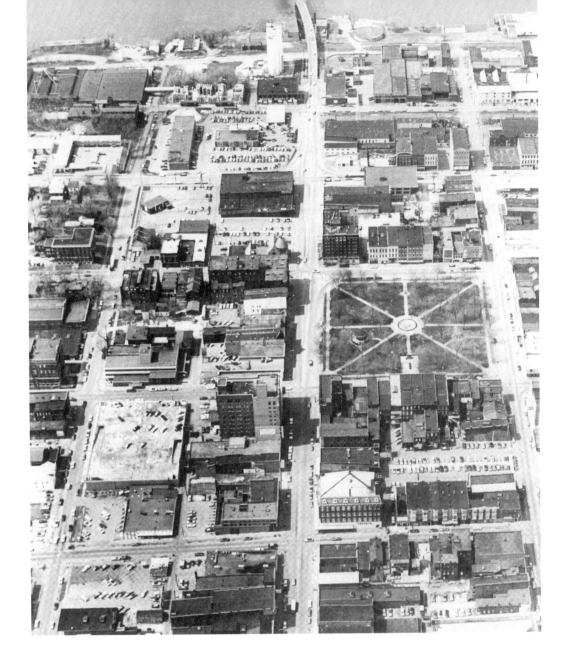

11.15 DOWNTOWN QUINCY, 1987

This aerial photograph looks west, toward the Mississippi River at the top. Here, storage tanks and industrial facilities line the riverbank. Maine Street, the broad avenue leading from the bridge through the center of the city, functioned as a central thoroughfare although it carried the name of the state. Washington Park dated from the very beginning of the city. Lincoln and Douglas

debated in the park in 1858, and William Jennings Bryan spoke there a half-century later.

Note the amount of space devoted to parking, including a multilevel parking facility occupying half a city block on the left. In 1978 Quincy Mall opened at the eastern edge of the city, taking much of the commercial activity out of this area to a suburban location.

11.16 NUMBER OF FARMS LOST, 1969–87

Each dot on this map represents the loss of ten farms, a dramatic image that is even more so when one realizes the data cover only eighteen years. During the same period the average size of an Illinois farm increased 32 percent, from 242 to 321 acres. Farmland consolidation eliminated fencerows, farmsteads, and wooded areas to make the fields more productive. Many farm losses in the northeastern part of the state were due to suburban development.

11.17 RICHARD M. DALEY

After the death of Richard J. Daley the leadership of Chicago passed to a succession of mayors, including the city's first woman mayor and first black mayor. The death of the latter, Harold Washington, a reformer, in 1987 created a political vacuum. Richard M. Daley, a former state senator, stepped into this void and quickly realized that the city had entered a new era. A return to his father's style would not work. He promised new ideas and a new enthusiasm on election night, April 4, 1989. His approach, delivering a "calm, stable, businesslike government," soon received accolades when he was selected as one of America's best mayors. On April 19, 2005, sixteen years later, the *Chicago Tribune* noted on the fiftieth anniversary of his father's inauguration that Richard J. Daley had "posthumously achieved what every father yearns for: a son more accomplished than the man who raised him."

A HISTORICAL CONTEXT	THE ILLINOIS EXPERIENCE	THE CHICAGO DIMENSION
1990	**1990** Amended Clean Air Act leads to decline in demand for Illinois coal	**1990** City drops to number thirty-seven in ranking of world cities by population
1991 USSR dissolved, end of the cold war		**1990–98** Michael Jordan leads Bulls to six basketball championships
1993 North American Free Trade Act	**1993** Great Mississippi River flood	**1992** Sears relocates from Downtown to Hoffman Estates
1995		
	1996 State of Illinois sets up a Web page	**1996** Demolition of high-rise public housing begins
1997–2006 U.S. housing boom lifts prices 85 percent above the inflation rate		
1999 Federal bank regulations repealed		
2000 George W. Bush elected president in a contested election	**2000** Population reaches 12,419,293; about a third are in Chicago, a third in the suburbs, and a third in the rest of the state	
2001 Terrorist attacks on 9/11		
	2001 Major wetlands restoration effort begins near Hennepin	**2003** Meigs Field closed
		2004 Millennium Park dedicated
2005		
	2006 Report indicates that more than five million citizens in Illinois live in or near poverty	**2007** Mayor Richard M. Daley elected to sixth term
2008 Severe economic recession takes hold Barack Obama elected president	**2008** Voters reject call for a constitutional convention	**2008** Victory rally in Grant Park for Barack Obama
2009 Economic Recovery Act	**2009** Gov. Rod Blagojevich removed from office by impeachment	
2010 Major oil spill in the Gulf of Mexico		

TWELVE

Entering Century 21

Illinois after 1990

AS ILLINOIS entered Century 21 its future seemed brighter. During the 1990s the state's population had increased by almost a million people, a great contrast to the 1980s when the comparable figure was only about four thousand. The pace slowed somewhat in the new millennium, and more people now leave the state than arrive, but a healthy birth-death ratio keeps the population expanding at slow but steady pace. In contrast, the nation as a whole is growing faster. This means that although Illinois can expect to continue losing representation in the House of Representatives, it continues to be a "large state" and retains a leadership role in national affairs.

Almost all the net gain in population of the state between 1990 and the present has occurred in the five collar counties around Chicago. Nevertheless, the figures for Chicago and Cook County continued to decline. If it were not for the fact that thousands of immigrants have come to the Chicago area in recent decades, Illinois would have experienced a severe drop in population. The 2000

census recorded 1.4 million foreign-born people residing in the metropolis, a figure representing more than 10 percent of the state's total population. About half of these new residents came from Latin America, fewer than a fourth each from Europe and Asia, with most of the balance coming from Africa. Of a total state population reaching close to thirteen million, the black and Hispanic segments each account for about two million people.

The redistribution of people within Illinois has put additional strains on the state's ability to provide housing, schools, roads, and the needed infrastructure to accommodate these shifts. In rural areas across the state old farmhouses and stores on main streets are vacant or underutilized, whereas in the booming suburbs more than 10 percent of the local economy was often based on new construction.

Statistics, of course, do not tell the whole story, but they clearly indicate that the major challenges facing Illinois over the coming quarter century will be concentrated in the northeastern corner of the state. Two million more people are expected in the metropolitan area that currently wastes $4 billion a year in traffic jams. In lost time these traffic delays add up to 253 million hours each year in Chicagoland.

Put another way, the out-of-pocket costs of traffic congestion in the Chicago area add up to about $300 per person for the entire state, a significant loss to an economy in which 1.5 million individuals live in poverty. This latter number includes almost one of every five children in Illinois. A detailed study in 2005 warned that conditions were expected to worsen in the near future because most economic growth in the state was creating low-paying jobs that could not lift families out of poverty even if there is enough work to go around. The recession at the end of the decade made matters even worse as the jobless rate exceeded 10 percent. In addition, improvements in education statewide were failing to keep up with global trends.

But Illinois entered Century 21 with

some notable successes as well as a host of challenges. The environmental movement had taken hold in every part of the state, and a chorus of voices pushed society into making more responsible decisions, giving thought to the future state of the earth. Public attitudes toward wetlands and natural environments underwent a notable shift during the 1990s, and perhaps a similar revision of thinking will animate discussion of other challenges facing society.

"Barely 20 years ago," the *Chicago Tribune* observed in 2004, "Chicago [and Illinois as a whole] was losing everything that mattered from an economic standpoint: factories and jobs, population and tax base, confidence in government as well as faith in the business community." But, the editorial continued, the city "reinvented itself" to put the metropolis into a good position to reap benefits from globalization. Then financial collapse called much of the old economic wisdom into question. Watching the ups and downs of the stock market as the recession began in 2008 it

was easy to miss the nagging shortcomings facing the state as a whole. A study of the state's economy in 2005 pointed out that Illinois had been losing higher-paying manufacturing jobs and replacing them with lower-paying jobs in the service sector. As a result, the median household income dropped $6,000 between 1999 and 2005. In many respects the state mirrored national trends. As one commentator noted, no net job creation occurred in the nation as a whole in the decade following 1999.

Illinois, it was true, continues to enjoy advantages of soil and climate, location and resources, heritage and innovation. It has done more than its fair share to fashion modern life. Its agricultural sector set the pattern for the world's farmers. Corn has become the earth's most widely planted crop, and machinery from Moline, Peoria, Chicago, and other midwestern cities can be found throughout the world. On any given day more than fifty million people visit one of thirty thousand McDonald's restaurants around the globe, similar to

that first one in Des Plaines. One could speak of the Chicago School in terms of architecture, literature, sociology, or economic thought in any university in the world and people would understand.

To be sure, the golden age, when Illinois fields and factories worked in tandem to dazzle every observer, has receded into history but so have the doomsday assessments of the Rustbelt litany. Economic diversity; a commitment to research and development; and a quest for justice, basic fairness, and human values are all deeply rooted in Illinois. So, unfortunately, is political corruption. Nevertheless, the conviction that people can make a difference is still widespread. "Yes we can" became a national refrain in 2008. How much it will matter is really up to us.

In 1979 Mary Nelson moved into Chicago and used a few thousand dollars of her own money to start Bethel New Life at her church. She was still at work a quarter century later, leading one of the nation's most successful community development efforts. Her organization has helped thousands of families over the years, giving them most of all a sense of possibility. "The thing that propels us," she said in 2004, is faith, a commitment "to be about the work of making room for everybody at the table." Such dedication attracted young people like Barack Obama to the Land of Lincoln. He learned how to foster community well-being on the other side of town.

What would an agenda look like if an assembly were to be convened to help Illinois realize its full potential? In November 2008, voters decided not to call for a new state constitution. Nevertheless, a desire for change animated the election that year, which elevated a citizen of the state to the nation's highest office. "Yes we can," the multitude chanted in Grant Park as the final votes were tallied. Old problems, of course, continued to sap society's strength, among them poverty, racism, environmental degradation, gender issues, selfishness, short-term thinking, and political corruption. And new ones were added

as the state and nation faced a deepening and lengthening economic crisis.

In taking inventory of the state's assets and liabilities, one could start with the land itself, with the extraordinary fertility of the prairie soils. In Illinois, agriculture has always been of fundamental importance, and it continues to play a substantial role in the national and world economy. Global discussions refer to the "Midwest agricultural miracle" and place Illinois as the region's leader, but soil erosion and degradation continue to be major problems. Water, the state's essential resource, is a blessing that climate and location have provided in abundance. Again, however, the state will face major problems if current trends continue. Measuring mineral resources, Illinois has a bountiful supply of coal, but new technology is needed to reinstate it to high rank on the state's list of treasures. The limestone underlayment for the soils of Illinois also provides many benefits that are often not acknowledged.

The state's human resources are probably more important than its natural gifts. The Land of Lincoln offers great examples of the democratic way to uphold essential human values. In 2002 Elmhurst dedicated its Millennium Fountain, a group of rugged rocks chiseled to suggest people from different places coming together to share a civic vision. "This sculpture is designed to be interactive and approachable," the sculptor, Dan Kainz, declared. The figures "pay homage to the spirit of cooperation in a community. The flowing water . . . represents a time and place that continues to change and give birth to new life and ideas."

In the closing weeks of 2008 Illinois showed two aspects of its politics to the nation and the world. The heights of glory came first as Barak Obama acknowledged the cheers of the multitude gathered on the shore of Lake Michigan. The world took notice of the first person of color to reach the nation's highest office. Then, in the following weeks, the state's governor was accused of taking advantage of the situation and seeking personal gain from his power to appoint

Obama's successor to the U.S. Senate. In Gov. Rod Blagojevich's subsequent impeachment, Illinois sank to the depths of disgrace. The world took notice again. Both men, the new president and the fallen governor, learned the rudiments of practical politics on Illinois soil, in the neighborhoods of the city and the halls of its legislature. They apparently learned different lessons, however, and used their knowledge to serve different ends.

Freedom gives choices, and sometimes we choose the wrong ways. This is true on a personal level as well as in community and governmental affairs. When President Obama returned to Springfield on February 12, 2009, to mark Lincoln's two-hundredth birthday, he observed that "while each of us must do our part, work as hard as we can and be as responsible as we can . . . in the end, there are certain things we cannot do on our own. There are certain things we can only do together." That is why we need a state and a union of states. Lincoln believed that "the mystic chords of memory," when touched "by the better angels of our nature," would swell the chorus of the Union, "giving a new birth of freedom; and [ensuring] that a government of the people, by the people, for the people" would "not perish from the earth." The name *Illinois* in its most ancient meaning refers to the people. It is the Land of Lincoln. It is my land and your land, my people and your people, our heritage and our hope. We are all here, on the prairie, together.

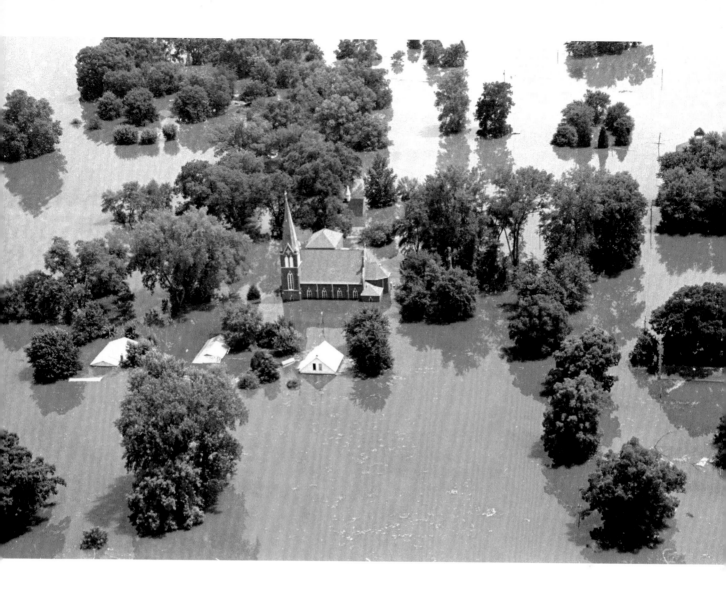

12.1 THE GREAT FLOOD, 1993

Although eclipsed in the next decade by hurricanes in the Gulf of Mexico and wildfires in California, the great flood on the Mississippi River and its tributaries alerted America to the vulnerability of modern society to natural disasters. Thousands of Illinois National Guard troops were called out to help civilians construct sandbag levees to protect communities and farmland from "perhaps the nation's worst" flood. Levees near Kaskaskia ruptured, submerging the town under nine feet of water (above) and leading to its evacuation. At the height of the tide, a million cubic feet of water per second passed under the Eads Bridge linking Illinois and Missouri at St. Louis. After the water receded, four towns in Illinois abandoned their riverfront locations and built new communities on the bluffs above the floodplain.

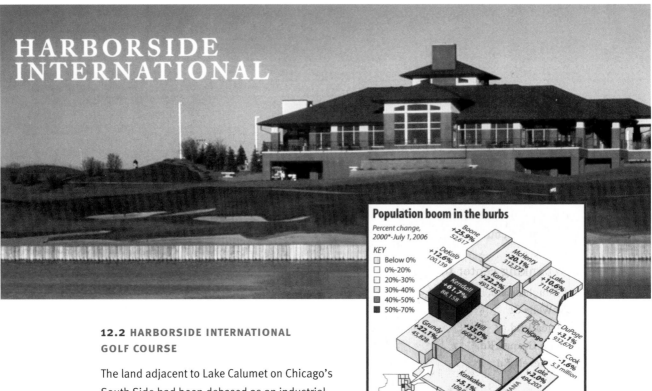

HARBORSIDE INTERNATIONAL

Population boom in the burbs

Percent change,
2000*–July 1, 2006

KEY
- ☐ Below 0%
- ☐ 0%–20%
- ☐ 20%–30%
- ☐ 30%–40%
- ☐ 40%–50%
- ☐ 50%–70%

Boone +25.9% 52,617
DeKalb +12.6% 100,139
McHenry +20.1% 312,373
Kane +22.2% 493,735
Lake +10.6% 713,076
Kendall +61.7% 88,158
Grundy +22.1% 45,828
Will +33.0% 668,217
Chicago
DuPage +3.1% 932,670
Cook –1.6% 5.3 million
Kankakee +5.1% 109,090
Lake +2.0% 494,202
Newton –1.9% 14,293
ILL. IND.
INDIANA
25 MILES

12.2 HARBORSIDE INTERNATIONAL GOLF COURSE

The land adjacent to Lake Calumet on Chicago's South Side had been debased as an industrial site and city dump for almost a century. The only way to convert it to a useful purpose was to seal it with a thick layer of clay, and it just so happened that excellent material for this purpose was at the bottom of the lake. Therefore, a dam was constructed so a portion of the lake could be drained to take up the clay. In the end, two championship golf courses emerged on the 448-acre site, along with a complex of prairie-style buildings. Leading a host of accolades, the Harborside project received an award for being America's Outstanding Environmental Project in 1996. Its name takes on additional meaning when the history nearby comes to memory (fig. 10.16).

12.3 POPULATION BOOM IN THE BURBS

The *Chicago Tribune* created this this illustration to show the explosive growth of the collar counties around Chicago in the twenty-first century. Cook County, which includes Chicago, declined in population during this period, and nearby Du Page County grew at a rate of 3 percent—nearly thirty thousand additional people. The spreading out of the metropolitan area restyled the landscape. These changes had implications for the political, economic, social, and cultural structure of the entire state. In the near future, fewer than one-fourth of the people of Illinois are expected to reside in the ninety-one counties not shown on this map.

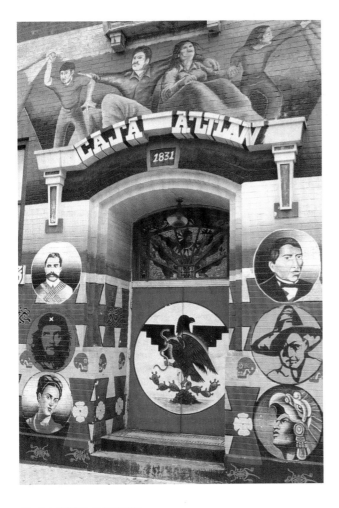

12.4 LATINO ILLINOIS

The most dramatic change in the population of Illinois in recent years has been the coming of Hispanic people, primarily from Mexico but from many states and other countries as well. About half of the 1.6 million Latinos in Illinois live in Chicago, another half are in the suburbs, and a small number are scattered throughout the rest of the state. A survey conducted in 2002 found that more than forty thousand Latino-owned businesses abide in Illinois, with more than $7.5 billion in total sales. This represented a 44 percent increase over the previous five years. Nearly half of the Latino people now live in owner-occupied homes, a remarkable achievement for any group of comparable immigrants.

The settlement house pictured here about 1996 was founded in 1905 as the Howell Neighborhood House and promoted the welfare of the Bohemian immigrant community centered at Eighteenth Street and Racine Avenue. As the neighborhood filled with people of Mexican heritage during the 1960s and 1970s, the Casa Aztlan took over and murals soon covered the facade of the old building. When the murals began to fade, they were repainted and somewhat revised in a community project led by Marcos Raya, a noted mural painter with roots in both Mexico and Springfield. This version of the mural was completed in 1993.

12.5 ILLINOIS GATEWAY ON THE WEB

George H. Ryan, the Illinois secretary of state, sponsored the state's first official Website in 1996. Various agencies under his office's general direction offered many different types of information on the site, but the centerpiece for the main page, pictured here, is especially interesting. The outline map employs a few simple elements: a major river flowing through a green countryside and a wide highway running from the tall urban structures in the northeast corner to the far reaches of the state. Along with the stylized and stylish automobile, the images suggest an accessible, bounteous state with a major city, central river, and broad horizon.

12.6 PRAIRIE CROSSING (LEFT), 2003

Prairie Crossing is a green community in Lake County that features hundreds of acres of protected open land, many facilities for outdoor recreation, a charter school with an environmental curriculum, and an organic farm. Following a plan approved in 1992, residents can walk to public transportation, including commuter railroads to O'Hare Airport and Downtown Chicago. This aerial view of one neighborhood, taken in August 2003 by the celebrated photographer Terry Evans, shows the traditional midwestern style of the community's architecture as well as the buildings' placement in a natural setting.

12.7 MICHAEL JORDAN AND
THE NEW CHICAGO IMAGE

When the Chicago Bulls drafted Michael Jordan as the third pick in the National Basketball Association's annual draft of college players in 1984, the team's management was disappointed because the player they really wanted was selected before their turn. The second choice for the Second City, however, turned out to be the foremost professional athlete of his time. "Air Jordan" gained fame across the nation and around the world, fashioning a new image of success for the City by the Lake. The Bulls won a clutch of championship titles in the 1990s. This statue, *The Spirit* by Omri Amrany and Julie Rotblatt Amrany, at the entrance to the United Center, carries an inscription that points to the star player "suspended above the Earth, free from all its laws like a work of art."

Athletes emerged in the twentieth century as heroic figures who brought people together and tied them to the community. In this respect Red Grange (fig. 9.14) and Michael Jordan played very similar roles.

12.8 PIONEER COURT, SEPTEMBER 14, 2001

Thousands of people gathered at the site of Jean Baptiste Point Du Sable's pioneer farm and trading post (fig. 5.1) for a prayer service following the September 11 terrorist attacks several days earlier. A gallery of classic skyscrapers flanked the historic Michigan Avenue bridge on that warm, sunny afternoon as the throng spilled into the street, stopping traffic. All Americans interrupted their daily routines for moments of reflection in those uncertain times.

This particular location, at the mouth of the Chicago River, was well known to the Native Americans and visited by the first European explorers. It long served as the focal point of the metropolis and a grand gateway to the entire state (fig. 9.12).

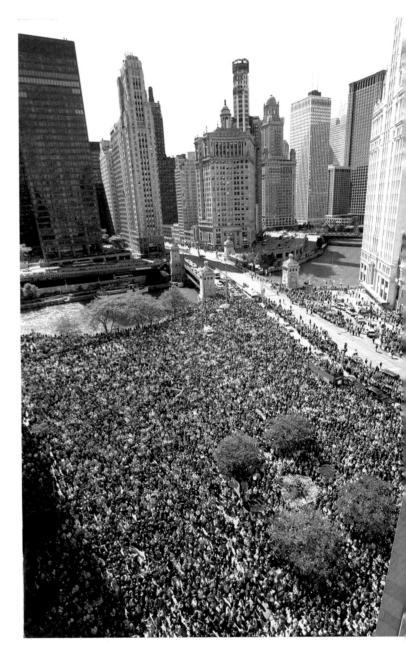

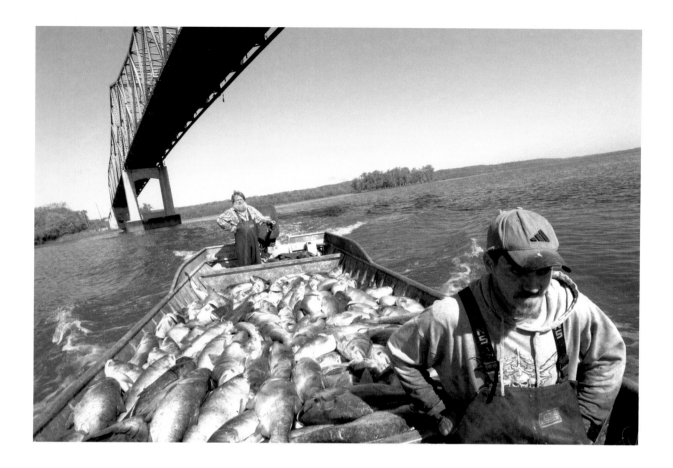

12.9 HARVESTING THE ILLINOIS RIVER, 2006

People have harvested food from the Illinois River since the beginning of settlement. Fishing continued as an important part of the Illinois economy throughout the nineteenth and early twentieth centuries. During the 1970s more than seven hundred commercial fishermen worked on the Illinois River, a number that had dropped to fewer than a hundred by 2006. One reason for the decline was the invasion of Asian carp, several invasive species that pushed up the Mississippi River to dominate the water. Carp hold an important place in Oriental cuisine, and a new industry began as a market developed for the carp in Asian American immigrant communities. Orion Briney's operation near Lacon, for example, sent ten thousand pounds each day to ethnic stores in Chicago, New York, and Los Angeles.

There was room for more fishermen because about sixty-five million pounds of these carp continued to swim in the Illinois River. As the fish moved northward, they disrupted the ecology of the river, pushing out native species and threatening to reach Lake Michigan, where, it is feared, they will work ecological havoc in the Great Lakes (fig. 1.7). Because a $4 billion sport and commercial fishery was endangered, other Great Lakes states brought suit against Illinois in 2010 and requested that the canal links to Lake Michigan be closed, severing a connection dating back to 1848.

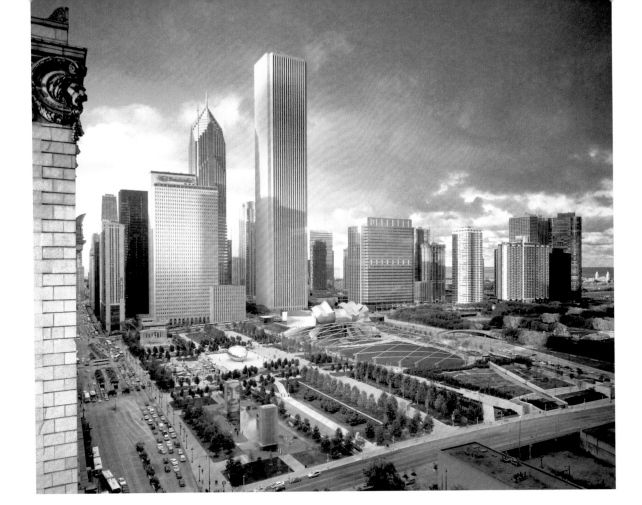

12.10 MILLENNIUM PARK, CHICAGO

In 1971, a Chicago lawyer decided to run for governor in the next year's election. To meet the people of Illinois and get name recognition Dan Walker walked, in zigzag fashion, the length and breadth of the state, some 1,197 miles in 116 days. If we were to embark on a similar journey today, aiming to get a handle on the problems and possibilities of the Prairie State, what route should we take?

One plan would start on Commercial Street in Cairo and certainly visit Lincoln's New Salem as well as one of the state's major research universities, but the journey would probably end at Millennium Park in Chicago. Here the city took an eyesore at the edge of Lake Michigan, land used in the past for railroads, industry, and a parking lot, and transformed it. The idea was to help visitors welcome the new millennium by interacting with nature, art, heritage, and each other. Millennium Park is a place to see your face in one piece of art and view hundreds of others in a fountain, to enjoy a concert in an audience of thousands or discover the wonder of crossing a snakelike bridge in solitude.

In the park one can jump in water in summer, ice skate in winter, or walk through a garden in any season. Here one can feel humanity fully alive. Then it would be time to sit and reflect on walking through the history and geography of Illinois, a state looking forward to its bicentennial in 2018.

12.11 A FLAG FOR OUR NATION

The U.S. Postal Service unveiled the design for a new postage stamp in the "Flags of Our Nation" series in August 2008. The Illinois flag features the great seal of the state on a white background. The new stamp also includes an optimistic sunset on the prairie, which highlighted a windmill, pro- duced, no doubt, at one of the large agricultural machinery manufacturers spread across the state. The selection of a windmill as a symbol for Illinois speaks of both the rural and urban economies of the state (fig. 9.2) as well as the ecologically ap- proved use of wind power. The red sky points to a new day coming, with pleasant prospects and a sunny sky. The stamp does not indicate, however, that Illinois is an urban state. There are cities on the prairie, especially the Chicago metropolis that houses two-thirds of the state's inhabitants.

12.12 A HISTORIC MOMENT (*TOP*)

E. Jason Wambsgans, a gifted photojournalist with the *Chicago Tribune,* took this shot of part of the multitude of people celebrating Barack Obama's victory on election night, November 4, 2008. The image captures the excitement of the occasion as it documents the orderly working of American democracy. The discipline of the crowd adds luster to the occasion. Many people reached the celebration by crossing a bridge over the his- toric Illinois Central tracks, about where the artist stood to create the illustration in figure 7.7. Grant Park rests on landfill that extended Illinois into Lake Michigan.

12.13 THE STATE CAPITOL (*LEFT*)

The Illinois General Assembly moved into the unfinished state capitol in 1876 and has met there ever since (fig. 8.1). The people of the state meanwhile have filled the building and its grounds with paintings, statues, and other memorials, each telling a piece of the state's story. For many, the imposing structure stands for Illinois, and year after year artists have created a host of pictures to bring images of the soaring dome to every region of the state. Renderings such as this regularly appear in state publications, encouraging, in very classical terms, the people of the state to lift their sight from level prairies to the skies. "Here I have lived," the state's most celebrated citizen told his neighbors in 1861, looking down to the ground as he left his beloved Springfield to take up the presidency and then, facing the citizenry, adding, "to this place, and the kindness of its people, I owe everything."

SATELLITE IMAGE
MAP OF ILLINOIS

12.14 SATELLITE IMAGE OF ILLINOIS

This satellite image map, created from Landsat 4 data gathered in October 1982, presents a dramatic view of Illinois as a productive state rich in resources. It is a false-color picture showing generalized land-use patterns. The topography can only be inferred, but it strongly resembles the vivid map in figures 1.5 and 1.6 Here, red indicates denser vegetation such as groves or forests, and blue points out densely populated areas that have many roads and buildings. The checkered white, light blue, and dark blue mosaic traces large fields, where some crops are still growing, others have been harvested, and still more are ploughed in preparation for the next year's crop. The darkest areas indicate the open water of rivers, lakes, and impoundments.

A close reading of the image helps one appreciate the diversity of geographic features in the state. The urban and suburban dichotomy of the sprawling metropolis in the northeast contrasts with the rocky forested reaches of unglaciated areas in the northwest and far south. A fertile plain between them dominates the landscape, supporting an intensive agricultural economy.

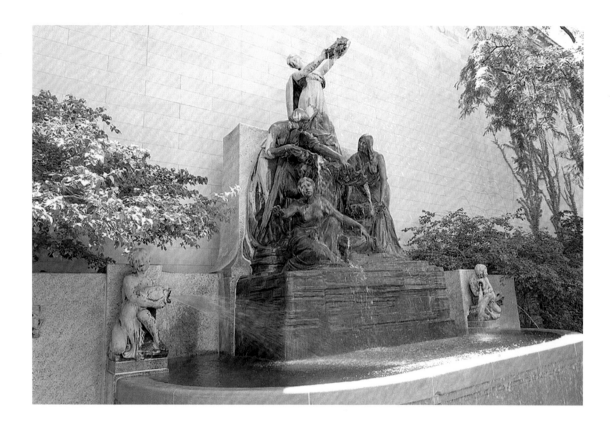

12.15 "HAVE WE BEEN FAITHFUL?"

Lorado Taft, the eminent Illinois sculptor of a century ago, posed this question at the end of his masterpiece, asking whether the people of the region had been good stewards or neglectful of their charge. He was referring to the figure of Lake Ontario in his celebrated *Fountain of the Great Lakes*. His dedication address on September 9, 1913, recounted the obvious: The maidens of the new world pour water from basin to basin, and then Lake Ontario, the last in the sequence, reaches wistfully after the departing water, reflecting on the handling of the precious resource.

People in Century 21 immediately put the contemplation into an ecological context as Illinois water flows out to sea by way of the St. Lawrence or the Mississippi. The flow stands for the entire Illinois experience, and the outstretched hand helps us visualize our heritage and measure our citizenship. Picturing our past gives us some perspectives, views wide and deep but leading in the end to the one question murmured in the flowing waters: "Have we been faithful?"

READING ILLINOIS HISTORY Some Suggestions

A handful of pictorial histories of Illinois have appeared over the years. The best one is David Buisseret's *Historic Illinois from the Air* (1990), which features aerial photographs, maps, visual resources, and a series of splendid illustrations by Tom Willcockson. *The Illinois Story* (2002) by Kenan Heise and others contains many dramatic photographs of the present state as well as an informed collection of historic images, but it has no maps and is difficult to obtain. Two places to find samplers of old maps of the state are a special issue of the *Illinois History Teacher* 11, no. 2 (2004), and *Illinois: Mapping the Prarie State through History* (2011) by Vincent Virga and Scotti McAuliff Cohn.

Many histories of the state are available in libraries. For the general reader the three most useful are Roger Biles, *Illinois: A History of the Land and Its People* (2005), Robert P. Howard, *Illinois: A History of the Prairie State* (1972), and Richard Jensen, *Illinois: A Bicentennial History* (1978). All three are cast in a political mold. The first volume is the most up to date and includes a useful bibliographical essay. Biles also features thumbnail sketches of a relevant place and a representative person in each chapter. Howard's book is packed with information, but its coverage ends in 1970. Jensen's shorter volume is an enlightening interpretive essay rooted in the historical concerns of the 1970s.

Every serious student of the state's history will want to consult the appropriate chapters and volumes of the *Centennial History of Illinois* (1920), edited in six volumes by Clarence W. Alvord and supplemented by several volumes that review the years between the Civil War and 1928 for the state's sesquicentennial. In addition, *Illinois History: An Annotated Bibliography* (1995), compiled by Ellen M. Whitney, and *A Guide to the History of Illinois* (1991), edited by John Hoffman, are useful guides to a sprawling historical literature. Two scholarly quarterlies devoted to the field are the *Journal of the Illinois State His-*

torical Society and *Journal of Illinois History* published by the Illinois Historic Preservation Agency. A helpful selection from the primary and secondary sources is *The Prairie State* (1976), a two-volume work edited by Robert P. Sutton.

Three useful tools with which to begin a study of the histories of localities are *Illinois: A Descriptive and Historical Guide,* produced by the Federal Writers' Project in 1939 and available in several later editions; *Illinois: Guide and Gazetteer,* issued by the Illinois Sesquicentennial Commission in 1969; and Edward Callary's *Place Names of Illinois* (2009). Libraries in every city and county as well as most villages and towns have local history shelves that should never be overlooked. By the very nature of things the history of Chicago is of central importance to Illinois history. *Chicago: Growth of a Metropolis* (1969) by Harold M. Mayer and Richard C. Wade is a pioneering work in pictorial history and retains value for its reach into the suburbs. The monumental *Encyclopedia of Chicago* (2004) edited by James

R. Grossman, Ann Durkin Keating, and Janice L. Reiff continues this metropolitan focus. Donald L. Miller's *City of the Century* tells Chicago's story in epic fashion from 1673 to the 1890s. In addition, three outstanding books present different contexts for understanding the city: William Cronon, *Nature's Metropolis: Chicago and the Great West* (1991); Perry Duis, *Challenging Chicago: Coping with Everyday Life, 1837–1920* (1998); and Harold L. Platt, *Shock Cities: The Environmental Transformation and Reform of Manchester and Chicago* (2005). Dominic A. Pacyga's *Chicago: A Biography* (2009) covers the city's entire history and includes 150 images.

Although several useful books on the geography of the state have appeared over the years, none has approached the subject in the systematic style of Douglas C. Ridgley's *The Geography of Illinois* (1921). *Illinois: Land and Life in the Prairie State* (1978), edited by Ronald E. Nelson, and A. Doyle Horsley, *Illinois: A Geography* (1986) update many of Ridgley's topics and add new

concerns. Two helpful volumes introduce the state's geology: *A View of the Past* (1986) by Christopher J. Schuberth and *Geology Underfoot in Illinois* by Raymond Wiggers (1997). *The Natural Resources of Illinois* (1987), a guide compiled by R. Dan Neely and Carla G. Heister for the Illinois Natural History Survey, contains many maps, graphs, and tables.

The long eras of Native American life in Illinois before the Contact Period must be pieced together from a host of the narrowly focused studies typical of archaeology and ethnology. A helpful attempt at synthesis is Charles W. Markman's *Chicago before History* (1991). *Koster: Americans in Search of Their Prehistoric Past* (1979) by Stuart Struever and Felicia Antonelli Holton tells the story of one site. A small library of studies exists concerning the great Mississippian city of Cahokia. Timothy R. Pauketat's *Cahokia* (2009), for example, underscores the center's "tremendous historical effects on the peoples who came later" (p. 158).

The French and Indian period of Illinois has been well studied, notably by Carl J. Ekberg. His *French Roots in the Illinois Country: The Mississippi Frontier in Colonial Times* (1998) focuses on the settlements, while Clarence W. Alvord takes a broad imperial view in *The Illinois Country, 1673–1818* (1920). In *French Peoria and the Illinois Country, 1673–1846* (1995) Judith A. Franke emphasizes the pictorial record. Wayne Temple's *Indian Villages of the Illinois Period* (1966) devotes a chapter to each tribe in historic times. For the broader context, see *The Atlas of Great Lakes Indian History* (1987), edited by Helen Hornbeck Tanner, which includes the Illinois Country, often on separate maps.

Tanner's atlas and Alvord's book are also good sources on the struggle for empire in Mid-America up to the Black Hawk War. See also, Allen W. Eckert's *Gateway to Empire* (1983) and several of the essays in *The Sixty Years' War for the Great Lakes, 1754–1814* (2001) edited by David Curtis Skaggs and Larry L. Nelson. The state-building process

through which the United States secured the area is detailed by Peter S. Onuf, *Statehood and Union: A History of the Northwest Ordinance* (1987). The statehood story is laid out in Solon Justus Buck's classic *Illinois in 1818* (1917).

James E. Davis presents a masterful survey of the Pioneer Period in *Frontier Illinois* (1998). *The Frontier State, 1818–1848* (1918) by Theodore Calvin Pease, based on extensive research in early Illinois newspapers, retains great value. For visual resources it should be supplemented by Betty I. Madden's *Art, Crafts, and Architecture in Early Illinois* (1974). For printed sources, Cecil K. Byrd's *Bibliography of Illinois Imprints, 1814–1858* (1966) offers many insights into the state's early history. For an archaeological perspective, which also reaches back to earlier periods, consult Robert Mazrim, *The Sangamo Frontier: History and Archaeology in the Shadow of Lincoln* (2007). Allan G. Bogue, *From Prairie to Corn Belt: Farming on the Illinois and Iowa Prairies in the Nineteenth Century* (1963) also remains a key study.

Arthur Charles Cole uses the coming of the railroads to mark the end of the Pioneer Period in his survey of Illinois during *The Era of the Civil War, 1848–1870* (1919). In *Building for the Centuries: Illinois, 1865–1898* (1977) John H. Keiser begins his account on farms and then moves to "Chicago: The Ultimate City." *The Industrial State, 1870–1873* (1920) by Ernest Ludlow Bogart and Charles Manfred Thompson is clearly organized into twenty discrete chapters.

A companion volume, *The Modern Commonwealth, 1893–1918* (1920), by Ernest Ludlow Bogart and John Mabry Mathews follows a similar pattern in even more rigid fashion but organizes a great deal of information, especially on governmental affairs. For more of a narrative account of the state's entry into the twentieth century, see *The Structuring of a State: The History of Illinois, 1899–1928* (1980) by Donald F. Tingley. The best source for a celebration of the state at the height of its power is in the May 1931 issue of *National Geographic Magazine*, "Illinois: Crossroads

of the Continent." A second essay appears in the June 1967 issue of the same periodical.

After Tingley's fine account, it is necessary to go to general histories of the state for a panoramic account of Illinois in the twentieth century. *Made in Illinois: A Story of Illinois Manufacturing* (1993) by Rolf Achilles, an institutional volume, and *Industrializing the Corn Belt: Agriculture, Technology and Environment, 1945–1972* (2009), a scholarly study by Joseph L. Anderson, suggest the type of sources necessary to knit the story together. *Illinois Issues* has collected news and views on state affairs each month since 1975. *Global Chicago* (2004), a collection of essays edited by Charles Madigan, is an optimistic evaluation of the future, and *Caught in the Middle: America's Heartland in the Age of Globalization* (2008) by Richard C. Longworth is a more sobering place to start a consideration of the state's current situation.

CREDITS AND NOTES

All images not credited are from the author's collection. Photo research assistance by Feldman & Associates (www.feldmans.net) is gratefully acknowledged.

1.1 Photograph by Marlin Roos. *The Living Museum* (Summer–Fall 2004). Collection of the Illinois State Museum.

1.2 Courtesy of the Abraham Lincoln Presidential Library. Reproduced in Andrea C. Terry, *Joliet-Lemont Limestone in Illinois: Its History and Preservation* (Springfield: Illinois Historic Preservation Agency, n.d.).

1.3 Illinois State Geological Survey, *Bulletin No. 7* (1908): 9.

1.4 M. M. Leighton et al., *Physiographic Divisions of Illinois* (Urbana: Illinois State Geological Survey, 1948), fig. 3.

1.5 Illinois State Geological Survey, *Bulletin No. 104* (1996): plate 1.

1.6 James A. Bier, *Landforms of Illinois* (Urbana: Illinois State Geological Survey, 1980).

1.7 Albert Perry Brigham and Charles T. McFarlane, *Essentials of Geography: Second Book* (New York: American Book Co., 1920), 15.

1.8 Data from H. L. Shantz and Raphael Zon, "Natural Vegetation," in *Atlas of American Agriculture* (Washington: U.S. Department of Agriculture, 1923), fig. 2. See also Hugh Prince, *Wetlands of the American Midwest* (Chicago: University of Chicago Press, 1997), 48.

1.9 *Harper's Weekly*, July 6, 1861, 421.

1.10 *Harper's New Monthly Magazine*, May 1872, 867.

2.1 *Archaeology* Folder. Chicago: Illinois and Michigan Canal National Heritage Corridor, n.d. Courtesy of the National Park Service.

2.2 *Mastodon and Landscape.* Painting by Robert G. Larson. Collection of the Illinois State Museum.

2.3 John Casper Wild, *Barbeau's Creek, Prairie Du Rocher, Illinois*, in his *The Valley of the Mississippi Illustrated in a Series of Views* (St. Louis: J. C. Wild, 1841–42). Courtesy of the Newberry Library, Chicago. Edward E. Ayer Collection 160.5.M76.

2.4 Collection of the Illinois State Museum; also reproduced in *The Living Museum* 62 (Fall 2000): 3.

2.5 Courtesy of the Illinois State Museum. Photographer: Doug Carr.

2.6 Photograph by John Smierciak, *Chicago Tribune*, June 3, 2006. All rights reserved. Used with permission.

2.7 Drawing by Charles A. Dilg. Courtesy of Chicago History Museum. ICHI-34506. Reproduced in Charles W. Markman, *Chicago before History* (Springfield: Illinois Historic Preservation Agency, 1991), 26.

2.8 Painting by Michael Hampshire. Copyright Cahokia Mounds State Historic Site.

2.9 Photograph courtesy of the Illinois State Archaeological Survey. Drawing by Mark J. Wagner reproduced from "Visions of Other Worlds: The Native American Rock Art of Illinois," *The Living Museum* 65 (Summer–Fall 2003): 9. Courtesy of the Illinois State Museum.

2.10 "The Real Piasa." Photograph copyright

5.2 Adapted from the *History of the Ordinance of 1787 and the Old Northwest Territory* (Marietta, Ohio: Northwest Territory Celebration Commission, 1937), passim.

5.3 Photograph courtesy of the Abraham Lincoln Presidential Library.

5.4 Colored lithograph by James O. Lewis in the William L. Clements Library, University of Michigan, reproduced in *Liberty's Legacy*, ed. Howard Peckham (Columbus: Ohio Historical Society, 1987), 38. Courtesy of the William L. Clements Library.

5.5 *Scene of the Great Earthquake in the West*, in R. M. Devens, *Our First Century . . . One Hundred Great and Memorable Events* (Springfield, Mass.: C. A. Nichols Co., 1879), 220.

5.6 Photograph in Randall Parrish, *Historic Illinois* (Chicago: A. C. McClurg and Co., 1919). opp. 232. This image was also issued in color as a postcard by S. M. Knox and Company in 1910.

5.7 John Melish, *Map of Illinois* (1818). Courtesy of the Abraham Lincoln Presidential Library.

6.1 Detail from Nicholas Biddle Van Zandt, *General Plat of the Military Lands between the Mississippi and Illinois Rivers* (Washington, 1818). Courtesy of the Newberry Library, Chicago. Everett D. Graff Collection. 4464.

6.2 George Flower, *Park House, Albion, Edwards County, Ill.* Watercolor painting. Courtesy of the Chicago History Museum. P&S-1926.6

6.3 From a sketch by Albert G. Brackett, *Gleason's Pictorial Magazine*, Feb. 26, 1853, 144.

6.4 Seth Eastman watercolor based on Henry Rowe Schoolcraft's 1820 sketch, as reproduced in Schoolcraft's *Historical and Statistical Information Respecting the Indian Tribes*, 6 vols., 1851–60, plate 27.

6.5 *Illinois Reporter* (Kaskaskia), Dec. 27, 1826, 4. Courtesy of the Abraham Lincoln Presidential Library.

6.6 *Lincoln the Rail-Splitter*, artist unknown, 1860. Courtesy of the Chicago History Museum. P&S-1917.0015.

6.7 Photograph courtesy of the Chicago History Museum. ICHI-11487.

6.8 George Catlin, *Black Hawk and The Prophet—Saukie*. Paul Mellon Collection. Image courtesy of the Board of Trustees, National Gallery of Art, Washington, D.C.

6.9 Mural painting by Lawrence C. Earle, reproduced in *Chicago: Pictorial, Historical* (Chicago: Chicago National Bank, 1902), 19.

6.10 Karl Bodmer, *View of a Farm on the Prairies of Illinois*. Watercolor painting (1833). Joslyn Art Museum, Omaha, Neb.

6.11 Roscoe Misselhorn, *Illinois Sketches* (Highland, Ill.: Swiss Village Book Store, 1985), 29. Used by permission of the Misselhorn Art Foundation.

6.12 William Strickland, *Prospective View of the City of Cairo, Illinois* (Philadelphia: P.S. Duval, 1838). Courtesy of the Library of Congress.

6.13 John Casper Wild, *View of Galena*. Courtesy of the Galena Historical Society. Reproduced in Betty L. Madden, *Art, Crafts and Architecture in Early Illinois* (Urbana: University of Illinois Press, 1974), 192.

6.14 Photograph from a daguerreotype. Courtesy

of the LDS Church History Library, Salt Lake City.

6.15 Olof Krans, *First Winter at Bishop Hill*, painted from memory in the 1890s. Courtesy of the Bishop Hill State Historic Site. Reproduced in *Bishop Hill, Ill.: A Utopia on the Prairie* (Stockholm: LT Publishing House, 1969), 81.

6.16 *Frank Leslie's Illustrated Newspaper*, Aug. 26, 1871. Courtesy of the Newberry Library, Chicago. +A5.34.

6.17 Photograph courtesy of the Abraham Lincoln Presidential Library.

7.1 *Frank Leslie's Illustrated Newspaper*, Nov. 17, 1860. Courtesy of the Newberry Library, Chicago. +A5.34

7.2 Library of Congress Prints and Photographs Division, Washington, D.C. (LC-USZ62–88928).

7.3 Courtesy of the Newberry Library, Chicago. Case oF545.1 272

7.4 *Ballou's Pictorial Drawing-Room Companion*, July 14, 1855, 25.

7.5 Congressional Map of Illinois, 1858, in *The Lincoln-Douglas Debates of 1858*, ed. Edwin Erle Sparks, *Collections of the Illinois State Library* 3 (1908).

7.6 Photograph courtesy of the Chicago History Museum. ICHI-61111.

7.7 *Illustrated London News*, Aug. 22, 1863, 204.

7.8 *Harper's Weekly*, Feb. 1, 1862, 72. Courtesy of the Newberry Library, Chicago. + A 5.392.

7.9 A. T. Andreas, *History of Chicago* (Chicago: A. T. Andreas Co., 1885), 2:300.

7.10 Polychromed wood carving. Folk art by Frank Pierson Richards. Collection of the Illinois State Museum. Gift of the Robert E. Church family. Reproduced in Joanne Trestrail, *Illinois: Art of the State* (New York: Harry N. Abrams, 1999), 29.

7.11 Albert D. Richardson, *A Personal History of Ulysses S. Grant* (Hartford: American Publishing Co., 1869), opp. 514. This image was based on a similar view in *Harper's New Monthly Magazine* 32 (May 1866): 681.

7.12 Photograph courtesy of the Galena Public Library, reproduced in Kenneth N. Owens, *Grant, Galena and the Fortunes of War* (De Kalb: Northern Illinois University, 1963), 55.

7.13 Drawn by A. Ruger (Chicago: Chicago Lithographing Co., 1869). Courtesy of the Library of Congress.

7.14 *Harper's New Monthly Magazine* 39 (July 1869): 174. Courtesy of the Newberry Library, Chicago. A5.391

7.15 *Richard's Illustrated and Statistical Map of the Great Conflagration in Chicago* (St. Louis: R. P. Studley Co., 1871). Courtesy of the Newberry Library, Chicago. Map 6F oG4104.C6 1871.R6.

8.1 *Harper's Weekly*, Aug. 24, 1867, 541. Courtesy of the Newberry Library, Chicago. + A 5.392.

8.2 *The New Combination Atlas of Ogle County* (Chicago: Everts, Baskin and Stewart, 1872), 9.

8.3 *The New Combination Atlas of Ogle County* (Chicago: Everts, Baskin and Stewart, 1872), 84.

8.4 *The New Combination Atlas of Ogle County* (Chicago: Everts, Baskin and Stewart, 1872), 6.

8.5 Everett Chamberlin, *Chicago and Its Sub-urbs* (Chicago: T. A. Hungerford and Co., 1874), 360. An earlier (1873) version of this view appeared in *The Land Owner.*

8.6 *The Cholera Epidemic of 1873 in the United States* (Washington: Government Printing Office, 1875), facing 52. House Ex. Doc. 95.

8.7 *The Land Owner,* supplement April 24, 1873, 70–71.

8.8 *Illustrated Encyclopedia and Atlas Map of Madison County, Illinois* (St. Louis: Brink, McCormick and Co., 1873). Courtesy of the Abraham Lincoln Presidential Library.

8.9 E. D. Kargau, *Mercantile, Industrial and Professional Saint Louis* (St. Louis: Nixon-Jones Printing, n.d.), 83.

8.10 *Harper's Weekly,* Aug. 18, 1877, 840.

8.11 Black-and-white drawing from *Scientific American,* May 14, 1881, 303. Color advertising card courtesy of McCormick–International Harvester/Wisconsin Historical Society, WHI-36369.

8.12 *Harper's Weekly,* May 12, 1883, 292. Courtesy of the Newberry Library, Chicago. +A 5.392

8.13 *Pullman, Illinois in 1886,* Mapcraft 2000. Courtesy of the Pullman State Historic Site.

8.14 Courtesy of Quincy University. Reproduced in Carl Landrum, *Quincy: A Pictorial History* (St. Louis: G. Bradley Publishing Co., 1990), 51.

8.15 *Harper's Weekly,* May 15, 1886, 312–13.

8.16 *Harper's Weekly,* May 3, 1890, 349.

8.17 *Tenth Annual Illustrated Catalogue of S. E. Gross' Famous City Subdivisions and Suburban Towns* (1891), 62–63.

8.18 *Portfolio: World's Columbian Exposition* (Chicago: Winters Art Litho Co., 1893).

8.19 *The Chicago Tribune Art Supplements: World's Columbian Exposition* (n.d.)

8.20 *Scientific American,* Oct. 20, 1894, 241.

8.21 *Chicago of Today: The Metropolis of the West* (Chicago: Acme Publishing and Engraving Co., 1891), 66.

8.22 Postcard, Amelia, Ohio, Art Mfg. Co. for Fishers Ten Cent Co., n.d.

9.1 *A Busy Bee Hive,* Montgomery Ward and Co. lithograph, ca. 1899. Courtesy of the Chicago History Museum. ICHI-01622.

9.2 Front cover of the Appleton Manufacturing Company, Batavia, Ill., Catalog, 1902.

9.3 Covers of Marshall Field and Co. brochure, 1905.

9.4 *Souvenir of Chicago in Colors* (Chicago: V. O. Hammon Co., 1915), n.p.

9.5 Photograph from an unidentified publication, ca. 1910. Courtesy of the Historical Society of Oak Park and River Forest.

9.6 Photographic postcard reproduced courtesy of the Abraham Lincoln Presidential Library.

9.7 Reid, Murdoch and Co. letterhead, 1913.

9.8 Illinois Traction System, *Industrial and Shippers' Guide.* Courtesy of the Abraham Lincoln Presidential Library.

9.9 Detail from a photograph by the Rockford Illustrating Co. (Rockford: The Photo Post Card Co., n.d.).

9.10 Library of Congress Prints and Photographs Division, Washington, D.C. (LC-DIG-npcc-32896). Sheet music published by Frank K. Root and Co., Chicago, 1918.

9.11 Photographic postcard, n.d., private collection.

the documents in the Cornell University Library. See Randall, *America's Original GI Town: Park Forest, Illinois* (Baltimore: Johns Hopkins University Press, 2000), 144. Used by permission.

10.13 Photograph by Continental Commercial Photography Co. in the *East St. Louis Journal* Photograph Collection. Courtesy of the Abraham Lincoln Presidential Library.

10.14 Postcard (Milwaukee: E. C. Kropp Co., n.d.).

10.15 *Chicago American* photograph by Ed Wagner, April 9, 1955. Courtesy of the *Chicago Tribune.* All rights reserved. Used with permission.

10.16 Photograph by Rail to Water Transfer Corp., reproduced in Harold M. Mayer, *The Port of Chicago and the St. Lawrence Seaway* (Chicago: University of Chicago Press, 1957), 156. With the cooperation of the Koch Companies Public Sector, LLC.

10.17 Photograph courtesy of Elmhurst Historical Museum, Elmhurst, Ill. See *Visionary: An Elmhurst Perspective,* comp. Virginia Stewart (Elmhurst: Elmhurst Historical Museum, 2006), 107.

11.1 Front cover of 1964 Illinois Official Highway Map. Prepared by Rand, McNally and Company. Copyright 1964 by State of Illinois. Courtesy of the Illinois Secretary of State.

11.2 Detail from U.S. Geological Survey, *Elmhurst Quadrangle Illinois* (1963).

11.3 Copyright Aero Distributing Co./CardCow.com.

11.4 *East St. Louis Journal,* Nov. 11, 1964. Courtesy of the Abraham Lincoln Presidential Library.

11.5 Military Airlift Command photograph in *East St. Louis Journal* Photograph Collection. Courtesy of the Abraham Lincoln Presidential Library.

11.6 Leaflet issued by the Tourism Council of Greater Chicago, n.d. "Printed with state and local funds, Illinois Division of Tourism."

11.7 *The Comprehensive Plan of Chicago: Summary Report* (Chicago: Department of Development and Planning, 1967), 7.

11.8. Photograph by the Illinois Department of Conservation in the *East St. Louis Journal* Photograph Collection. Courtesy of the Abraham Lincoln Presidential Library.

11.9. Copyright *The Telegraph,* Margie M. Barnes/AP Images.

11.10 Photograph in the *East St. Louis Journal* Photograph Collection. Courtesy of the Abraham Lincoln Presidential Library.

11.11 Map produced by A. Doyne "Doc" Horsley, meteorologist at Southern Illinois University, Carbondale. Horsley, *Illinois: A Geography* (Boulder: Westview Press, 1966), 54.

11.12 *State Journal-Register* (Springfield), June 6, 1982. All rights reserved. Used by permission.

11.13 *Metro Area* (Richmond, Ill.: Perspecto Map Co., 1982) in *Chicago Visitor Map and Guide* (Chicago: Chicago Convention and Tourism Bureau, 1982). Perspectovision®© 1982 by Perspecto Map Co., Inc. Crystal Lake, IL 60039–1288. Used by permission.

11.14 *1986 Chicago Neighborhood Festivals,* City of Chicago brochure, Mayor's Office of Special Events.

11.15 Carl Landrum, *Quincy: A Pictorial History* (St. Louis: G. Bradley Publishing, 1990), 179.

11.16 Thomas A. Rumney, "Patterns of Agricultural Land Change in Illinois: 1919 to the Present," *Bulletin of the Illinois Geographical Society*, 34 (Fall 1992): 29. Courtesy of the Illinois Geographical Society.

11.17 *Chicago Tribune* file photo. Photograph by Chris Walker taken April 4, 1989. All rights reserved. Used with permission.

12.1 Copyright James A. Finley/AP Images.

12.2 Harborside International Golf Center brochure, n.d. Courtesy of the Illinois International Port District.

12.3 Graphic by Sue-Lyn Erbeck and Phil Geib, *Chicago Tribune*, March 22, 2007. All rights reserved. Used with permission.

12.4 Photograph Chicago History Museum, reproduced on the cover of its newsletter, *Past Times* (Fall 1996). An earlier version of the mural, photographed by Thomas Schlereth, appears in *The Encyclopedia of Chicago History*, ed. James R. Grossman, Ann Durkin Keating, and Janice L. Reiff (Chicago: University of Chicago Press, 2004), plate A5.

12.5 *Illinois Blue Book, 1997–1998*, 11. Courtesy of the Illinois Secretary of State.

12.6 Terry Evans, *Prairie Crossing, Grayslake, Lake County, August 24, 2003*, photograph reproduced in John C. Hudson, *Chicago: A Geography of the City and Its Region* (Chicago: University of Chicago Press, 2006), plate 84. Courtesy of the artist.

12.7 Photograph by the author, Feb. 11, 2010.

12.8 Photograph by John Konstantaras, *Chicago Tribune*, Sept. 16, 2001. All rights reserved. Used with permission.

12.9 Orion Briney (rear) and Jeremy Fisher on the Illinois River by State Highway 17 Bridge at Lacon. Photo by Zbigniew Bzdak, *Chicago Tribune*, May 7, 2006. All rights reserved. Used with permission.

12.10 Hedrich Blessing photograph in the Chicago History Museum reproduced in the initial portfolio for Timothy J. Gilfoyle, *Millennium Park: Creating a Chicago Landmark* (Chicago: University of Chicago Press, 2006). Courtesy of the Chicago History Museum. HB-60907-T.

12.11 United States Postal Service. Bethany Jaeger's photograph of the stamp's first-day-of-issue ceremony appeared in *Illinois Issues* (Oct. 2008): 12.

12.12 Photograph by E. Jason Wambsgans, *Chicago Tribune*, Nov. 16, 2008. All rights reserved. Used with permission.

12.13 Watercolor by Paul N. Norton. Michael J. Howlett, *Keepers of the Seal* (Springfield: Secretary of State of Illinois, 1977). Courtesy of the Illinois Secretary of State.

12.14 Richard E. Dahlberg, Donald E. Luman, and Alden Warren, *Satellite Image of Illinois* (Champaign: Illinois State Geological Survey, 1985).

12.15 Taft, Lorado, American, 1860–1936, *B. F. Ferguson Fountain of the Great Lakes*, September 1913. Bronze, granite base, limestone pool. B.F. Ferguson Monument Fund, RX23235/1, The Art Institute of Chicago. Photography © The Art Institute of Chicago.

INDEX

GERALD A. DANZER is a professor emeritus of history at the University of Illinois at Chicago. A former director of the Chicago Neighborhood History Project, he is the coauthor of numerous history textbooks, including *America! America!, Land and People: A World Geography,* and *The Americans.*

The University of Illinois Press
is a founding member of the
Association of American University Presses.

• •

Designed by Kelly Gray
Composed in 10/15 Trump Mediaeval LT Std
with Meta display
at the University of Illinois Press
Manufactured by Bang Printing
University of Illinois Press
1325 South Oak Street
Champaign, IL 61820-6903
www.press.uillinois.edu